MARY LOU'S WAR

Mary Lou's War

a novel

Lia Schallert

Lia Schallert (signature)

2005 Fithian Press
McKinleyville, California

Published by Fithian Press
A division of Daniel and Daniel, Publishers, Inc.
Post Office Box 2790
McKinleyville, CA 95519
www.danielpublishing.com

LIBRARY OF CONGRESS CATALOGING-IN-PUBLICATION DATA
Schallert, Lia, (date)
 Mary Lou's war : a novel / by Lia Schallert.
 p. cm.
 ISBN 1-56474-446-9 (pbk. : alk. paper)
 1. Young women—Fiction. 2. World War, 1939–1945—Virginia—Fiction. 3.
Hospitals—Staff—Fiction. 4. Rape victims—Fiction. 5. Women clerks—Fic-
tion. 6. Virginia—Fiction. I. Title.
 PS3619.C3254M37 2005
 813'.54—dc22
 2004021604

This book is for my husband, William Schallert.

For my writing mentor, Sid Stebel.

*And for the Westside Writing Group members: John Albert,
Dyanne Asimov, Bonnie Barrett, Lynn Bird, Judy Buchner,
Jennifer Cecil, Linda Chase, Todd Cook, Rich Ferguson,
Diane Hailey, Ted Humphrey, Diane Klein, Mary Pat Koos,
K.D. Parks, Brendan Schallert, Ann Siracusa and Alex Sokoloff.*

MARY LOU'S WAR

CHAPTER 1

10 MARCH 1943
*Sicily: Allied bombers make heavy attack
on Palermo.*

IN FAR AWAY PLACES in March of 1943, generals were planning battles, but in Richmond, Virginia, Mary Lou Cottrell was wondering where she would go to college. She and her best friends were eating lunch on the lawn of St. Gertrude's School for Girls.

Rose Marie Carney, a redheaded sliver in plaid skirt and cashmere, announced, "I've decided on Sweet Briar. My cousins all go there."

"I'm going to Dunbarton in Washington, D.C.," Ann Marie Bolden declared softly. "My mother wants me to see a little northern culture while I'm away at school."

"Where are you going, Mary Lou?"

"I don't know. We haven't discussed it."

The group started to giggle, thinking she was being her usual amusing self. The six, who were the most popular group at St.

Gertrude's, finished telling where they'd be going. Bryn Mawr, Mary Washington, Longwood were additional choices.

The rest of the lunch break was a blur to Mary Lou. Where will I be going? she wondered. We've blundered again. Her parents were sweet, but disorganized. Their home was a place where you could never find a safety pin or a pen or scissors except by chance.

That evening Mary Lou stayed in her room until dinner thinking of the day's revelations. All of her friends would be leaving town. She had been so caught up in the senior year—going to proms and being a sponsor girl and cheerleader at the military academy down the street from St. Gertrude's—that, typical of her family's haphazard style, college had never been thought of or discussed.

Halfway through dinner she asked, "Daddy, where am I going to college?"

Her father, who worked in a dental supply store and spent his lunch hours in the public library, answered, "Well, I don't think you are. We don't have the money to send you to college."

Mary Lou was stunned. "Everyone is going."

"Well, then you can see them off at the train station because you aren't."

"How come you never told me this?"

"Because you never asked. I don't think it's important for girls to go to college. And besides, you've never been that good in school." That was the truth, but not because she wasn't smart. Sister Antoinette, the principal, had always said, "Mary Lou's I.Q. is the highest in the room. It's a shame she doesn't apply herself."

When Mary Lou was twelve she and her best friends had seen *Gone With The Wind* the day it opened at the Richmond Loew's Theatre. In fact, they'd taken their lunches and seen it twice. From that day on Mary Lou wanted to be like Scarlett O'Hara and practiced flirting and being popular and never thought about school work at all.

Mary Lou went to her room after dinner, did her homework for a change, and thought about college. The next day she went in to see Sister Antoinette, the principal.

"Sister, I want to go to college," she said.

"But Mary Lou, your family doesn't have much money and you aren't eligible for a scholarship."

"What's that?"

"Well, colleges will sometimes take poor students for free if they have extremely good grades."

"Why didn't someone tell me about this?"

"Because you never inquired."

"Is it too late now?"

"I'm afraid so."

Mary Lou looked like she did when she was eight years old and her cousin, Sonny, hit her and made her see stars. This was the first big disappointment of her life.

"I'm sorry, Mary Lou, I always assumed you'd be going to work right from school."

"Sister, I want to go to college. If there's any way please help me find it."

"I'll see what I can do. But I'm afraid it's too late."

How can something be too late when I'm only sixteen, Mary Lou wondered.

This was the first time that Sister had been this friendly. Usually she called her into the office to inform her that her soul was in mortal danger because she was so popular. In fact, she called her in quite often to tell her not to let boys do fresh things to her and that she must get more school spirit.

At least we didn't have the usual pep talk, Mary Lou thought as she left the office. For once I don't feel like Belle Watling. Sister Antoinette was quite a formidable woman, very tall, with a large aquiline nose and piercing black eyes. Everyone else was terrified of her, but Mary Lou was afraid of no one.

From the day of discovery about colleges Mary Lou started

doing her homework, studying for tests, and doing very well in school, even though there was a lot of back work she didn't know.

I'll get to college somehow, she decided. If Scarlett could keep Tara I can find a way to do this.

The next week Sister Antoinette called her into the office after chapel. "Mary Lou, there's a Catholic school called Dunbarton in Washington, D.C. which will give you a half-scholarship. I've told them that you have a very high I.Q. and seem to be sincere in wanting to attend college."

"Oh, thank you, Sister. I'll tell my father tonight."

"Now, remember, keep yourself pure. You never know when you're liable to get a vocation to be a nun." This was another discussion that they had often.

Mary Lou wondered how it felt to get a vocation. She hoped the Holy Ghost wouldn't appear with it in the middle of the night. She knew it would scare her to death.

"I've told you, Sister, I don't do anything bad on my dates."

"Even holding hands can lead to other things."

"I'm a good girl, Sister. I want to keep my reputation."

Keeping one's reputation was very important to Mary Lou and her friends. To be a good Scarlett O'Hara was really her ambition.

At dinner that night Mary Lou told her father about the offer of a half-scholarship. "We still can't afford to send you. We don't have a penny to spare. The only way you could go would be to work and save the money yourself."

"But there's not enough time for that."

"That's too bad. You can't get water from a stone."

"I don't think it's fair. You should have warned me." She felt betrayed somehow. She went to her room and studied harder than ever. If only I had another year, she thought. The next day she told Sister Antoinette about her father's reaction to the scholarship.

"I'm sorry, Mary Lou. If only you'd been motivated when you were a freshman."

"I'm going to go somewhere, somehow," Mary Lou said. "I'm not going to be left behind."

When she thought about it she realized she'd grown to like studying in the last few weeks. *There's a whole world out there that I never knew about.* She had always liked reading and after rushing through her textbooks in the first weeks of school was bored for the rest of the term.

"We're taking the Catholic University test for high school seniors on Saturday," Rose Marie said as they left school. "So I won't be able to meet you at People's Drug Store for lunch." Four of the girls met every Saturday and had chopped olive sandwiches and chocolate milk shakes.

"I'm taking it too," Ann Marie said.

"What is it?" Mary Lou asked.

"Well, you take this test in Latin, Math, and English, and if you pass it you get a second diploma at graduation. Only straight-A students get to take it. It's a real honor."

Mary Lou felt like crying. *I'm being left out again,* she thought. "Y'all go on. I have to talk to Sister about something."

She raced back into school, knocked on the Principal's door and was called in. "Pardon me, Sister, but I want to take the Catholic University test."

"You may not. You aren't eligible because of your grades."

"Please, Sister. I've been studying more. Let me take it, please."

"Well, I don't think you can pass it."

"I don't care. I want the chance."

"Well, all right. Maybe it'll prove something to you. But I'm afraid the other girls won't like it."

"Oh, thanks a million."

The other girls were still waiting for the streetcar. "I'm going to take the Catholic University test too."

The others started laughing. "Oh, Mary Lou's getting serious. What a change."

As Mary Lou got to her stop she called back, "Call me if anything exciting happens." That was what they always said to each other in the afternoon, but they called each other anyway even if nothing happened—sometimes three times a night.

"Mary Lou, Mrs. Smithe across the street said that you should apply to the Telephone Company before school lets out. She said they're always looking for girls from good schools to be clerks and they start at sixteen dollars a week. If God finds a way for you to go to college you should have some money saved for it." Her Mother, Elizabeth, was an incredibly beautiful woman of Irish descent who believed that: One, rules are made to be broken; Two, if it's only a dog let it wag its tail to you (Mary Lou figured this was out of her control); Three, Saint Anthony will find anything for you even if you've been incredibly careless. That was the way all scissors, pins, pens, and loose change were found in their house. As for the dogs wagging their tails, Mary Lou wondered about that for years until her Mother explained that it was better than being bitten by a dog whose enemy you'd become.

"Somehow God will find a way for you to go to college."

"But, Mom, if I'd known about it I would have studied and gotten a total scholarship."

"Never mind. Better late than never."

"Yes, Mother, but a miss is as good as a mile, you always say."

"Now, don't be fresh, Mary Lou."

On Saturday Mary Lou went to school for the Catholic University test. Six girls sat at the long table in the library on the second floor overlooking a beautiful garden. The school had once been a private mansion.

This is fun, she decided. It never occurred to her that she might not pass. After the test, which lasted three hours, some boys from Benedictine Military School were waiting outside.

"Let's ride the streetcar downtown. I have to get a form from the Telephone Company," Mary Lou said.

"Oh, how corny, Mary Lou. You're not going to be an operator are you?" Rose Marie said. Her father was a rich Irish contractor and they lived in a big house with lots of sterling silver and lace tablecloths.

"No, I'm going to be a clerk, temporarily."

"We're going to the river again," Rose Marie said. Most of the families had summer homes on the James River or Virginia Beach.

"I'll be in boot camp," Ernest Cavedo said. He was incredibly handsome and he and Mary Lou had dated for two years. "I've joined the Marines."

Most of the boys were eighteen and had to go into military service. "I'm going into the Air Force," John Bryan said. "The day after graduation."

Until that moment the war had seemed very remote to Mary Lou. "Do you think you'll be fighting Japs?" she asked. "I hear they're all weird and cut their intestines out if something goes wrong."

"Mary Lou, don't be so ignorant," Ernest said. "They're Orientals with different customs from us."

Our world's coming apart, she thought. Just like the scene at Twelve Oaks when the men all left to join their regiments, but at least that war was fought at home, not way overseas somewhere.

"If only I were twenty-one I'd join the Nurse's Corps," Mary Lou said.

"You'd meet nothing but poor white trash in there," Ann Marie said.

"Yes, but I'd be part of the excitement. By this summer our whole crowd will be gone."

* * *

Mary Lou had her job interview the next week. Mr. Tippett, a red-haired man who looked as though he needed a square meal, questioned her. "Do you want a permanent home with the Telephone Company?"

"Oh yes, Mr. Tippett." It seemed rude to say no.

"Because some girls are only looking for temporary work and we can't afford to train for just a short time."

"I have no other plans right now," she answered as truthfully as she could.

"How come you're not going to college? I see you had four years of Latin and three years of French."

"We can't afford it and I wasn't studious enough for a scholarship, but when I make up my mind I can do anything. I would work very hard for you and the Telephone Company." That's the truth, she thought.

"All right, consider yourself hired. The pay is sixteen dollars a week for five and a half days. When do you graduate?"

"June the fourth."

"You can start on June the sixth."

On the streetcar ride home May Lou tried to figure out how much she would make during the summer. It was about one hundred and ninety dollars minus carfare and lunches. I wonder how much college costs. I'm liable to be at the Telephone Company for years.

"I'm going to make sixteen dollars a week starting on June the sixth," Mary Lou said at the dinner table.

"That's good. You can pay ten dollars a week for room and board," her father said.

"But I want to save to go to college. That's not fair."

"Who said life was fair?" He was a good man who'd had the stuffing knocked out of him by the Depression. They'd come to the South when Mary Lou was five after he'd been out of work for two years. He used to walk miles a day selling dental supplies out

of a valise. His hands had always had blisters on them in those days.

"I'll pay five dollars," Mary Lou said. "No more. At that rate I won't save more than eight dollars a week."

"All right," he answered. He was a reasonable man.

Mary Lou and her mother made plans for a dress for the military cotillion in June. The cadets and their dates, who would be wearing white formals, marched around a ballroom and formed mathematical figures. It was the social event of the year.

"I want to get a very plain pattern as everyone else will be all gussied up," Mary Lou said.

They went to Thalheimer's Department Store and bought white lace and when Mary Lou came home from school the next day her mother was posing in front of the mirror with the lace draped around her.

Mary Lou went to her and they hugged without saying a word. Her mother hardly ever got any new clothes.

That Sunday Elizabeth didn't come home from a church meeting that was held in downtown Richmond. The streets were filled with servicemen at that time. I guess Mother thought she would just have a few friendly drinks with someone, Mary Lou decided, but if she had even one beer that would be the end of her. One drink and she was like a vaudeville act. It was the curse of the Irish, which had struck most of the McClains.

"You will have to stay home and mind your brother," her father said.

"But Daddy, I want to graduate. I'll ask Mrs. Ernst to baby-sit. Besides, Mother won't be gone long and I can't miss the last few months of school. I'm maid-of-honor for May Day and in the Cotillion. These are the best days of my life. I'll get Glenn dressed in the morning and walk him to Mrs. Ernst's and get him right after school."

The neighbor, who had small children of her own, obliged

and baby-sat. Mary Lou made terrible dinners. Her father sat in the living room at night just staring into space.

A month after Elizabeth disappeared the phone rang. It was eleven o'clock at night. Her father came into her room and said, "I'm asking Mr. Cunningham to drive me to get your mother. Someone on the phone said, 'Your wife is at the Star Motel on the Washington Highway. You'd better come get her.'"

Two hours later they returned. Elizabeth had been a slightly plump woman, but now she was thin and when she got in bed with Mary Lou she was shaking all over. I'm glad she's back. I hated it when she was away, Mary Lou thought. She hugged her all night. They never talked about it, but her father said he'd found her climbing into the back of a truck trailer and if he'd been a moment later she might have been gone forever.

The cotillion dress had to be made overnight and didn't fit well, but her mother never apologized. I still like it better than anyone else's, Mary Lou decided. The next few months were great fun. Ann Marie was May Queen and Mary Lou maid-of-honor. Mary Lou did pass the Catholic University test although her name wasn't announced in church with the rest of the recipients. Sister Antoinette's revenge, Mary Lou decided. For what she wasn't sure, but thought maybe it was cumulative.

The graduation cotillion was held in the ballroom of the Dominion Hotel. The boys marched in their dress uniforms with the girls by their sides. They stayed up all night and Mary Lou's mother made breakfast for them.

Two days after graduation on the sixth of June 1943 Mary Lou went to work for the Telephone Company. She worked in the personnel section, where she filed employee records. She wondered why almost everyone there had cystitis, a female disease.

"Miss Cottrell, you're not supposed to read through the records every time you file a folder."

Her boss was a virgin lady named Stone, who was short and solid. One day Mary Lou accidentally brushed against her. I guess when bosoms are never used they harden like rocks, she thought. God, I don't want to be here when I'm forty like her.

"I'm sorry, but they're very interesting and I'm a fast reader." She'd always wanted to say "Fiddle-dee-dee" like Scarlett but had never had the nerve. This would have been a good time to do it, she thought.

"I don't care how fast you are. You're on Telephone Company time now and you can't do what you want."

"Yes, ma'am." Our nuns at school let us talk to them as equals, she thought. I never realized how nice they were.

Mary Lou's girlfriends were at their summerhouses, and all the boys her age had gone into the service. It's pretty bleak around here. I might die of boredom, she thought. She looked around the streetcar she was riding. Maybe I should flirt and pick up a service-man. Oh no, I can't do that. If anyone saw me I'd really lose my reputation. Besides, I'd only pick up an officer and there are none on this car. She had read somewhere that officers were gentlemen.

Mary Lou had trouble keeping awake at work. No matter what time she went to bed at night the minute she arrived at work she felt sleepy. The only thing she looked forward to was her lunch hour, which began at twelve noon. She would practically run out of the building and up to Main Street and spend fifteen minutes in Thalheimer's Department Store. Then she would go to Miller and Rhoades, the other department store. She'd top this off with a quick trip through Woolworth's, where she would buy a hot dog and eat it before heading back to the Telephone Company. Sometimes she would buy a new Tangee lipstick, but was very good about not wasting money. In case a miracle came she had to save to pay for it.

One night she received a call from a boy named George Bark-

er. "Hi, Ernest Cavedo gave me your number. I've just graduated from V.M.I. I'm waiting to get my commission in the Marines. Could you go to the movies with me?"

"I guess it would be all right since you're a friend of Ernest's." I hate blind dates, she thought. But at least he's from Richmond and not some weird Yankee.

When he arrived the next night she was pleasantly surprised. He was tall and not bad looking in a big-faced kind of way and drove a Ford convertible.

"I hope to be in the Marines any day," he said. "I haven't passed the physical exam because when they take my pulse I get excited and it goes over the limit."

"I guess it's not good to be too excitable in the Marines," Mary Lou said. "I've seen some newsreels about battles."

"I think I'll be all right once I get in combat, but I just want my commission so bad. I can't think of anything else. My Dad's going to ask a friend of his at the club if he can get something to calm me down. Some kind of drug."

They went into town to the movies. "I don't like to be out on the street much because soldiers call me names," he said. They crossed to the other side of the street to avoid servicemen.

"What do you mean?"

"Well, like draft-dodger or goldbricker. I can't wait until I get my commission and have my uniform."

"Don't worry about what people think. My mother says if someone bothers you just think, 'They don't pay my board.'"

"That's great. I never met anyone like you. You seem so care-free and sure of yourself. I think it's great that you have a job too. My sisters and all their friends are at Virginia Beach just getting tans."

"I'm working until I figure a way to get to college."

"My grandparents left us all trust funds to take care of our college education."

He's like one of the Tarleton twins, she decided.

As he left her at the door he said, "I'll come by tomorrow and take you to lunch. What time do you get out?"

"Twelve o'clock."

"There's a lunch place called White's. Do you know it?"

"Oh yes," she said. I hate that place, she thought. It was an old-fashioned tearoom where lots of old ladies went. She didn't let him kiss her goodnight. "I don't do that on the first date," she said.

The next day she was as sleepy as ever. All morning she could barely stay awake. I'm not looking forward to lunch with George. I love my free time and today I don't have any. I'd rather buy my own lunch.

They ate chicken salad sandwiches at White's. She liked her hot dogs better. George had a hot fudge sundae, which he ate like a little boy, never looking up. She got back to work two minutes before one o'clock.

They went to the movies three times that week and one night went dancing. "I'd rather dance than eat," Mary Lou said. He couldn't jitterbug but could do the basic slow dancing passably. She wished he wouldn't pump his arms up and down so much.

"I went to Miss Porter's Cotillion," he said. "But I've never been smooth."

He seemed to be out of breath and was panting in her ear. I'm afraid he's a drip, she decided. I can't stand seeing too much of him.

She went to the ladies room and when she came out he was in a fight with a sailor. The manager came over. "That guy started it for no good reason," George said.

"I'm sorry, but you civilians drive the service men crazy."

"He has a medical excuse," Mary Lou said in a loud voice, hoping everyone around them would hear.

"Let's go, Mary Lou." His lip was getting puffy. When they got

to her house he kissed her goodnight. It was a very wet kiss and he kept his mouth open. Just like Rhett did when he left Scarlett in the wagon near Tara. No wonder she was disgusted, Mary Lou thought.

"I'll see you tomorrow at twelve," he said.

"Okay," Mary Lou said. Oh, no, she thought! But I can't think of any way to get out of it. It's bad enough being bored and sleepy all day, but now I can't have my hour of fun.

She started thinking of ways to have her lunchtime free again. I can't say I have a dentist's appointment. He'd probably want to go with me. Why can't I just tell him the truth? That I just need some time alone. I feel totally trapped.

Every day for two weeks when she left the building to go to lunch she could see him across the street waiting for her. Then one day she thought, Oh God, I can't face one more boring hour with him. I'll find another way out. She looked for one as she came to the lobby but there was no side exit. I'll just stay inside. I'll go to the employee's lounge. She took the elevator to the fifth floor where she happened to see an emergency exit sign. There was a fire escape visible through the window. I'll go out that way! Mother says rules are made to be broken. The window was hard to open but she managed it. This is kind of scary, but kind of exciting too. Carefully she went down the steps.

When she got to the third floor she noticed some people pointing up. Were they pointing to her? What's the matter with them? she wondered. Haven't they ever seen anyone come down a fire escape? A crowd started to gather and as she got to the bottom she saw three policemen and George Barker toward the back.

"You're under arrest, miss."

"Why?"

"This building is protected under the War Emergency Act. We're on the lookout for saboteurs. It's a vital part of communications. We've called the army police to pick you up."

"What did you think I was doing?"

"We don't know but they will find out."

"I work in this building. I can explain." Oh God, this is too embarrassing, she thought. Who would understand? George Barker did not step forward but turned around and walked away. What a Marine he will make! It's not what Rhett would have done.

The army came and took her to their headquarters. The captain was very kind and believed her story. He said he would tell the Telephone Company to let her keep her job. As she waited for him to question her she saw a sign that said, "Positions opening up for civilian workers at McGuire General Hospital. Apply now." She memorized the phone number.

The captain had her sent home in a jeep. Her mother looked mildly surprised. When her father came home he said he understood.

"I guess it's hard being cooped up all day when your friends are all on vacation. But I have some good news. I heard that you can get a loan from the state of Virginia for three hundred dollars to cover one year in a state Teacher's College."

"That's great, Daddy." And in the meantime I'll call that number about working in the hospital, she decided.

CHAPTER 2

9 SEPTEMBER 1943
At 3:30 A.M. *General Mark Clark
launched "Avalanche," the landing of
Allied troops on the Italian coast
near Salerno.*

ON THE NINTH of September 1943 in a large room in the army hospital on the outskirts of Richmond, fifty women were preparing to take the Civil Service exam to qualify for jobs there.

Mary Lou, her long blonde hair pulled back with a barrette and dressed in a pink sweater, plaid skirt and saddle shoes, leaned over to the girl at the adjoining typewriter and introduced herself.

The girl, who looked like a sunflower with her brown eyes and yellow dress, answered, "Hi, I'm Barbara Busser."

"Is this your first job tryout?" Mary Lou asked.

"No, I used to work in the A&W Root Beer store, but this is my first typing job and I'm pretty nervous. Are you?"

"Yes, and I'm not usually nervous about tests, but I haven't typed very much."

"I took a course in high school," Barbara said.

"I used to practice at the Telephone Company when nobody was looking."

"Good luck!"

"Same to you. The pay is so great, I hope we make it. I want to save to go to college."

"I'd like to buy myself a horse and keep it on my uncle's farm."

Captain Virginia Brade, an officer in the Women's Army Auxiliary Corps, entered the room. She was a large person with a mannish haircut, but had a very sweet way about her.

"Welcome to McGuire General. We will have a lot of job opportunities to offer to you who pass this test." Mary Lou and Barbara exchanged smiles.

"I'm in charge of staffing this hospital before our patients start arriving in a week or two. Good luck! I know a lot of you are inexperienced, but don't worry, you'll improve rapidly once you start working. And now I'll turn this over to the administrator of the test."

The civilian in charge explained that the test was in two parts. The first consisted of basic intelligence questions and the second was a typing exam for speed and accuracy.

These questions don't seem too hard, Mary Lou thought. This is fun! Now if I can only type well enough. The handbook said accuracy is more important than speed. One mistake and the whole sentence is eliminated. Careful! Careful! Barbara looks so serious. Hope she makes it. Hope we both do.

They typed for half an hour and then the test was over. Everyone took their papers out and looked around, breathing sighs of relief.

Captain Brade entered the room again, accompanied by a sergeant.

"I hope you all passed. We really need you. And now Sergeant Salvio of Special Services will give you a tour of the base. You'll

also be shown an indoctrination film, on the assumption that you will be working here."

"This sounds like fun," Mary Lou whispered. "I love the movies, don't you?"

"I adore movies."

"Hello, ladies! I'm Sergeant Salvio and I'm going to introduce you to the army." He was a small natty-looking man in a tailored uniform.

"Were going to walk to the base theatre where you'll see a film that teaches you how to act around the patients. Follow me!"

He led them down a long corridor, which connected all the buildings. As they walked he called over his shoulder. "The gist of the movie is that you civilians are to show no alarm, disgust, or pity in front of the patients no matter how bad off they are."

"I think we'd know better than that," Mary Lou said to Barbara.

"I heard that," the sergeant said. "But you'd be surprised how many workers are too sympathetic. You'll see that that just makes the patients feel sorry for themselves and interferes with their recovery."

As they walked he pointed to places of interest. "This is the mess hall, where you'll be allowed to eat. And that's the PX over there, where you'll be allowed to buy things."

"I've heard that we can get nylons there," Barbara whispered.

"Great, I haven't had any in two years," Mary Lou whispered back.

When they arrived at the theatre they saw it was a huge auditorium with a stage upon which a large screen had been placed. Someone had tried to make it cheerful, so instead of the usual olive drab paint they had used a bright yellow-green. Folding chairs, some unfolded, some leaning on the wall, were scattered about. A sad-sack private was putting finishing touches on a sign that read:

WELL COME

WHEEL CHAIRS IN REAR

DO NOT EXIT WHEN LIGHTS ARE OFF

"Okay, here we are! Be my guests. Take your seats." As the lights were turned down he called from the back, "Sorry, no popcorn or candy." The girls started to giggle.

"Is he the corniest ever?"

"Glad to see some of you have a sense of humor. You'll need it here."

"It's him that's funny."

"Yeah, not his jokes!"

The first scene showed a patient in pajamas sitting in a wheel-chair asking for assistance from a civilian worker at a desk.

"Do you know where I go to have some forms filled out?" He appeared to be healthy.

"Go right down the hall and turn left to Military Personnel." The civilian was pert and cheerful.

"Thank you, miss."

"You're very welcome." She almost sang the line. He scooted off.

There was a caption at the end that read: YOU WILL NOTICE THAT MISS JONES NEVER ASKS ABOUT HIS INJURY AND NEVER LOOKS UPSET.

There were a few nervous giggles in the audience.

The next scene showed a civilian worker standing by a patient in bed. It was the same pert and cheerful Miss Jones.

"I brought your payroll records here so we could go over them in detail."

"Oh, thank you so much, miss."

"Any time. Just call when you need assistance."

Another caption followed. YOU WILL NOTICE NO SIGNS OF DISGUST OR PITY ON HER FACE.

"I don't blame her. He was cute, wasn't he?" Barbara said.

The next scene was in a PX coffee shop. Patients were sitting around tables, some of them in wheelchairs. Miss Jones entered.

"Hello, Miss Jones," one of the patients called to her. "Would you like to join us?"

"Sure, but I only have time for a coke." She sat down. "Have to get back to the office and take care of your records," she said jovially. They continued smiling to each other as they drank their cokes.

Another caption; NOTE THAT MISS JONES AT ALL TIMES ACTS IN A VERY MATTER OF FACT MANNER TO AVOID EMBARRASSING THE PATIENTS.

The lights went up and the sergeant returned to speak to them from the front of the theatre.

"Sorry there was no singing or dancing! Maybe next time. By the way, you will be entitled to watch regular movies here too. Any questions?"

Mary Lou raised her hand. "Suppose they want to discuss their injury?"

"Just change the subject."

"Wouldn't that be hard to do?"

"Not really, if you make up your mind. Look, missy! Don't work up a lather about this. Just obey the rules!"

"I'm not working up a lather," she said with a determined look on her face.

"If there are no more questions we'll go back to the front of the hospital where you can get a bus back to the city. You'll be notified by mail if you passed or not."

They walked back, talking among themselves.

"If we get the jobs do you think we'll like it here?" Barbara asked.

"I don't know, but it's sure worth a try," Mary Lou answered.

"I hope I know how to act."

"I guess the main thing is to be friendly and make them feel at home."

Ten days later at eight A.M. newly hired workers were arriving at the Military Personnel Department, which turned out to be a huge warehouse filled with desks.

Mary Lou walked up the center aisle, which had two rows of desks facing it, past Officer's Payroll, Morning Reports, and Records Section, where she saw Barbara standing by the Enlisted Payroll sign.

"Oh, you made it too!" she called.

"And we're in the same section," Barbara answered. "Oh, I'm so glad." They ran to each other and hugged.

"Isn't this exciting? This is the day the patients arrive too."

"Oh, I wondered why the band was on the platform outside."

A sergeant came over. He was a slightly chubby young man, about twenty-five with knock-knees, who stood with his feet totally turned out. In fact, his legs seemed to bend the wrong way.

"Hi, girls! I'm Sergeant Fred Percy. You'll be working for me. Here are your desks. We won't have much to do until the records get here, but you can read these Army Regulations for now."

The girls put their purses in their desks and sat down to read.

The noise from the engine was deafening as it approached. It almost drowned out the band playing "The Stars and Stripes Forever." It came closer and closer. There were the squealing of brakes, sounds of doors opening, orders being called out, and then the band seemed loud again. The newly hired workers in the Military Personnel section stopped what they were doing and looked toward the huge double doors of the warehouse, which served as their office. Two M.P.'s moved quickly up the ramp at the end of the room and stationed themselves on either side of the doors.

After a few moments a soldier appeared at the top of the ramp. His head was heavily bandaged. One eye was covered. His uniform was battlefield dirty.

Mary Lou stared at him in dismay. Nothing had prepared her for this moment. Oh gad, she thought. What have I gotten myself into?

The soldier walked slowly down the ramp and through the office by way of the center aisle. Oh, God, Mary Lou thought, that noise was the train bringing the soldiers from the hospital ships in Newport News. They're really here! This is unbelievable!

Other patients followed in quick succession, as though they'd rehearsed their entrances—someone's son, his puffy face barely showing through the bandages, standing for a moment at the top of the ramp not knowing what was expected of him, then with measured steps, walking through—the next, not handsome, not sweet, on crutches, moving quickly, giving them a sweeping glance—the next, some mother's joy, one arm gone, listing to one side, swinging his legs with extra energy. They kept coming. The office workers sat frozen at their desks and watched as though in a trance.

"They're still in their battle uniforms," Mary Lou said.

"Should we say hi?" Barbara whispered.

"I don't know. I don't know how we should act," Mary Lou said. "I guess normal as possible like in the training film." Oh God, she thought, this is so weird. I feel like we should do something, but I don't know what.

No one said a word. Mary Lou could see in the passageway outside the office the severely wounded, heavily bandaged, tubes attached, being taken to their wards. The footsteps of the orderlies and the wheels of the gurneys filled the silences between the band's songs.

What have I gotten myself into? Purgatory? I don't know if I'm ready for this. Mary Lou was traumatized. She looked over at Barbara, who seemed in a trance. I'll try to look nonchalant, but my lips are quivering. I sure don't feel like the girl in the training film, or even the girl I was this morning.

Chapter 3

1 October 1943
*Austria: Allied bombers drop one hundred
and eighty-seven bombs on Vienna.*

MARY LOU had been working at McGuire for a few weeks
and was on an important errand for Sergeant Percy, taking infor-
mation from Military Personnel to the Accounting Office.

I really like my job, she thought. I'm making great money. I
can save a lot working here and then I can go to college. Now I'd
better hurry so we can get these new patients on today's payroll.
Sergeant Percy asked me to type them because I'm the fastest.
That's nice.

Without thinking she started skipping down the long hall-
ways connecting the buildings.

Wonder why Accounting's so far from us? We work so closely
you'd think we'd be in the same building. Oh, here I am!

"Hi, Sergeant Gold! Sergeant Percy would like these patients
added to the payroll we sent up earlier." Master Sergeant Gold's

desk was in a cubicle in the front of an office with eight other accountants. She handed him the payroll forms.

"Sit down, Miss Cottrell."

His eyes look gigantic behind those thick glasses, she thought. If it weren't for them he'd be pretty cute. He has a nice triangle nose in a square face.

"It's too late to make any additions, Miss Cottrell."

"Oh, please, Sergeant. I typed them as fast as I could, but we didn't get the service records until an hour ago. Can't you put them in?"

"It wouldn't be alphabetical."

"Well, make it a separate little section."

He couldn't help smiling. He was only twenty-two and hadn't been in the army long enough to lose his sense of humor.

"Why go to so much trouble?"

"These men haven't been paid in months and one's a double amputee."

He looked guilty for a second. After all, he'd come here straight from Harvard. Only his bad eyesight had saved him from combat. "Well, okay this once, but next time they'll have to wait."

"Oh, thanks a million."

"What time do you go to the mess hall, Miss Cottrell?"

"One o'clock."

"Maybe I'll see you there?"

"Sure, but civilians eat last, remember."

"Oh, that's right.

"Well, I'll say hi on my way out," he said.

"See you, Sergeant."

"By the way, will you give these statistics to Sergeant Percy?" He handed a file to her.

"Sure, thanks again."

Glad I wore my moccasins today. They're sure more comfort-

able than high heels. She skipped through the long hallways toward her office. *If I hurry I'll be back in time to do some more work before lunch.*

"Miss! Miss! Stop that! Stop that!"

She turned around. A tall thin major was ten feet behind her. She waited until he caught up.

"How dare you skip through these halls!"

"I was on an errand for Sergeant Percy." *Gosh, he scared me to death.*

"I don't care what you were doing. You have no right to skip."

"Oh, I didn't know that. But why not, sir?"

"Are you questioning me? What's your name?"

"Mary Lou Cottrell."

"Where do you work?"

"Military Personnel."

"I'm going to report you to your chief. You should know better than to behave this way."

Oh, I hope I don't cry, she thought, trying not to show her feelings.

"And your attire is all wrong too. You look like a schoolgirl in that skirt and sweater."

"Well, that's what I was, sir. I can't buy all new clothes."

"Well, maybe not. But you can alter your behavior. Run along now! I mean, walk back to your office."

"May I ask your name, sir?"

"I'm Major McClintock. Second in command here."

Oh, he's the one they call "Major Mistake."

"Now, go back to work."

"Yes, sir." She walked in as dignified a manner as she could back through the connecting corridors. *Gad, I was so happy. I hope I don't lose my job. Nobody said not to skip. He made me feel silly.*

"Miss Cottrell, I'm very disappointed in you. Major McClin-

tock called and said you were acting in a disorderly fashion." Captain Holden, the Chief of Military Personnel, had called her into his office when she returned.

"All I did was skip down the halls."

He put a frown on his smooth, handsome face and said, "Well, I hope you realize now that that kind of behavior is uncalled for."

"Well, I was in a hurry."

"No excuses now. I want you to promise to act in a more dignified way."

"Yes, sir, I will."

"And if I hear of any more misbehaving I'll have to do more than just reprimand you."

"Yes, sir." Thank God, she thought, I'm not being fired.

"And now you can go back to your desk, Miss Cottrell."

"Yes, sir." She got up. Gee he really looks you over.

"And remember, I want to be your friend as well as your boss." He gave her a very friendly look and a long handshake.

"Thank you, sir." All the girls say he makes passes—now I believe it. His hand was sure hot.

She went back to her desk and rearranged everything to look like the picture in the training manual.

CHAPTER 4

23 NOVEMBER 1943
Three thousand, five hundred Americans
were killed and wounded in the Gilbert
Islands.

MARY LOU and Barbara were working at their desks in Military Personnel. "Don't look now, Mary Lou, but your friend's coming down the aisle." Barbara's desk was in front of Mary Lou's, so she had a better view of people entering their department.

"How can you tell? They all look alike to me in their P.J.'s."

An amputee, missing one arm, approached her desk. "Miss Cottrell, I was wondering if I could have a partial payment to hold me over until the end of the week?"

"What's your name?"

"Private Huntley."

"I'll go get your file." She went to the cabinet and came back reading.

"Private Huntley, I just authorized a partial payment ten days ago. I'm not allowed to give more than one a month."

"I know, miss, but I had to send train fare to my mother to

visit me and I've run out of cash. You know the army cheated me out of some of my combat infantryman's pay so my lump sum wasn't as large as I expected."

"Private Huntley, I computed your pay and like I explained the first time you came in, you weren't cheated. It wasn't as much as you expected because we deducted for your dependent's payment to your wife."

"But I got a 'Dear John' letter in Sicily and told the captain to stop sending her money. She was shacked up with some Seabee from Newport News."

"But Private, the notice wasn't sent in officially so the army went on sending her money."

"Well, that's not my fault and I want those deductions back." At this point he pulled his cigarettes from his pocket and tried to light one with his one hand.

"Can I help?"

"No, miss, I've got to learn to do this by myself. Why couldn't it have been my left arm that went?" She just looked at him for a moment and didn't try to answer that.

"Don't you have any of your lump sum left?"

"No."

"Well, do you mind my asking where it went?"

"I lost it in craps."

"Oh, no!"

"With my luck I guess you're wondering why I would gamble."

"No, I'm just sorry you lost it all and I want you to know I did write a letter asking if your deductions could be reimbursed, but I wouldn't count on it."

"Well, at least you listen to me. I appreciate it." He put the cigarette out on her ashtray.

"You know, I guess I could authorize one more payment and call it an emergency partial, but you've got to make it to the end of the month. I'll have to finish it before Sergeant Percy comes

back from his break and please don't tell the other patients about this. I could get in big trouble." She handed him the finished authorization.

"You'd better hurry to the paymaster. He closes at four."

"You're a nice kid. Thanks a million," he said as he hurried away.

"Did you give that guy another partial?" Barbara called back to Mary Lou.

"Yes. I couldn't say no. He's so pitiful. Did you see him try to light his cigarette?"

"Don't you remember our training film? We're not supposed to show any pity. It's not good for them."

"Maybe we're not supposed to show it, but I still feel it."

"If Sergeant Percy finds out you'll be in big trouble."

"I'm hoping he doesn't notice. Anyway, my mother says rules are made to be broken."

"Then how come you wouldn't come have a drink in the ward lounge party?" Barbara asked.

"I just don't want to start going to those parties. Anyway, you have to know which rules to break."

"Is that part of your religion?"

"What do you mean by that?"

"I always heard Catholics have lots of rules that are different from other people's. Until I met you I thought all Catholics spoke Italian."

"Why did you think that?"

"Because your Pope's in Rome and my mamma says you obey him in all things."

"We do in matters of religion, but I've never been to Italy."

"But all they speak in your church is Italian, isn't it?"

"It's in ancient Latin. A dead language, which nobody speaks anymore."

"Do you understand it?"

"Some of it. Our Missal has the English printed right beside the Latin so we can follow along." She started to type. "I've got three letters to do for Sergeant Percy. I'd better not talk any more."

In a little while Sergeant Percy returned from his coffee break and announced in a loud voice, "We have hundreds of service records coming in an hour so we'll have to work tonight. The Colonel wants all patients paid in the five days they're here."

One of the girls farther down the aisle called out, "I have a date tonight, Sergeant. How come you didn't know earlier?"

"Because the Colonel doesn't tell me all of his plans ahead of time. Besides, you should be happy. You'll make all that overtime. I do it for free."

"It beats being in North Africa," Mary Lou whispered to Barbara. He stood with his back to them clenching and unclenching his buttocks which he always did when he was upset, then announced, "I'm 3F, which isn't my fault. If I was 1A I'd be a pilot in the air force."

"Not with those glasses," Barbara whispered to Mary Lou.

"You can start taking turns for dinner. I think we'll be here until two or three in the morning," he concluded.

The next morning at eight o'clock the girls uncovered their typewriters, then went to the large table and got an armful of service records left over from the night before.

"We've got another Lipshitz in this bunch. I swear I'd have my name changed," one typist called out.

"I had another Jesus last night. He's getting a medal. Do you think there's any connection?" another asked.

"Ask Mary Lou," Barbara answered.

"Maybe a name can make you brave. I don't know. The last Jesus I had shot himself in the foot so he would be sent home. The name didn't help him."

"Oh, I know who you mean. He's always roaming the halls alone on his crutches looking so sad."

"Sergeant Percy says he'll probably get a dishonorable discharge."

"Oh, that's awful. After that he won't be able to vote or anything."

Sergeant Percy stood up and called out, "Enough talking, girls, the patients will be lining up soon with questions about their pay so don't waste time. And remember, no more than one partial per month. I want this department run perfect." Barbara and Mary Lou exchanged glances.

Three days later while Sergeant Percy was at lunch, Barbara called to Mary Lou. "Oh look, here's your friend again."

"Oh, no!"

Private Huntley came down the aisle. He was pushing a double amputee as best he could.

"Good afternoon, ma'am. I brought my friend with me. I told him you would explain his pay mess to him. He hasn't been paid for three years. His name is Sergeant McClure. Tell the little lady your story, Jim."

Sergeant McClure was thirty and black-Irish handsome. He looked fifty.

"Well, it's not much of a story. About the time we landed in New Caledonia the records for the whole company got sunk—along with the ship that took us in."

"We'll have to recreate your records as best we can. We'll issue replacements. You can give me all the facts and I'll start on them." Mary Lou got out the forms.

"I'm gonna get the short end of the stick again. Like when we got here, they gave us a free phone call so we could call home and tell them we'd lost our arms and legs."

"Yeah, one guy swears he's gonna walk into his living room and say, "Look, Ma, no hands.""

Private Huntley stared at Mary Lou when he said this. Sometimes the patients deliberately said things to shock the civilians. She didn't flinch.

"But I told you, this girl is okay," Private Huntley said. "She looks like a kid but she's smart as a whip. Did you go to college?"

"No, but I want to," Mary Lou answered. She had played their game and hadn't let them know how much they'd bothered her.

"After you make his new records can he get some pay?"

"Well, yes, he's eligible for a partial payment right now."

"Any chances of me getting another?" Private Huntley asked half-heartedly.

"Oh, no, the sergeant would have a fit." She started to type the authorization for the new patient. Just then Sergeant Percy returned.

"It's not quite time for personal interviews pertinent to payroll problems."

"I know, Sergeant. Actually, I started to push my buddy here down the corridor and made better time than I expected. This little girl deserves a promotion. She can explain any payroll mess."

Sergeant Percy came over and looked over her shoulder. "What's the problem?"

"His records were destroyed so I'm making a new service record and authorizing a partial payment. It's automatic, right, since his records were destroyed?"

"You'll find them in the South Pacific, Sergeant. I sent my legs down to find them," Sergeant McClure joked.

"Yes, but remember, soldier, only one partial payment per month."

"That's what I should have told the Japs, Sergeant. Only one...leg, I mean, only one to a customer."

Mary Lou finished typing and handed him his form. "Take this to the paymaster. Private Huntley knows where it is."

Private Huntley gave her a big wink. "I sure do, don't I, miss?"

He pushed his friend into the aisle, looked back, and said, "How many miles of corridors do you figure there are connecting these buildings?"

"I think they said ten at the orientation," Mary Lou answered.

"Why do you suppose they put the buildings so far apart?"

"Afraid I don't know, Private."

"Guess they had to keep things SNAFUED. Situation normal, all fouled up," the two men said in unison. "Thanks, ma'am."

After the patients were on their way Sergeant Percy called Mary Lou to his desk. "Miss Cottrell, the patient pushing looked familiar to me. Has he been here before?"

"Yes, sir, he has. I explained his records to him. He hadn't been paid in two and a half years—from North Africa to Anzio and he needed some money. His Mother was coming on a visit."

"But he's been here long enough to get his back pay. Why was he short?"

"He lost his lump-sum gambling."

"Don't you know these men are all alike? No-good morons. They can't hold onto their money. They get drunk at the Green Lantern every night. So don't you let them talk you into more than one partial payment. I could get a reprimand for that."

She looked at him for a long time. "It's too late. I already gave Private Huntley two this month and if any other poor devil begs me for an extra one I'm liable to do it again. And who really cares? It's all deducted from their next check. It's their money."

"There are rules, Mary Lou. I run my department strictly by Army Regulations."

"But where does it say in the Army Regulations that men are supposed to lose arms and legs?"

"I'm sorry, but I'm going to send you to the captain for another little talk. I'm not taking the flak for this. I told you after the reprimand for skipping in the halls that you've broken too many rules."

The captain's office was at the end of the warehouse, closed off by a partial wall to the ceiling.

"Miss Cottrell, have a seat." Captain Holden gave her his "dashing commander" smile.

I guess I'd have a crush on him like all the other girls if I hadn't seen his service record, she thought. He's never seemed glamorous since I read that he has a wife, five children, and a hernia.

"This is the second little conference we've had. The first one was regarding the skipping incident."

"Yes, sir."

"You really don't miss skipping down the corridors, do you?"

"Not too much. But nobody ever showed me in the Army Regulations where it says not to skip down the corridors. It just seems like the fastest way to get around. And by the way, sir, why do they put the buildings so far apart and then connect them with corridors?"

"Well, the corridors are covered, as you know, so no one gets wet or cold. I'm not sure why the buildings are a block apart but I'm sure the army has a very good reason. Miss Cottrell, you have an outstanding record here. You never call in sick like the other girls. You often work seven days a week, sometimes eighteen hours at a stretch. You work twice as fast as the others and I hardly ever have to initial erasures for you."

"Would you mind explaining that to me?"

"What?"

"Why you have to initial where we've erased?"

"Well, so they can see no one has been tampering with the payrolls."

"But couldn't the person who erased just initial it themselves if they were thieves?"

"Miss Cottrell, you mustn't question everything so."

"But, sir, it's demeaning to have to come in here and have you initial every mistake."

"You're not here to talk about erasures. Sergeant Percy tells me you've given a patient two partials in one month."

"Yes, sir, I did."

"I'm sure it was an oversight."

"No, sir, I'm afraid it wasn't.

"Why did this occur?"

"Because he seemed so desperate and he was an amputee and I guess all he wanted was to buy some beer to drown his troubles."

"Now, you know, Miss Cottrell, pity is very detrimental to the patients."

"I know but he needed to feel he'd gotten away with something. I wanted him to feel his luck had changed."

"I can see that this was deliberate, which makes it much worse. But if you're sorry and promise never to do it again I'll overlook this incident."

"Then I'll have two of the three conditions for a perfect confession. The only thing missing is penance."

"Miss Cottrell, you're not acting like the perfect young lady I interviewed for this job such a short time ago."

"I'm not that young lady, sir. I deal directly with these men all day. I have to have a little leeway. I won't break the rules very often, but I'm not making any false promises."

"Then the next time I have a complaint I may have to fire you. I'm sorry."

She got up to leave. "I'm sorry, too."

"Just try to do better now. I'd really like for us to be friends." He gave her a long handshake and a soulful look.

She left. What was that supposed to mean? she wondered.

When she got back to her desk Barbara whispered, "How did it go?"

"I'm not sure. His hands are hotter than ever and I think he made a pass at me." They started to giggle. "He's as old as my daddy." More giggles.

"Quiet girls," Sergeant Percy called. "If I were you I'd watch my step, Mary Lou."

"Sorry, Sergeant. I'll try to be good."

CHAPTER 5

5 DECEMBER 1943
*Italian Front: In the Western sector, units
of the U.S. Fifth Army hold on to their
positions with heavy losses.*

MARY LOU and Barbara had just returned from lunch and were picking up their assignments on the large table in the center of Military Personnel.

"I don't know why civilians eat in the mess hall behind the P.O.W.'s. I'm tired of waiting in line a half hour then rushing my lunch, then having to run through the corridors to get back to my desk." Barbara didn't look as though she'd been deprived of nourishment. She'd gained about twenty pounds since starting to work in the hospital fresh from high school.

"I know," Mary Lou said. "I don't mind being behind the patients, enlisted men, WACS, and orderlies, but I don't think we should be served after the prisoners, do you, Sergeant Percy?" He had just returned from lunch and had brought his dessert back with him to eat as his afternoon snack.

"Just think of the great pay checks you get twice a month.

That should make up for anything. I bet you're making more than your fathers do out in the real world."

"But Sergeant, we work from eight to five, six days a week— lots of Sundays and nights too," Barbara said.

"So do I, girls, and I get the same pay every month and you get all that overtime."

"By the way, are they allowed to send 3F's overseas to do the office work?" Mary Lou asked. She knew this would shake him up and put an end to the discussion.

"So far they're not that desperate, Mary Lou, but now that we've landed in Europe I'm keeping my fingers crossed. I don't think they'd put me with combat troops, but you can never be sure of anything in the army." He started to look very nervous and since he was standing beside her desk Mary Lou could see his but- tocks clenching and unclenching again.

He clapped his hands. "Okay, girls, back to work. No gold- bricking in Military Personnel." He went back to his desk. Just then the phone rang. He spoke a moment then said, "Mary Lou, Miss Elliott, in Civilian Personnel wants to talk to you in her office."

"I wonder why."

"Probably just a routine matter."

"Is the captain mad at me?"

"No, I don't think so."

"Well, here I go." She got her purse from her desk drawer. "See y'all in a while."

"Good luck," Barbara called after her.

On the walk to Civilian Personnel she started wondering why she'd been called. I just talked to her yesterday. She seemed extra friendly. Couldn't be anything too bad.

Justine Elliott's office was the first cubicle in the large office. She greeted Mary Lou with an effusive, "Hi, cutie! Have a seat. Thought you might like a break from the routine."

Mary Lou sat down. She's acting like we're best friends, she thought. I wonder why. Justine was almost pretty in a sharp-featured way, but for the acne scars on her cheeks.

"Is something missing from my files?"

"No, honey, I want to ask a favor."

"Sure, what is it?"

"I've planned a trip to Washington, D.C. in two weeks and I want you to go with me. I know you have lots of time off that's accumulated and could go if you want to. We could have a heavenly time. I know two gorgeous pilots who will be there that weekend and I've told them about you."

Why would she tell them about me, Mary Lou wondered. "I don't know whether my daddy would allow me to go on a trip like that." Why is she asking me? I hardly know her.

"I could call him. And since I'm older than you I bet he'll let you go."

"I've never been crazy about blind dates, especially for a whole weekend. And I'm saving my money to go back to school."

"The guys will pay for the hotel. We could have a glorious time. We'll dance every night and go to great restaurants."

"I love to dance," Mary Lou said. "It does sound like fun." But it would ruin my reputation, she thought. Justine's dated every doctor in the place and everyone kids about her.

"Let me think about it. I'll let you know tomorrow."

"Want to have a coke in the PX? Might as well take a long break."

"Thanks, but I have to get back to work."

The ambulatory patients lined the walls in the corridors on the way back, waiting for weekend passes. Lots of "hubba hubbas" were called to her, but Mary Lou pretended not to notice. If I don't look directly at them it's not too bad, she thought. Wish I didn't have to wear these high heels. My saddle shoes would be so

much more comfortable, but Sergeant Percy likes us to look grown-up. I'm running out of stockings, though. Think I'll try the leg make-up I read about. But how the heck do you paint the line on the back of the leg to make them look real?

Barbara couldn't wait to hear what the meeting was about. "Were you in any trouble?"

"No, actually she wants me to go on a trip with her to Washington, D.C."

"Why?"

"To meet some pilots and just have fun dancing and eating at great restaurants."

"Wow! Are you going?"

"I don't know. I can probably get permission. My daddy says now that I pay board he'll treat me like an adult, but I'm not sure I want to go. I don't want to ruin my reputation."

"With who?"

"I don't know. Here at the hospital, I guess. I'm just so used to worrying about it that it's a habit. It might be fun to go on a trip though—planning what clothes to take—organizing a suitcase. I haven't been to Washington since our senior class trip and that wasn't too great since we spent the nights at a convent on the outskirts of the city. Gee, Barb, we'd better not talk too long. We've got lots of work to do."

The next day Sergeant Percy called her to the phone. "For you, Mary Lou. Miss Elliott again."

She went to the phone. "Hi, Justine! Yes, I think I'd like to go. Sure I'll pay you back for the tickets. Bye." She's a bit of a drip, Mary Lou thought, but my social life's been pretty dull lately and this does sound glamorous.

Five days later they left for Washington, D.C. The train was crowded and dirty and they had to sit in the aisles on their suit-cases.

"Wish I'd saved my stockings for the city," Mary Lou said.

"Don't worry, I've got great connections at the PX for stockings and any other goodies you might need," Justine said.

I bet, Mary Lou thought. I don't know why she had to wear such a loud outfit. Justine had on a red dress with black polka dots, red spike-heeled shoes, and a big black bow hat. Mary Lou was wearing a plain camel coat over her skirt and sweater from high school. Gad, if the girls at St. Gertrude's could see me now. And Sister Antoinette would have a stroke, but it is an exciting adventure so I guess I don't care.

"I'm mad about my date," Justine said. "His name is Nick Lagatta from New York and your date's name is Cotton Meir. He's from Texas. Nick says Cotton's a divine dancer so you'll have a great time."

"I can always tell where a soldier's from after dancing with him for five minutes—from going to the U.S.O. dances."

"Now, cutie, don't talk about corny stuff like that or they'll think we're hicks."

Speak for yourself, Mary Lou said to herself.

After a dusty trip on the train they checked into the Capitol Hotel in the heart of Washington. The overused lobby—Williamsburg blue—was teaming with servicemen, their women, their about-to-be women, and ancient bellhops barely keeping up with the arriving guests.

"I haven't been here since my class trip," Mary Lou said.

"That's just the kind of remark you mustn't make," Justine said.

"Why not?"

"Because I told them you were twenty-three and you wouldn't still be talking about your class trip if you were."

"Why did you tell them I was twenty-three?"

"Oh guys, especially pilots, don't like to go out with anyone under twenty-one."

"Well, what will I say I've done for the last four years?"

"Been out in the world working. I told them we share an apartment. If they think you still live at home they'll get nervous."

"Gad, I'm going to be tongue-tied. I'll be afraid to talk."

"Just tell them you think they're divine and flirt a lot."

Mary Lou was tempted to imitate her heroine, Scarlett O'Hara, and say, "fiddle-dee-dee."

"How much should I tip?" Mary Lou whispered to Justine. The bellhop had just finished putting their bags in the room—the "Alice Roosevelt Room," the plaque on the wall said.

She must have liked blue flowers, Mary Lou decided. They were everywhere—the wallpaper, the twin bedspreads, and the love seat.

"Just give him a big smile. That's tip enough."

Mary Lou handed the bellboy a quarter anyway. Her mother had told her not to be a cheapskate.

"This is the first time I've been on a trip without my parents or the nuns. I'm really excited."

"You really haven't been around very much, have you, baby?"

"No, I guess not. When we came here on our class trip Sister Antoinette and Sister Xavier chaperoned us and we stayed at a convent on the outskirts of the city. Actually, some of us slipped out one night and hitch-hiked into town and went to the movies, but then when we got back we had been locked out and Ann Marie Bolden caught a cold from sleeping outside on the porch swing. Then, her cold went into her ears and she couldn't be in our final swim meet. Sister Antoinette blamed me for the whole thing."

"Like I said, you haven't been around very much. Let's unpack, shall we?"

"Great! I want to get organized. What time are the boys coming to pick us up?"

"Now, honey, don't call them boys. They're war heroes. They've been overseas for two years and seen lots of action."

"You're right, Justine. I'll try to act sophisticated. Let me show you the black dress I bought. I think it makes me look a lot older."

"Let's see."

Mary Lou held it up for Justine to see. "It's pretty plain, but I think very sophisticated."

Justine looked a little jealous when she saw the dress. "Well, wait 'till you see mine," she said. She ran to her suitcase and pulled out an orange chiffon dress that was cut low in front and even lower in the back. "How's this for sexy? I feel just like Rita Hayworth when I wear it."

"Oh, that's quite something," Mary Lou said. I just hope we don't see anyone I know, she thought. Thank God we're not in Richmond. That dress is the color of the vests the men wear who work on the highways.

"Our darling guys will be here in an hour. I'll shower first, then you. It takes me longer to make up, I'm sure. In fact, I'd like to teach you to do more with yourself in that department and maybe fluff up your hair a little too, cutie. But I don't think we'll have time tonight."

Thank God! Mary Lou thought.

"See you toots suite." Justine disappeared into the bathroom with her make-up case, which was almost as large as her suitcase.

Mary Lou finished unpacking. Then she lay down on her bed to wait for her turn in the bathroom. She fell asleep and was awakened by Justine in all her splendor. Double dose of pancake make-up and orange lipstick to match the dress. Her sweet perfume permeated the room.

"Sorry I took so long. Can you be ready in fifteen minutes, cutie? I'll put my nail polish on while you get ready."

"Gosh, I hope so." Mary Lou dashed into the bathroom. It's a

good thing I get dressed fast. While she showered she thought, I can't believe what I saw in there. She looks worse than Belle Watling. I hope this trip wasn't a mistake.

She showered quickly and then went to the closet and put on her black dress. "I got these black stockings in the PX last month. I've been saving them for a special occasion."

"You do have great legs, I must admit. It's a good thing I'm not the jealous type," Justine said. "Are you only wearing those pearls? We'll have to get you some glamorous jewelry tomorrow. We'll go shopping and put some oomph in your wardrobe."

The phone rang. "Nicky, darling! We'll be down in a sec. Oh, Mary Lou, I'm so excited," she said as they left the room.

"I can tell," Mary Lou said. I hope she doesn't talk so loud in the lobby.

Their dates were waiting as they got off the elevator. One was medium height, dark, and the other tall and blonde. At least twenty decorations were on their chests. Oh, they're really cute, Mary Lou thought. Things are looking up.

Justine ran up to her date and squealed, "Darling! It's been so long." She threw her arms around his neck and held on for a long time.

The tall one said, "You must be Mary Lou. I'm Cotton Meir. I'm from Texas."

"Hi, Cotton. Yes, I'm Mary Lou from Richmond." He looked very pleased to see her.

Nick pulled Justine from around his neck. "Baby, introduce your friend."

"I'm just so thrilled to see you again, darling." She put her arm through his and said, "This is Mary Lou Cottrell, my friend and roommate from the hospital." He shook hands with Mary Lou.

"I told you Justine would fix you up right," he said to Cotton. "I hope you like to dance, Mary Lou, because we're going to hear Tommy Dorsey at the Shoreham."

"I love to dance," Mary Lou said.

"Well, let's go," Cotton said and ushered Mary Lou out through the lobby.

"They make a cute couple, don't they?" Justine said.

"She'd make a cute couple with anyone," Nick answered. "You didn't tell me she was a blonde pin-up girl."

"Now, no roving eyes. Justine get jealous," she said in a little-girl voice.

After a short taxi ride they arrived at the Shoreham. "This is a fab table, Nicky," Justine squealed as they were seated in the ballroom.

"I told them we had to be right by the dance floor," Nick said.

"Well, girls, what do you want to drink?" he asked.

"I'd like a pink lady," Justine said.

"I usually just drink bourbon and ginger ale," Mary Lou said. "You know in Richmond we can't buy mixed drinks. It's against the law. So we just bring our liquor in a paper bag."

"Mary Lou, don't be such a hick." Justine gave her a scathing look.

"I mean that's in even the nicest clubs."

"I know, Mary Lou. I was stationed at Marshall Field for a while," Cotton said. "I've heard of a great new drink made with Southern Comfort. Want to try one?"

"Sure, I'll be brave," Justine said.

"Me too," Mary Lou said.

Tommy Dorsey's orchestra started playing "I'll Never Smile Again." Cotton asked, "Shall we?"

"Sure," she answered.

They danced to the big band sound, round and full. "Are you having a good time, Mary Lou?"

"Oh, yes."

"I like you a lot. You're a very sweet girl. I wish…" He broke off his sentence.

"What?"

"I'd better not continue," he said.

This is a time of half-said sentences, Mary Lou thought.

Their drinks were waiting when they returned to their table. "I'm really thirsty," Mary Lou said. She took two large swallows.

"How do you like it?"

"It's a lot sweeter than bourbon and ginger ale."

"Who wants steaks? They have the best in the city," Nick asked.

"Oh, I do, I do, I do," Justine gushed. "We haven't eaten since eleven o'clock on the train."

"You must be starved," Cotton said.

"I guess so. I forgot we haven't had any food. I think I've been too excited to notice," Mary Lou said.

"Cutie, don't sound so naive," Justine glared.

"I think she sounds just right," Nick said. "How about a dance, Mary Lou?"

"Do you mind, Cotton?"

"No, honey, I could use a rest."

"You mean you won't escort me around the floor?" Justine pouted. "Maybe later," Cotton said as he watched Nick and Mary Lou glide onto the dance floor. The band was playing "Green Eyes."

"How did you ever get mixed up with Justine?" Nick asked Mary Lou as they danced.

"What do you mean?"

"I mean you're so different."

"Well, to tell you the truth, we don't room together. We do work in the same hospital though. I still live at home and I'm only nineteen, but she thought it would sound more sophisticated the other way. Please don't tell her. She meant well. She wanted this to be a perfect weekend."

"Now I get the picture. You know, Mary Lou, I really could go for you. I'd like to see you without the others."

"Oh no, Nick. Justine is crazy about you. I thought you two were in love."

"We've only dated twice before. But she gets pretty intense."

"Yes, that's a good word for her." Gad, I didn't even flirt with him, she thought. Justine will kill me if she finds out about this.

"Cotton's your friend. I don't think you should cut in on him. After all, I'm his date."

"You really are a little girl, aren't you? You still go by all those silly high school rules. Anyway, Cotton is married."

"Oh no! I would never go out with a married man."

"Well, you have tonight, honey."

"I'd like to sit down now, please."

"Have it your way."

When they returned to the table it was obvious that Justine had had more Southern Comfort. Her voice level had risen dramatically.

"Nicky," she cooed, "I'm not even going to be jealous of you dancing with her. Let's go to a new place. I want to really see this town."

"I want to go back to our hotel," Mary Lou said firmly. "My stomach feels a little funny. I think those drinks were too sweet."

"Oh no," Justine shrieked. "The party's just started."

"Maybe we should call it a night," Cotton said.

"Let's go to the little girl's room," Mary Lou said getting up.

Justine stumbled after her. In the ladies' room Justine said, "Now don't you ruin this weekend for me."

"I'm sorry, but I really don't feel too hot. I may be sick to my stomach. And Nick told me Cotton is married," Mary Lou said splashing cold water on her face.

"Why'd he have to go and tell you that?"

"I guess because it's the truth. I never would have come if I'd known that."

"What difference does it make just for a weekend?"

"Well, if you don't know I can't tell you."

"Maybe we should go back to the room. I want to be alone with Nick."

"What do you mean?"

"You and Cotton can wait in the lobby while Nick and I have a private conversation."

"I'm not waiting in the lobby. I have to get back to the room in case I get sick."

They arrived back at the hotel after a quiet cab ride during which Justine fell asleep on Nick's shoulder. Mary Lou kept praying she'd make it back without coughing up.

Justine awakened with a start. "Oh, are we back already?"

When they entered the lobby Nick said, "Why don't we say goodnight here? We'll call you in the morning."

"Good night, Cotton," Mary Lou said.

"Mary Lou, are you okay?"

"I just feel a little queasy."

"No, Nicky, we have to talk, talk, talk," Justine squealed. "Come up for a few minutes."

I'll be lucky to make it to the room, Mary Lou thought.

"Okay," Nick said. "Just quiet down, Justine." Justine was laughing uncontrollably as they rode the elevator.

"I want to have fun, fun, fun."

I want to sleep, sleep, sleep, Mary Lou thought.

When they got to the room Cotton said, "We'll just stay a few minutes, Mary Lou." They sat on the couch.

Maybe if I say Hail Marys I won't be sick, Mary Lou thought.

Justine pulled Nick onto the bed with her. "Why don't you love me anymore," she cried. "I feel so sad. Nickiiiiiiiiiii, I love you." He whispered something in her ear. Mary Lou overheard the word "Tomorrow."

"Oakie doakie. You can go now but I feel soooo sad."

Nick and Cotton got up. "We'll call tomorrow about noon," Nick said.

"Hope you feel better, Mary Lou," Cotton said. "I guess I should have warned you that Southern Comfort is a liqueur and almost one hundred proof."

"I'll be all right after I sleep a while." Please, God, don't let me be sick in front of everyone.

The men left. Mary Lou stumbled to her bed and closed her eyes. Oh, that's a mistake. The room's going around in circles. I'll try to keep my eyes open. Justine seemed to have passed out on her bed. But after a little while Mary Lou could hear her thrashing about.

"Nicky doesn't love me anymore," she cried. "Oh, I wish I was dead," she moaned, her voice getting louder.

"Please, Justine, let's sleep. I feel awful."

Justine rolled off the bed, then got to her feet and stumbled around, knocking into the furniture.

"Go back to bed," Mary Lou said. "They'll send the detective up if you don't quiet down." In the shadows Mary Lou could see Justine taking her clothes off. She must be getting ready to go to bed, thank goodness.

Suddenly, Justine went to the door, opened it and ran out into the hall screaming, "Nicky, Nicky, I love you."

Mary Lou could see that all she had on were her bra and girdle.

"Oh, no. I've got to stop her." Mary Lou chased her into the hall. "Justine, you'll be arrested." She caught her and pulled her back to their room just as the elevator doors opened.

"Oh, no, I hope no one saw us," Mary Lou said.

Justine was sobbing now. "You want my Nicky."

"I don't want your Nicky one bit, I swear."

"Promise me you won't see him or I'll jump out the window."

"I promise. I promise. Now calm down. We've got to get some sleep." She pushed Justine down and pulled the covers over her.

"You can see Nick tomorrow." Mary Lou collapsed on her bed. Oh God, I feel so awful, she thought. Why did I have to come on this stupid trip?

Justine mumbled, "See Nicky tomorrow," over and over.

Mary Lou got up and spent the rest of the night on the bathroom floor, just in case.

They were awakened at eleven the next morning by the phone. Nick said he and Cotton had been called back to their base unexpectedly.

"I bet," Justine said. "It's all your fault, Mary Lou. You tried to steal Nicky away from me."

"That's not true. I didn't flirt with him one bit. I think he got tired of your hanging on him so much. Men don't like that."

"What do you know, anyway?"

"I know that much."

"Let's pack and go home," Justine said.

"I would like to see the Washington Monument at least while we're here. Anyway, our train's already left for today," Mary Lou said.

They dressed in silence. Justine wore dark glasses and cried a lot while they had breakfast in the coffee shop. Then they glumly visited the Washington Monument. When two sailors tried to pick them up Mary Lou said, "No, Justine, don't even ask."

Back at the hotel Mary Lou carefully folded her black dress and finished packing.

"Are you sorry you came, sweetie?" Justine said.

"No, I guess not. The beginning of the night was fun."

"I do know two darling Marine lieutenants from Quantico and they're not married and they've just gotten back from Iwo Jima...and..."

"Sorry, Justine. No hard feelings, but count me out. I'm just not cut out for the glamorous life."

CHAPTER 6

21 January 1944
Italian Front: The ships carrying the American
VI Corps, scheduled to land on the beaches of
Anzio and Nettuno, sail from Naples.

WHEN MARY LOU returned to work the next morning she noticed a small brown envelope in her desk drawer with the inscription "To be read by Mary Lou Cottrell in private—matter of great urgency."

Who could have sent this? she wondered. She started to open it, but there was something about the handwriting that made her hesitate. She put it in her purse and decided to read it on her coffee break.

Barbara arrived for work and came over to her bouncing with energy. "How was your weekend? I can't wait to hear about it."

"Oh, Barbara, it was a fiasco. I almost got sick in public. Justine got drunk and ran around the hall in her underwear and my date turned out to be married."

"Oh no! I kept thinking of you on your glamorous weekend. I went bowling with that orderly from Kentucky and he got mad at

me because I wouldn't stop talking about your trip to Washington."

"There were a few bright spots. The hotel was beautiful and the steak dinner was great, but I've got to warn you, don't ever drink Southern Comfort. It's lethal."

"How was your date?"

"Pretty cute, from Texas and a super dancer, but he was a married man."

"Oh, no! Did he try to seduce you?"

"I think so, but I was too sick to notice. I don't think men make passes at girls who are about to throw up."

"Gee, I'm really sorry."

"Thanks, Barb. We'll talk more at lunch time."

Sergeant Percy arrived, looking more rumpled than usual. "Good morning, girls. We expect one thousand patients today so I guess we'll be here all night. Let your families know. Miss Cottrell, please come here."

She stood by his desk. "Please sit down, Mary Lou." The phone interrupted him. "Yes, Corporal, your service record was lost, but as I told you last week, we reconstructed your history as best we could. Yes, I'll send someone to talk to you." He wrote a name on a slip of paper and put it on a spindle with about twenty-five other notes. He gave Mary Lou a sheepish grin. "That's my B.L.N.T. file."

"What does that mean?"

"Better Luck Next Time." She looked shocked. "I figure if they can't get to the office I'm not going to go looking for them in their wards."

"But Sergeant, they're so helpless."

"There's not enough time for all the work, you know that."

"But, Sergeant, I could go see a couple of them a week."

"I need you here."

"I'll do it on my lunch hour."

"We're not allowed to remove the records from this office.

Now forget about it. I have something to tell you. But first, how was your weekend?"

"Not what I expected."

"I don't think you should associate with a wild girl like that. You're lucky you got back at all."

"Yes, Sergeant." He's getting just like Sister Antoinette, she decided. Next thing he'll be saying is that I need more school spirit.

"What I meant to tell you, Mary Lou, is that I'm making you my first assistant. You'll move up a grade and make more money, but what's more important is that you'll be in charge whenever I'm not here."

"That's great, Sergeant, I'm sure I can do a good job."

"I know you can, Mary Lou. But I'm putting myself on the line for you and you must be on your best behavior."

"Yes, Sergeant, I will be, I promise."

"No more breaking any rules."

"No sir." I hope I don't have to, she thought.

"Okay, I'll tell you the details later."

She decided to take her break and go to the ladies' room. Mary Lou was really excited about the promotion and although she felt the urge to skip down the corridor she held herself back.

She saw the note when she got her comb out. Oh gad, I almost forgot. She opened it and read: "It is most urgent that I see you in private. Be in corridor Thirteen L at six-thirty this evening. Don't show this to anyone." The handwriting was like nothing she'd ever seen.

She wondered whom it could be from. Maybe it's a patient wanting an extra large partial payment. It must be something that they don't want Sergeant Percy to know about. But I can't break any rules now that I've been promoted and Sergeant Percy is counting on me.

Should I go to the meeting or not? I'll decide later. She al-

lowed herself two skips then walked very properly the rest of the way back.

During lunch she told Barbara about her promotion. "Oh, you lucky dog."

"I don't want to have to tell the other girls what to do, but I don't think this promotion involves much of that. I guess I'll just supervise for Sergeant Percy when he's out of the office."

"Mary Lou, you really deserve this. You do twice as much work as anyone else."

"Thanks, Barb."

The rest of the morning they were extremely busy organizing the work for the new group of patients, but Mary Lou kept thinking about the note and decided to meet the person after the dinner break. She volunteered to carry some completed forms to the Accounting Office. It was six-fifteen.

By six twenty-five she'd arrived at corridor thirteen L. She started walking slowly. As she reached a turn in the hall someone motioned to her to step into a small storage room. Without thinking she followed instructions. As her eyes adjusted to the light she realized who she was looking at. He was the most handsome man she had ever seen. He had piercing blue eyes, blonde hair, tanned skin, and was wearing a black uniform. He was a German P.O.W., one of the group who ate in the mess hall before the civilians.

"Please don't be afraid. I won't hurt you. I just want to talk to you." His English was impeccable. He spoke with a slight British accent.

"How did you get here?"

"I do some volunteer work in the laboratory. I was a medical student before the war. I asked to work here." Mary Lou had heard of such volunteers but had never seen one up close.

"I can't talk to you. You're a prisoner—a Nazi. I can't have anything to do with you." She started to leave but turned around at the door. "Why did you send me that note?"

"My friend, who does voluntary cleaning at night, saw your picture with your family on your desk and thought you might have German relatives."

"No, I'm three-fourths Irish. I don't know why you thought that. I can't help you in any way. I shouldn't even be talking to you."

"Please don't tell anyone about this. They would take me from the laboratory work. I just have one favor to ask. My brother was taken prisoner shortly before I was, but my family has not heard one word about him. Could you find out if he is also in the United States?"

"I have no way of finding information like that. I only know about people at this hospital."

"Please help me."

"No, I can't promise that. You mustn't contact me anymore." She stepped back into the hall and looked around. There was no one in either direction. She started back to her office.

My heart is pounding, she thought. I hope no one can hear it. I can't believe what has happened. Why did he contact me? I could lose my job or even be charged with a crime. People would think I was a traitor.

When she returned to her office she had a hard time concentrating. He's the most handsome person I've ever seen. I've never looked at their faces before. They always seem to be just prisoners, not people. I've got to put him out of my mind.

The next five days the Military Personnel office worked around the clock because the colonel in charge of the hospital wanted every patient paid before being shipped to the hospital specializing in his or her injury.

"What do you want to do when the war is over, Barbara?"

Mary Lou and she were waiting in the mess hall line for lunch. The war was going well for the Allies and people were beginning to think the end was in sight.

"I don't know. Get married, I guess. What about you?"

"I used to be really sure about going to college but I've been dropping by the library here. They have some fascinating magazines. One is called *Theatre Arts*. I read about schools that train you for the stage. You can study history of the theatre, costumes, and all kinds of things. I think I might like to do that. Anyway, I just know I want to leave Richmond."

"But what about promotions? Everyone says you could end up with a really great job and make tons of money."

"I couldn't stay here after the war. I've always known this would be temporary. I couldn't watch these men get old with no hope of getting better—most of them anyway. Just think, we can leave but they'll be here forever."

"I never thought of that." Barbara looked toward the people finishing their lunches. "Mary Lou, don't look now but that P.O.W. over there is looking at you."

Mary Lou started to blush and when she looked where the prisoners ate she saw the one she'd met in the utility room staring at her.

"Mary Lou, you're blushing. But I don't blame you. He's super looking."

"Don't look over there, Barb."

"It's a shame you can't meet him. Did you hear about the nurse who fell in love with one of the prisoners? They gave her a dishonorable discharge."

As the P.O.W.'s got up and started filing past them, Mary Lou couldn't resist looking directly at him. Then it was the girls' time to go through the food line. "Why do they have to get the mashed potatoes on the pie," Barbara complained. "Mary Lou, what did you think of him?"

"Oh, I guess he's nice looking, for a Nazi."

"I think he's gorgeous. I wonder how they get their boots so shiny. They look brand new," Barbara said.

"I don't know. I'll ask him the next time I see him alone," Mary Lou joked.

"Tell him I said hi," Barbara kidded back.

Later they saw him again. He was walking down the corridor with three other prisoners and a guard. She tried to look nonchalant but as they passed his eyes caught hers. I mustn't start to like him. They're the cause of our paraplegics and amputees. She knew there would be a second note soon.

Two days later another note arrived. She opened it in the ladies' room.

"Must see you one more time. Please meet me in the same place again at six thirty P.M."

I know I shouldn't go, but I will just one more time, she decided. She pretended she wanted to see a movie showing that evening and stayed after work. At six-thirty she was standing outside the meeting place. He didn't open the door. She waited for a moment, quickly looked in either direction, then entered. She didn't see him at first.

"Thank you for coming, Mary Lou." He was standing in the corner in the darkest part of the room.

"I did find out one thing for you. The Red Cross will help you with information about your brother. But I'm surprised you didn't know that."

"I have a confession to make. It's true about my brother but I only used that as an excuse to see you alone. Ever since the first time I saw you I haven't been able to get you out of my mind. I had to talk to you. I had to know something about you, your family—your schooling. Do you have a lover?"

She felt her face turn pink. "You must realize I can't see you again. I would lose my job and anyway, it's wrong. You're the enemy." Oh God help me, she thought. I feel so drawn to him. Don't let me show it.

"Please at least write to me. Leave your letters in your desk

and my friend will bring them to me. I want so much to know you."

"Just tell me one thing. What did you do in the army?"

"I am a captain in charge of medical supplies for the Twenty-First Armored Division. I've never killed anyone. I never want to."

"But you're from a country that's killed millions."

There was a long silence. "Please don't hate me. Give me a chance."

I can't give in, she told herself. "I have to go now. Even meeting you like this is insane." But she stood looking at him for a long moment before she opened the door. Then before she knew what had happened he kissed her softly on the lips. Oh heavens, what have I gotten into, she thought as she quickly went down the hall and back to her office.

CHAPTER 7

22 JANUARY 1944
Italian Front: Anzio landing—Operation
"Shingle" is launched in the small hours of
the morning.

MARY LOU and Barbara were browsing through the PX, a lunchtime ritual.

"This is like Thalhimer's and Woolworth's rolled into one," Mary Lou said as they walked down the narrow aisles past the candy and nylons to the jewelry section.

"Yeah, at bargain basement prices. There's so much stuff jammed into these cases. I wonder where they get it all," Barbara said. "Oh, look at that beautiful gold watch trimmed in rubies. Should I get it?"

"How much is it?"

Barbara leaned over and read the tag. "One hundred dollars!"

"Wow! That's a lot."

"But I love it, Mary Lou."

"Well, it's your money, but I think we should stop coming in

here every day. We always see such great things. We won't have any money saved."

"You're right, I know. Maybe I'll think about it."

"Good. We have to get back to the office now, anyway. If you still want it tomorrow we'll come back."

They hurried past two wheelchair amputees looking for presents. "Can six nylons make up for one leg?" one patient asked the other, with a sidelong glance toward the girls.

"I'm convinced they say some of those awful things just for our benefit," Mary Lou whispered as they left the PX and started down the corridor.

"By the way, have you noticed those notes on Sergeant Percy's desk?"

"Which notes?"

"They're really just slips of paper on a spindle."

"You mean his B.L.N.T. file?"

"Oh, he told you too?"

"Yes."

"I'm going to start answering their questions on my lunch time."

"I don't think he'd like that."

"Why? I'd be helping him, actually."

"I wouldn't do it unless he gave me orders," Barbara said.

"But it worries me. I can't stop thinking about those patients lying helpless in the wards. I won't take their records out. I'll just copy the information from their service records and go to see them."

"Well, if you have the nerve."

Later that afternoon Mary Lou copied information about two patients and put it in her bag. When she finished work that day she went to see one of them.

She stood in the doorway to the ward for a moment and looked at the patients. Amputees with constantly moving

stumps—like white caps on a stormy ocean. I guess they keep moving them to try to get used to it.

She saw an orderly. "Which bed is Private Goggins in?"

"In the back, miss. But I don't know if you can see him now. Ask the nurse."

She saw the nurse approaching. "Private Goggins had some questions about his pay that I've come to explain. May I see him now?"

"This is a strange time for you to be here. The mornings are better when he's been up just a short time."

"I'm sorry. But I'm doing this on my own time and I work in the morning."

"Well, let me see." They walked toward the back of the ward where the nurse disappeared behind a curtain. She came back in a moment. "Go on in. I just wanted to see if he was decent."

Mary Lou walked behind the curtain. She wasn't prepared for what she saw. He had tubes coming from his abdomen and his right leg was gone. She had never seen a patient this severely wounded.

"Hello, I'm Mary Lou Cottrell, from Military Personnel." She took her notes from her bag and tried to look unperturbed.

"Well, somebody finally came. I thought the sergeant was giving me the old b.s. when he said he would." He motioned for her to sit by the bed. "I want to change my beneficiary back to my mom. My wife's divorcing me and I don't think I got enough parachute pay. Things are bad enough without getting cheated. Can you handle this for me?"

"I'll have to bring the beneficiary form back on my next visit, but I can explain your parachute pay and everything else."

After she finished he said, "You're all right, miss. I'm sorry you had to see me like this but I really appreciate your coming."

"I don't mind at all. I'll bring the form back tomorrow." She got up to go. He motioned for her to stop.

"Miss, please stay for a few more minutes." She sat back down.

"I haven't had any visitors and it's nice to remember what civilians look like, especially a pretty one like you."

"Thanks."

"How come you came here at night?"

"Well..."

"You're on your own time, aren't you?"

"Yes, but..."

"I'll never forget you for this. I don't feel like talking anymore, but if you would just sit here a few minutes while I doze off I'll appreciate it. This is the time of day I really get lonely." He half smiled.

"Sure, I'll stay." She sat for about fifteen minutes while he went to sleep. Now he looks like a little boy away at summer camp, she thought. Then she tiptoed out of the cubicle.

The nurse stopped her at the door to the ward. "Your timing was perfect, miss. He's really been worried about his records."

"I'm so glad I came. I'll be back tomorrow and finish."

"That's wonderful. I know he'll appreciate it."

The next morning at eight o'clock Mary Lou got the benefice forms and returned to Private Coggins's ward. As she approached his unit she saw that it was empty.

"You looking for Pete, ma'am?" the patient in the ward.

"Yes, I have a form for him to sign."

"No more forms for him, he won—unless you certificate. He brought it about six this morning."

"Oh no. He wanted to change his beneficiary."

"Well, he don't care now."

She stood immobilized. "I couldn't come. The office was locked with the form. I could have done the thing in longhand, but I had no idea he would

he's gone. God, I feel strange. I'd better sit down." She sat where she had the day before to keep him company.

"This is what war is all about, ma'am—absences." Mary Lou noticed for the first time that he was missing two legs.

"I think you could stand a shot, ma'am. You look dead white." He pulled a flask from under his mattress and offered it to her. She took a long gulp.

"Wow, that burns, but thanks," she said in a voice hoarse from the whiskey. "What happened?"

"The abscess in his stomach just spread all over."

"Oh God! I'm sorry! I have to get back to work. They don't know I'm here." She leaned on the bed to get up.

"Almost every soldier in every bed in this ward has a question about his pay, ma'am. Anything you can do will be appreciated. And I know Pete appreciated your coming yesterday."

"I'll be back soon, I promise." I feel so light-headed. I've never known anyone who died before, she thought. How will I get through the day?

"Mary Lou, are you all right?"

Mary Lou was sitting at her desk staring into space. She had just returned from the ward.

"You know, Sergeant Percy, it smells different in the wards than in here. That's where the war really is. We're just outsiders. I don't know why the patients don't hate us."

"What do you mean?"

"We don't know where they've been and what they've gone through. I just want you to know that I'm going to the wards in my spare time and if you don't like it I'm going to ask the colonel for permission. He always says they're to come first whenever he makes his announcements on the intercom."

"Well, I guess if you feel that strongly about it, it's okay with me. As long as it doesn't interfere with your regular work in the office."

On the way home that night Mary Lou pulled her scarf up

higher than usual. The other people in the car pool thought she was cold, but she wanted privacy. I feel different, she thought. Now I know what life's all about. It's about no one being in charge. If only I'd realized how sick he was I would have gotten back with the form last night somehow. For the first time in her life Mary Lou had trouble sleeping that night.

CHAPTER 8

11 FEBRUARY 1944
*President Roosevelt describes the situation
at the Anzio beachhead as "very tense."*

"MARY LOU, Mary Lou, look at this notice." Barbara pulled Mary Lou to the bulletin board outside the PX.

The notice said "Volunteers needed to be in theatrical skits with the band—will perform at McGuire Hospital and nearby bases. Meeting at 18:30—2 Feb 44."

"What do you think that means?"

"I guess they need people to help put on shows."

"Wouldn't that be fun? You said you might want to study theatre now. Let's sign up."

"But I don't think that's real theatre."

"Oh, please, Mary Lou, I know one of the guys in the band and he's darling."

"Well, I guess it might be good experience if I ever decide to act. But gosh, the first meeting is tonight. I'll miss my ride home."

"We'll just stay after work, okay? They're going to have a

show on the fifteenth of February and Lena Horne and Red Skelton will be here."

The meeting was held in the auditorium. The sergeant in charge was starting his speech when they arrived.

"I don't know if any of you have had any experience along these lines or not, but we need two girls to be in skits for our big show. They are mostly sight gags and there's not too much dialogue to worry about."

Mary Lou and Barbara exchanged looks. Mary Lou whispered, "I didn't think they'd be doing Shakespeare." Barbara giggled.

"I don't know what's so funny, girls. If you have a good joke we'll put it in the show. The big night is the fifteenth. That's two weeks from now."

Mary Lou whispered again, "We're from payroll, we could have figured that out." Barbara giggled really loudly this time and couldn't control herself.

"If you're just crazy dames I don't think you'll fit in here. I'm serious about putting on a good show. You two in the back row, what's your names?"

"Barbara Busser!"

"Mary Lou Cottrell!"

"Why don't you come up first, Miss Busser, if you can stop laughing long enough."

Barbara started toward the stage.

"Good luck," Mary Lou whispered.

"What was so funny, Barbara?" the sergeant asked.

"My friend always makes me laugh, I'm sorry."

"Maybe we'll let her replace Skelton. Where do you two work?"

"Military Personnel."

"Let's see if you can read. Here's the script." Sergeant Salvio was the same sergeant who had showed them around the hospital the day they took their entrance test. Still dapper as ever, his uni-

form looked custom made and not baggy like those of most of the soldiers in the hospital.

"Hello, sir," Barbara almost yelled the first line.

"Not so loud, miss."

"Sorry." Barbara looked a little panicky and she tried to get some approval from Mary Lou in the audience.

"Don't look at your friend. Look at me."

"Okay, hello, sir," she started again.

"I'm not a sir. I'm a private," he answered.

"I thought you were a sergeant."

"No, girlie. In the script. I'm reading the script."

"Oh, sorry. Maybe you'd better read my friend first. She acted in high school."

"Is that true?" he called out to Mary Lou in the audience. "Have you ever acted?"

"Yes, in school."

"Well, this ain't like school but come up on stage. Now, let's start again." He gave her the script that Barbara had read.

"Hello, sir."

"I'm not a sir. I'm a private," he said putting his arms around her.

"Well, don't be so familiar and you can take your arms from around me. It's not what gentlemen do." She pushed him away.

"I've told you, I'm not a gentleman."

"You can say that again."

"I've told you, I'm not a gentleman. I mean in the army you're not a gentleman until you're an officer."

"My boyfriend told me you're not an officer until you're a gentleman and you're only a gentleman until ten P.M."

"Here," he said. "I'm supposed to kiss you." With this she slapped him.

"Who's your boyfriend?"

"Colonel Bradley."

"The C.O.?"

"Right."

"How come you know what C.O. means?"

"Because my father is General Adams."

"Slap me again. I deserve it."

"Here's where the blackout comes," Sergeant Salvio said. "You did a great job, Mary Lou. You're hired."

"The ad said two girls."

"But your friend here can't act too good."

"Well, we're a team."

"Okay. She can play the silent girl. Come tomorrow after work and we'll get started. And try not to look like such bobby-soxers."

"I don't know if we can miss our ride home every night."

"That's okay, we'll send you home in a jeep."

Mary Lou and Barbara started leaving the stage. Mary Lou whispered, "He looks like Don Ameche with that mustache."

"Let's go to the PX for some coffee."

A little later they were finishing their drinks. "Barbara, I'm afraid I'll really lose my reputation if I do this, and you too."

"But you said you might want to be an actress."

"Yes, but not this kind. I didn't know there would be kissing in it! I'm not wild about smooching with Sergeant Salvio. I bet he tries to do a French kiss."

"Well, I'll come to all of your rehearsals and you come to mine."

"Okay, I guess. But it all sounds so cheap. God, I hope none of my old friends hear about this."

"But they're all in college, aren't they? They'll never know."

"And suppose we get a bunch of new patients the day of the show?"

"I'm sure Sergeant Percy will let us off for a few hours if necessary."

"Oh, gad, Barbara, isn't that sergeant a joke with his mustache and his New York accent?"

"He thinks he's God's gift to women."

"I could hardly keep from laughing the whole time."

"Do you think that's all he does—puts on shows?"

"Yes, that's what Special Services means."

The next night they stayed after work. They were both dressed up a little more than usual. Mary Lou was wearing a silk dress and Barbara a velvet jumper. They waited in the auditorium for their turn on stage.

"Where are the two dames from Military Personnel?" Sergeant Salvio yelled.

"Here we are," Mary Lou called as they joined him on the stage.

"Now I'd like you two to wear something special for this—something sexy."

"This is one of my best dresses," Mary Lou said.

"Mine too," Barbara said.

"Well, maybe down in Dixie here they call this stuff sexy but it won't go over on the stage."

"What do you mean, sexy?"

"Well, you know. Why do they call Lana Turner the sweater girl?"

The girls started to laugh. "Why?" Mary Lou asked.

"Because she wore her sweaters tight and because she filled them out. So keep that in mind when you're dressing for the show."

"We'll do our best," Mary Lou said. "But remember it's mostly up to God."

"You got a great sense of humor, girlie, but I don't think you're taking this serious enough. Remember, if the show isn't good it's overseas for me—and not to entertain."

"Yes, I saw the service record of a singer who lost his voice and ended up in a foxhole."

"Don't tell me about it, honey. Okay, let's get started."

After two hours they had blocked out the skits. Barbara

played a woman who kept getting up in her seat to let soldiers go by to get to theirs. As they did they made lascivious remarks about her. At the end she poured popcorn over a totally innocent private who had done nothing.

"You did good, girlies. I'm going to have Tony here drive you home in our jeep." Tony was a short stocky boy who was in charge of odds and ends for the sergeant.

"How far do you live from here?"

"A good half-hour's drive."

"That means an hour in the jeep." He called over to his friend, Roger, a chubby boy right off the farm. He looked like he'd been waiting to be asked to join them on the ride. Roger's main job was to carry the equipment back and forth to the trucks.

Oh gad, Mary Lou thought. This looks like double dating. "I'm sure somebody will see us out in the jeep and misunderstand," she whispered to Barbara. "They won't know what we're doing."

"Maybe they'll think we're WACS."

The ride home was hectic—whipping through city traffic. And it was freezing with no protection from the wind.

"Hey girls," Tony called loudly over the noise of the jeep and traffic. "Wanta stop at a drive-in?"

"No thanks," Mary Lou said.

"Oh, please, Mary Lou, let's stop. I'm starving. We haven't had any food in hours." Barbara was always ready for fun.

"Well, all right but I don't want to get home too late. We have hundreds of patients arriving tomorrow."

They pulled into the drive-in. "What'll it be?" Tony turned around in his seat and asked the girls in the back.

"Let's get Charles River barbecue beef sandwiches," Barbara said. "They're famous for them here."

Roger ordered double sandwiches plus two milk shakes. "I'm trying to eat my way out of the army. When I reach two hundred and fifty I'm out."

"You mean you used to be thin?" Mary Lou asked.

"Yes, when I was drafted I weighed one hundred and thirty pounds."

"Do you like eating that much?"

"When I was a boy my mom said that I had a very finicky appetite, but I've sure gotten over that."

"Well, how will you get back to one thirty when this is over?"

Roger's face fell. There was a long silence. "I'm not sure."

The waitress brought their food out, but couldn't attach it to the side so they had to hold the trays on their laps. The waitresses were dressed as Dutch girls and were wearing wooden shoes that made walking difficult. The outfits were not connected in any way with the drive-in's name, which was Sam's.

"What do you girls think of Sergeant Salvio?" Tony asked.

"I guess he's okay," Barbara said.

"I'm not going to kiss him until the night of the show. I know that," Mary Lou said.

"Don't tell him I said this but he thinks he's a real Don Juan. Watch your step with him."

"He reminds me of George Raft," Barbara said. "What did he do in real life?"

Roger chimed in between bites, "I think he was a hood."

"I'm not surprised," Mary Lou said. "I hope I don't catch anything."

"He was almost brought up on moral charges in Petersburg."

"I noticed in his service record he's been married twice."

"The girls in the shows usually end up as his girlfriends."

"You mean his molls." They all laughed.

"Now listen, girls, we could really get in trouble if any of this is repeated."

"We won't tell—and thanks for warning us."

"I'd like to go to the little girl's room," Mary Lou said. "My hair's all tangled. Let's go, Barb."

"Just a minute, I want to finish my sandwich."

"Okay, I'll be right back."

In the ladies' room she looked in the mirror. Gad, my hair's hopeless—all the wind. What am I doing here, anyway? I don't know why I let Barbara talk me into this. I'm always getting stuck doing things I don't want to do. Never again! She left the ladies' room and headed back toward the car. As she rounded the corner she saw that Chubby Roger was now in the back and Barbara was up front by Tony. Oh God, she thought, it really looks like we're double-dating now.

As she climbed into the back seat she heard a voice call, "Mary Lou!" A large Buick convertible had parked beside the jeep in her absence. In the front seat was Lieutenant George Barker, from the dismal summer after high school, and Ann Marie Bolden, of the lace tablecloths and the rich Irish father. Another lieutenant and a girl Mary Lou didn't know sat in back. Both girls attended Vassar now.

"Honey, what are you doing here?" Ann Marie asked. Implied was, *in that jeep!*

"I'm being brought home from my job at McGuire General."

"What's that?" The girl in the back asked.

"It's an army hospital. How are y'all?"

"I'm home on leave, Mary Lou," George said.

I guess he finally got his blood pressure under control, Mary Lou thought. I wonder if it went up during battles.

"I tried calling you, but you're never home."

"Well, I work six or seven days a week so I'm gone most of the time. This is my friend Barbara Busser and Tony and Roger from Special Services."

"Call if you ever get a day off," Ann Marie said.

Mary Lou said, "Let's go, Tony." God, I'm so embarrassed, she thought.

"Wait a few minutes," Barbara said. "I have to go to the little girl's room."

Mary Lou sat quietly in the back seat. I don't know why I'm so embarrassed. I guess I'm just a snob. Why should I care what they think? I hate myself.

After an eternity Barbara came back.

Suddenly Mary Lou called over to the convertible. "And by the way, Roger and I just got engaged and as soon as he eats his way out of the army we're going to get married. I'll invite y'all to the wedding." At this point Tony backed the jeep out and they were on their way. "I'm sorry, Roger, to lie like that."

"That's okay. It was worth it to see that lieutenant's face," he said.

They sang, "Row, row, row, your boat, gently down the stream," all the way home.

Mary Lou never felt better.

Chapter 9

18 February 1944
*Italian Front: During the night massive air
bombing and artillery fire slow down the
German attacks on the Anzio beachhead.*

"NOW WHAT'S THIS I hear about your being in a show
with the band members?" Sergeant Percy had called the girls back
to his desk for a conference.

"I guess we got talked into it," Mary Lou answered.

"Those guys from Special Services are really wild. You
shouldn't be doing that. It's not dignified. After all, you are my
assistant, Mary Lou. Sergeant Salvio is a very shady character,
take my word."

"We know. We read his service record," Barbara said.

"Certain facts that I know about weren't even put in. So why
don't you forget about this?"

"It seems like fun when we're actually doing the skits," Mary
Lou said.

"I happen to know that if certain things had been substantiat-
ed he would have been court-martialed and sent to the stockade."

"What allegations?" Barbara asked.

"You're both too young to know about these things."

"Oh, Sergeant, we'll be careful. After all, there are always lots of people around. What could he try?"

"Well, just make sure you're never alone with him."

"We will. We promise. He gives me the creeps," Mary Lou said. "He reminds me of George Raft."

That evening Sergeant Salvio was standing on stage in his perfectly tailored uniform with a large clipboard, gesturing, giving orders, and playing the part of the director. Band members were wandering at will and paying no attention to him.

He shaded his eyes and called toward the audience, "Mary Lou," in an exaggerated southern accent. "On stage puleese."

He thinks he sounds like Rhett Butler, Mary Lou thought, but he sounds like he's from South Hollywood. That's what the girls from St. Gertrude's used to call motion picture southern accents.

"We're going to do the doctor and nurse skit now." As she walked toward him his eyes lit up. "I must say you're dressed much sexier tonight, honey chile."

"I'm just wearing a skirt and sweater from high school."

"Well, honey, now you're looking more like Lana Turner. I'm glad you took the hint."

Mary Lou could feel her face flush. "I wasn't thinking about you when I picked my clothes out this morning. I've been wearing this outfit for years."

"Well, they really suit you, Miss Corn Pone, if you know what I mean."

She heard some snickers from the audience. Oh God, how embarrassing. "Let's get on with the rehearsal, Sergeant," she said and gave him a furious look.

"You're beautiful when you're mad, kid," he said in a mocking tone.

"One more personal remark and I'm leaving."

Roger and Tony set up the furniture for the skit. The drummer from the band—a tall, thin soldier, whose uniform was two sizes too small, sat behind a desk and wore captain's bars on his shoulders.

Mary Lou, wearing the uniform of an army nurse, entered from stage right. Saluting, she said, "Reporting for duty, sir."

"Is this your first day at the hospital, Lieutenant?"

"Yes, sir." She continued saluting.

"I think you'll like it here. At ease!"

She started to unbutton her sweater.

"What are you doing, Lieutenant?"

"I'm following your orders, Sir!"

"What orders?"

"At ease!"

"What's that got to do with unbuttoning your blouse?"

"The captain at Letterman Hospital said at ease meant to unbutton, sir."

"Well, you've got a lot to learn, Lieutenant."

"Yes, that's what he said when the eight patients died." At this point blackout music was played very fast.

"Pretty good," Sergeant Salvio called up to them. "Let's do the medic and the nurse skit. Barbara and Roger on stage!"

Roger, who was a lot closer to two hundred and fifty pounds now, was standing by a bed when a nurse lieutenant, played by Barbara, entered.

"Medic, you must salute me when I enter the ward. Do you understand?"

"Yes, ma'am, but..."

"There are no buts about it."

"But suppose…?"

"Suppose what?"

"Suppose I'm busy doing something."

"I don't care what you're doing. Drop it and salute me."

"But, ma'am."

"Don't answer me back anymore, Private, and remember to-morrow when you see me for the first time come to attention and salute!"

Blackout music was played at this point. The lights went back on indicating the next day. Barbara, playing the nurse again, "Good morning, Private." The Private turned around showing he had two bed pans in his hands. He dropped them and saluted. She saluted back.

"Private, why did you drop those pans?"

"You said for me to drop whatever I was doing and salute you."

"I hope you're never holding grenades when I enter." Blackout music played very loudly.

Sergeant Salvio hopped on stage clapping his hands. "Everything's moving right along. We'll break for the night now. I'll take you two girls home."

Mary Lou and Barbara exchanged glances. "What about Tony and Roger?"

"I've dismissed them for the night. Why, did you four have plans? Some hanky-panky going on?"

"No, Sergeant," Mary Lou said, "but they've taken us home every other night."

"Well, I have a staff car so I'm doing it tonight."

I guess there's nothing we can do, Mary Lou decided. Maybe it'll be all right, but this is what Sergeant Percy warned us about.

"Come on, I'm parked right out here." He motioned to the stage door exit.

Outside in the parking lot the girls started to get in back. "You gotta be kidding! What do you think I am? A chauffeur? In front!"

"It'll be crowded," Mary Lou said. "I'll sit in back."

"I'm not sitting up front alone with him," Barbara whispered.

"You kids afraid of me? Both up front! That way we can talk and I'll get a couple of cheap thrills." They just stood outside of the door. "Only kidding. Boy, you two are real hicks. What do you think I am? Some Yankee soldier about to take advantage of two little southern flowers?" All three of them squeezed into the front. Barbara was in the middle.

They drove about ten minutes in silence. "You want something to eat, girls?"

"Yes," Barbara said.

"No, Barbara," Mary Lou said. "We have an extra long day tomorrow. I want to get home."

"You're a real spoilsport. Don't you want to have some fun?"

You're not my idea of fun, she thought. "Let's just get home."

He pulled a flask from his pocket. "In that case I need a little fortification." He took a swig. "Well, where to?"

"We live in Lakeside."

"Where's that?"

"Out past Bryan Park. We'll show you."

Sergeant Salvio started doing a bad imitation of a Frank Sinatra record. Pretty soon they were passing the park.

"What kind of park is that?"

"It has lots of old trenches still there from the Civil War. It's like a memorial to the dead soldiers," Barbara said.

"Why don't I drive through? I've never seen anything from the Civil War."

"You can't see anything at night," Mary Lou said.

"Sometimes we used to come here on picnics and roast hot dogs and bake potatoes," Barbara said. "There's a ravine with a quarry and the boys all skinny-dipped." Mary Lou poked Barbara in the side.

"Hey, that sounds like fun. Why don't I drive in and you can show me the quarry."

"We have to get home," Mary Lou insisted. But he drove through the entrance anyway.

"Which way to the quarry?"

"Just turn right around now. I want to go home."

"Oh, Mary Lou, don't be such a killjoy," Barbara said.

"What are you afraid of? There's safety in numbers," he said.

"You make a right turn at the first fork in the road there," Barbara said.

I could kill her, Mary Lou thought. He's up to no good.

He turned at the fork. "How far?"

"Right down this road about a half a mile. It's really bumpy. Are you sure this car can go on a road like this?" Barbara asked.

"Sure, little magnolia blossoms, cars like these are overseas in the war. Boy, it sure is dark tonight."

"Oh, there it is!" Barbara pointed ahead. Sergeant Salvio pulled off the road. Just then the moon came out from behind the clouds and they could see the quarry to the right. The top of the water was at least fifty feet below the rim. It was dead still. They sat looking at it.

"This is spooky," Mary Lou said.

Sergeant Salvio got out.

"Where are you going?" Mary Lou asked.

"I want to take a leak and see things up closer."

"Oh, how crude! Why did you encourage him, Barbara?"

"I couldn't see any harm in it."

"Well, I'm afraid you will before we get home. Where the heck is he?"

After a few minutes they heard him call. "Girls! Girls! Come here!" They could tell he was some distance away.

"Come back here," Mary Lou yelled.

"I need your help!" he called. "Come here!"

"Oh God, where is he? What's happened?"

"We'd better go," Barbara said.

"Hold my hand, Barbara," Mary Lou said. "And don't let go no matter what."

They slowly walked through the woods toward Sergeant

Salvio's voice. "Down here, girls, down here!" The moon came out again and they saw him standing stark naked on a rock overhanging the water.

"I can do anything your rebel boyfriends can do. I'm going to dive in. I wanted you to see."

"But Sergeant!" Mary Lou screamed. Just then he took off and just like something Mary Lou had seen once in a newsreel he did the most perfect swan dive ever performed. He seemed to stay in the air forever with the moonlight shining on him as though it were a stage light. He disappeared from sight and then they heard a splash far below. There was another long pause.

Then, like a voice from another world, with all bravado gone, they heard, "How do I get up, girls?"

"Climb the rocks on the other side."

"I can't see them."

"Our friends only did it in the day time," Mary Lou called.

There was a really long pause. "I'm going to swim to the other side. Hope to see it in the moonlight. Get my clothes off the rock. If I'm not back in one hour call the police."

"Oh, Barbara, this is horrible."

"I'm scared to go to the rock to get his clothes," Barbara said.

"Well, you stay here. I'll see if I can get them."

"No, no, don't leave me alone. Forget the clothes."

"Do you want to be driving in a car with a naked soldier?"

"I never thought of that."

"Well, start!"

Why can't I be at Vassar or Sweet Briar joining a sorority and going to tea dances? She inched her way through the brush. Oh, please God, don't let me die in Bryan Park. It'll be in the papers and I'll lose my reputation forever. She reached the rock and carefully slid to the pile of perfectly stacked and folded clothes. Why did he bother to be so neat when he'll never see them again? She picked them up. The moon came out bright. She could hear

splashing in the water below. I hope that's him! She inched her way back to Barbara and they made their way back to the car.

Barbara was half-crying now. "What time is it?"

"Eleven o'clock. We'll wait until twelve o'clock, then we'll go for the police."

"Maybe we should go now."

"I'm hoping we don't have to. Besides, I don't know how to drive, do you?"

"I used to drive a tractor on my uncle's farm."

"I don't think it's the same. Now stop crying. We'll lock the doors and hope for the best." They huddled together.

At twelve o'clock Mary Lou said, "We'll give him ten more minutes." At twelve-ten she said, "Ten more." At twelve twenty-five she said, "We'd better walk toward the entrance."

"I'm scared," Barbara said.

"Me too." As they started to get out they heard noises in the bushes.

"What's that?"

Sergeant Salvio stumbled out of the woods and approached the car. In the moonlight they could see his Brooklyn-white body covered with cuts and bruises.

"Throw my clothes out!" he yelled in a hoarse voice. They did. In a few minutes he was at the door. "For God's sake unlock it."

He got in. The car bounced back to the main road. Without looking at them he said, "I don't want one sound from either of you. And you're both out of the show."

"May I just ask one question, Sergeant?"

"What is it?"

"Where did you learn to dive like that?"

CHAPTER 10

1 MARCH 1944
*The German offensive against the
Anzio beachhead is contained.*

"YOU GIRLS rehearsing tonight?" It was close to 8:00 A.M. and work was just starting in Military Personnel. Sergeant Percy was sipping coffee and eating donuts at his desk.

"No, Sergeant, we're not," Barbara answered from her desk in the front of their section.

"We're never rehearsing again," Mary Lou added from hers.

"How come?"

"It doesn't really matter."

"Something happen, girls?"

"No, not exactly."

"Come on. If Salvio did anything bad I want to know."

"Please don't ask."

"I warned you, Mary Lou. He's a bad character."

"He's dumb, I know that." Barbara got up and stood between Mary Lou's and Sergeant Percy's desks.

"Barbara, let's not talk about it, please."

"Well, we didn't do anything. I don't know why we were kicked out," Barbara said.

"Kicked out?"

"Barbara, do you want everyone on the base to know about this?" Mary Lou said.

"It might serve him right."

"And we'll look just as foolish."

"All right, girls, time to work," Sergeant Percy said. "I expect to hear the rest of this story before the day is out."

"Barbara, look at that pilot," Mary Lou whispered. He was standing by the desk of the woman in charge of Officer's Payroll—tanned, composed, and elegant in his uniform, his hat perfectly crumpled.

Barbara stopped typing and stared at him. "Keep typing," Mary Lou said. Then she went to Barbara's desk and pretended to read some papers. "I don't want him to know we're looking at him."

"Oh gosh, he's darling. "

"I wonder why he's here."

"We can ask Lois as soon as he leaves," Barbara whispered.

Just then he looked in their direction and caught them staring. He smiled to them—an old friend's smile—a funny we should be here at the same time smile.

Barbara started typing again. Mary Lou leaned over pretending to confer about the piece of paper in the typewriter.

"Oh gad, he caught us," Mary Lou whispered. "He acts like he knows us." She was blushing. "I'm so embarrassed."

He sat at the desk, signed some papers and was gone, never looking in their direction again.

"I've never seen you go for anyone like that," Barbara said.

"I know. Let's ask Lois about him."

They went to the officer's section. Lois was a big woman with short black hair always askew—always talking about Seabees she "dated." She said their motto was "wham bam, thank you, ma'am." Mary Lou thought she understood what that meant but she couldn't understand why Lois thought it was so funny.

"Hi ya, kids! How's business in Enlisted Men's Payroll?"

"Oh, fine. How's yours?" Mary Lou asked.

"Couldn't be better! I'm leaving early today. Got a tooth to be pulled and then a date with a guy fresh from Guam."

"How can you go on a date after having a tooth pulled?" Barbara asked.

"Well, I figure I'm gonna get drunk anyway, might as well use it to kill some pain."

The girls were dumbfounded at this. Then, after a moment's silence. "Do you mind telling us who that pilot was?" Mary Lou asked.

"No, honey. He was a knockout wasn't he? Here's his file." She handed it to Mary Lou.

"Colonel William McCafferty, Flying Tigers, thirty years old—eight years in the Far East." She flipped some pages. "He's here at McGuire for treatment of malaria."

"Is that serious?" Barbara asked.

"Almost everyone from that theatre of war has it to some degree," Mary Lou answered.

"See if he's married."

"It says divorced, in 1943, while he was in Indo-China. That's sad."

"It all depends on how you look at it," Barbara joked.

"Well, thanks, Lois." Mary Lou handed the file back. "We've got to get back to work. Good luck at the dentist."

"Thanks, kiddo. I'll save my luck for my man from Guam."

They started towards their desks. "He's a little old," Barbara said.

"Yes, I know and a little sick. Malaria never goes away. You just try to control it with quinine or atropine. Wasn't that funny the way he smiled to us, like he knew us. Well, we'd better get busy or we'll be here all night. The bus leaves at six-thirty."

Later, when they were on their way to catch their bus they saw him in the hall walking toward them with a nurse.

"Oh no, look, Barbara. There he is. Oh gad, I'm starting to blush," Mary Lou said.

As they got nearer they heard him say, "I know I can lick it." He looked in their direction, but didn't acknowledge them even though they passed close enough to touch.

"He looked so friendly this afternoon."

"Do you think he recognized us?"

"Well, we haven't really met him."

"I know, but I feel like we have. Oh, we're going to miss the bus if we don't hurry." They half ran the rest of the way.

"I don't feel like going right home. Let's go to a movie in town."

"Great! Let's get a seafood dinner at the Shore House and then see the Betty Grable picture at Loew's."

"Do you ever feel restless?" Mary Lou asked as they ate their seafood platter.

"Not exactly. But I think I know what you mean."

"Sometimes I feel something welling up inside of me and I want to jump up and down and yell or something. I think I miss the way life could have been without the war. I feel like I'm in an intermission. I'm saving to go to college, but that doesn't even seem real anymore. I want something, but I don't know what it is."

After dinner they saw the movie, then they rode the bus home past Bryan Park. They said Sergeant Salvio's name at the same time and started to laugh.

Mary Lou walked the two blocks from the bus to her house.
Now that I work, I'm free. Nobody tells me what to do.

Half a block from her house she saw a black car parked in
front of it. Who could be visiting at this hour? She could see that
the driver was inside.

Then he got out. It was the pilot. "I got your address from a
friend in civilian personnel. I've been sitting here for hours. You
really take your time getting home," he kidded.

"Oh, I've been to the movies." They stood for a long moment
seeing each other in the light of the street lamp.

"My name's Bill McCafferty. I'm assigned to McGuire tempo-
rarily." He extended his hand. "How do you do, Miss Cottrell."

She knew his hand shake before they touched. She knew *him*.
"Why did you come?"

"I had to see you and I'm short of time."

"But I thought…"

"Oh, I'll be around here for a while. But not long enough."

"I'd ask you in but my family's in bed by now."

"I understand. When can I see you? May I see you?"

"Well, I guess tomorrow night would be all right." Anytime!
Now! she thought.

"Good, I'll pick you up at work."

A pause. "Well, good night."

"Good night, Mary Lou."

He stood by the car watching her. She walked to the front
door of her house, looked back for a moment and then went in.
He waited a few minutes more, then got in and drove away—fast.

It was dark inside the house. She tiptoed to her room and un-
dressed in the dark so she wouldn't wake anyone. My untouched
body. All closed up, waiting—for what? I'm breathing funny.
What a strange thing for a stranger to do. I would have driven off
with him if he had asked. She had a hard time sleeping.

* * *

Oh, it's tomorrow, she thought. The date day—six-forty—time to get up and get washed and dressed. What'll I wear? What do you wear for a date with a hero with a chest full of ribbons? Navy blue's good. It makes me look older. She put on her bright red lipstick. Daddy hates that. One time she'd boarded a bus that he was already on and he wouldn't speak to her. Said she'd looked like a pair of lips getting on. I guess he was embarrassed. She combed her long blonde hair looking in the bathroom mirror. Maybe I'll try mascara sometime, but I don't want to look cheap—even though I'm dating a thirty-year-old divorced pilot. Just the thought of him made her catch her breath. I hope we go dancing! Oh, oh, my ride's here. She ran out to the waiting car and joined the other civilian employees who rode together every day. The owner of the car was a butcher who kept the window open rain or shine, summer or winter, even though he never signaled for stops or turns.

"Mr. Graves, it's freezing back here."

"Sorry, Mary Lou. I must drive safely."

I'll never get the connection, she decided.

"Oh, Barbara, I'm so nervous. We didn't say where to meet." It was five o'clock and the girls were covering their typewriters and organizing their desks at the end of the workday.

"There he is now, Mary Lou."

The pilot stood by the door to the office, gave her a wink and nodded his head. She knew he wouldn't come in.

"Bye, Barbara." She laughed as if they had been discussing something entertaining. Sometimes she did childish things like this when she was self-conscious. Barbara was puzzled for a moment, and then realized what she was doing.

"Oh yes, bye, Mary Lou," pretending along with her.

Mary Lou met him at the door. "Thought I'd better not give your co-workers anything to gossip about, unless you do this all the time," he teased.

"Actually, no. I haven't dated many boys, I mean men, here. Sometimes Barbara and I go to the Officer's Club and hostess but we work late a lot of nights." By this time they'd reached the parking lot.

"Where would you like to go?"

"Wherever you like."

"Do you like to dance?"

"I love to dance. What a cute car."

He opened the door to a black Ford convertible. "Yes, we older folks like convertibles, too. Actually, I've borrowed it from a friend."

"I dated a boy who was given a car like this before he went into the Marines. He went to Iwo Jima."

"What happened to him?"

"Oh, he's home now."

"And now he can enjoy his car again?"

"I'm afraid not. He's blind. But he likes to sit in it. His mother invited me to lunch one Sunday, but when I got there he was sitting in his car and wouldn't come in the house. She was really embarrassed and so was I." They rode in silence for a while. Why did I tell him that?

"I've had two places recommended. The Tarentella in town and the Charles Club out on the Washington Highway. Which is better?"

"Well, the Tarentella has a larger dance floor, but the Charles Club has better food. They even have steaks. They say the owner is a black-marketeer."

"Then we'll definitely go to the glamorous Charles Club with the shady owner." A comfortable silence. "How old are you, Mary Lou?"

"Didn't you find that out in civilian personnel when you got my address?" She tried her Scarlett O'Hara quizzical look.

"No, actually Justine would only give me your address. But she did say you were a very nice girl."

Oh God, I hope she didn't tell him about the weekend in Washington.

"I'll be nineteen in January."

"Which makes you eighteen and a half now."

"Yes."

"I guess you know all about me. I'm sure you've seen my records."

Oh gad, I'm blushing. He knows I've seen his files.

"I've never dated anyone this much younger than I, but you have a way of carrying yourself that seems very mature. Anyway, I felt I had to know you."

She saw that he was looking ahead with a very serious expression. I love his face, she thought. But I mustn't stare.

After they'd arrived at the club and been seated they ordered their steaks. He offered her some bourbon, which he'd brought in a paper bag. "Would you like a drink?"

"Yes, bourbon and ginger."

"How long have you been drinking?"

"Since I was sixteen."

"That's pretty young."

"Well, I don't drink much. I've only had one bad experience—with Southern Comfort."

He started to laugh. "Let's dance."

Before he took her in his arms she knew what it would be like. Firm grasp around her waist—gently leading. Instinctively she followed him as the band played "Embraceable You."

"Where did you learn to dance like this?" he asked.

"When I was little my daddy danced with me. He taught me to dance to the 'Missouri Waltz.'"

"He did a really good job. You're superb."

"I can usually tell in five minutes where a soldier's from by the way he dances."

"Where am I from?"

She hesitated. "From New York."

"Oh, you little devil. You read my whole service record. So you know I'm divorced also."

"Yes."

"Would you have gone out with me if I were still married?"

She thought a long time, then said quietly, "No."

"Well, then, I'm glad you read it."

They ate their steaks, had two more drinks—one more dance. Then it was time to go. In the car he reached for her. She went to him. They kissed. Her cheeks felt hot. They kissed again. She felt herself go to him in a new way. Now I know what the warnings were about, she thought. Nice girls don't kiss boys in parked cars, Sister Antoinette would say. Now I know why. It's not enough.

"I want you. Do you want me?" he asked.

What does want mean now? The language had changed. This was a different country.

"I'd better go home." Or I'll be lost, she thought.

"All right, little girl." Like a parody, he smoked one cigarette.

They drove in silence. At her house she said, "I really had a great time." It was the same thing she said to all the boys she dated.

"Don't play games with me, Mary Lou."

She watched him drive away and stood by her doorway feeling silly. After going inside and undressing in the dark, she thought, It was all such fun until it got too real. I want to go to tea dances and wear angora socks. I want to be a rosebud, not a rose. Lying in bed, she thought, Will I see him again? Will he see me again?

The next day Mary Lou and Barbara were proofreading the payroll and discussing the night before.

"Yes, it was very glamorous. We went to the Charles Club and yes, he did kiss me." And almost more, she said to herself.

"What was it like?"

"Different. Men of thirty don't kiss like Andy Hardy, I can tell you."

"I know. One time my gym teacher kissed me. I almost fainted. He wanted to date me but he had a wife and three kids."

"You didn't do it, did you?"

"No, but before he was fired he'd gotten three girls in my class pregnant. And they all told me they didn't even enjoy it that much."

"Thank God it wasn't you."

"I always wanted to be one of the good girls," Barbara said.

"Me too."

"But I can see how you could get carried away. I think I could be pretty passionate."

"Me too."

Five o'clock came again. No wings in sight. Guess I won't see him again and I want to.

A week went by. A new batch of patients had arrived and needed to be paid. At two A.M. the exhausted girls walked toward the staff car that would take them home.

"Mary Lou, I'll drive you home."

"Oh, hi!" He's here! He's here!

"I'll drive you home." He'd been waiting in the parking lot.

"Well, okay. See you tomorrow, Barb."

They rode in his car. She stared at her purse in her lap, wanting to talk but having nothing to say. After a while, "Haven't seen you for a while."

"I went home for a week."

"Oh."

"I thought you'd see it on the morning report."

"No." Why didn't I think to check it? she thought.

"I couldn't stop thinking of you," he said. "I want to see you every day."

"I thought you'd decided I was silly."

"No. I just have to remember how young you are." He drove

her to her house and kissed her on the cheek. "You should get right to bed. See you tomorrow. We'll go to dinner."

"Good night. Thanks for the ride." Thanks for being born, she thought. She went inside and got ready for bed. He came back! He came back! Now what will I do with him?

They went to dinner every night—dancing and good night kisses. I'd like more, she thought. One night she said, "I have to go with Barbara to the Officers Club on Saturday. I promised her a long time ago."

"Sure, I'll drive you both."

"Sorry, but we have to go on the bus with the other girls and the chaperone."

"Well, then maybe I'll come by."

"Wonderful!"

The girls waited by the bus that would take them to the dance. Mrs. Bailey, the chaperone, a plum pudding in flowered georgette, and her lump of a daughter stood in front and checked their names off the list as they got on. "Now remember, girls, we're all southern ladies and we must act refined. Do you all have handkerchiefs in your purses? No more than two drinks apiece and we all leave promptly at eleven o'clock. Last week two girls didn't come back with us and they are being checked off of the list of eligibles."

"I bet she wishes her daughter was one of them," Barbara whispered to Mary Lou.

Mary Lou and Barbara barely had time to sit down when two lieutenants came over to their table.

"Hello! I'm Robert Nelson and this is Dan Reeves. Would you girls like to dance?"

"Sure," Mary Lou answered.

"Or maybe you'd like to have a drink first." They joined the girls at the small round table.

"This is one great place for an officers club," Dan said.

"This dark wood paneling is sensational."

"Yes, it's an old mansion. Grace Street has lots of them," Mary Lou said.

"Where are you girls from?" Robert asked.

"We're Richmond girls. We work at McGuire General," Barbara answered.

"Let's leave this place and get something to eat," Robert suggested.

"Sorry, it's against the rules," Mary Lou said.

"Well, what will you have to drink?" Robert asked.

"I'll have a B&G," Mary Lou said.

Barbara ordered a Pink Lady.

"What's a B&G?"

Mary Lou felt silly. "A bourbon and ginger." Why did I say it that way?

"I thought it was some kind of new drink but I think we can manage a B&G," Dan kidded.

After they finished their drinks the band started playing "Sentimental Journey." The two couples started dancing.

She saw him across the room. It was Bill. I love him, she realized. He saw her. He started towards them. He tapped the lieutenant on the shoulder.

"Sorry, Colonel, no breaking in."

"Sorry, Lieutenant, this is my wife."

"Then what's she doing here?" Dan asked. "You'd better keep an eye on her, Colonel." He handed her over.

Bill took her in his arms. School was out. She was home for the summer.

"He'll tell Mrs. Bailey. She'll cross me off the list."

"Good! I never want you to dance with anyone else again. I'm going to Texas next week. Come with me."

"What?"

"We'll be married there. I have to go back overseas."

Why can't things stay the same? she thought. Long school
years—vacations to plan for—the same crowd coming back. I'm
not ready to graduate.

"You love me, don't you?"

"Yes."

"Then it's simple. We'll tell your parents tonight."

"But I don't know…I have to think."

"You can have the rest of the evening. I'll wait at your house."
He took her to her table, then left. By then Dan had found anoth-
er partner.

He's treating me like a child—I guess because I act like one,
she decided.

On the bus ride home Barbara asked, "Did you have fun?"

"Sure, did you?"

"Yes. Dan said Bill told him you were his wife. I told him he
was kidding."

"That's what he wants me to do."

"What?"

"Marry him."

"Oh my gosh! Are you going to?"

"I don't know. He wants me to decide tonight."

"Wow! I wouldn't blame you if you did. All the girls in the
office think he looks like Tyrone Power."

"But Barbara, this isn't a movie. I have to live this." They
came to her house. "Night."

"Good luck!"

"Thanks."

The car was there like he said. She got in. They kissed. "What
is your answer?"

"I want to marry you, but I never thought of myself as a wife. I
don't know if I'm ready. I want to go to college. I don't know what
I want to be."

"Then the answer is no!"

"Please, not so fast. Why do I have to make up my mind tonight?"

"Because that's the way it should be. You should know right away. You either love me or you don't."

"I do love you. I'll wait for you. I wouldn't date anyone else."

"I don't think you realize where I'm going. I know your rules. I want to make love to you and I'm willing to marry you to do it. Yes or no."

"I guess...no."

He paused. "Then kiss me goodbye."

This kiss is different. Is this a married kiss?

"Goodbye, Mary Lou. I won't be seeing you again. Sorry you weren't ready."

She got out silently and went inside her house. Then she sat on the sofa in the dark for a long time.

CHAPTER 11

4 MARCH 1944
Approximately six hundred Flying Fortresses
and Liberators of the U.S. Eighth Air Force
carry out the first daylight raid on Berlin.

"MARY LOU, "What happened last night?"

Barbara and Mary Lou were standing by the filing cabinets.

"He asked me to marry him."

"Oh my gosh! What did you say?"

"I said no."

"But I thought you had fallen in love."

"I did, but he wanted me to get married right away—next week."

"Well, why not?"

"Barbara, I want to be somebody. I want to go back to school. I want to read a lot of books. I don't want to be just a wife."

"Well, what do you want to be?"

"I don't know. Just more than I am now."

"Oh, I guess I understand."

"I have to go now. I'm working in the wards this afternoon."

"How do you stand it?"

"I don't mind, except for the smell."

"What is that smell, anyway?"

"I don't know—medicine, I guess, and something else. I'm afraid to ask. Anyway, they seem so relieved after I explain everything. It's really worth it."

"See you later."

"Oh, I almost forgot," Barbara said. "Sergeant Drake was here and said we could come to the base movie tonight. Want to?"

"I'll think about it. See you in a few hours."

"I thought you'd never get back." Barbara's cheeks were pink with excitement. Mary Lou had just returned from the wards and was putting some records away.

"They're showing *Alexander's Ragtime Band* with Alice Faye at the movie tonight. I'm dying to see it. Let's have dinner in the mess hall and stay for the show. Please, please, pretty please."

"Okay, it sounds like fun. But I wish I'd worn something fancier than this old skirt and sweater."

"Oh, don't worry. You look great!"

They went to the ladies' room to freshen up. Mary Lou looked in the mirror. "Would I look better with a pompadour?" She held her hair up and showed the effect to Barbara.

"No, you're lucky you can wear it plain like that just pulled over with a barrette. I need curls around my face."

"You really don't. But we should both go on a diet. I think our faces are a lot rounder than they used to be. This mess hall food is fattening and I don't think typing makes people thin."

"No, look at Mrs. Pratt." They laughed. "Let's try to not eat too much tonight."

"Okay."

As they passed through the serving line in the mess hall the attendant piled their plates with fried chicken, mashed potatoes

with gravy, and peas. Then he plopped the apple cobbler dessert on top.

"This isn't what I'd call dieting."

"Me neither." They laughed as they picked a table in the huge room, which could seat at least five hundred people.

"Don't look now but I see Tony and Roger from the band. Act like you don't see them."

"Hi, girls! Do you mind if we join you?" Roger looked like he had almost made his weight goal to be discharged.

"No, it's a free country," Barbara answered. Roger and Tony took seats beside the girls.

"Whatever happened to you two?" Tony asked.

"Didn't Sergeant Salvio say? I thought he'd tell you, Tony. You're his next-in-command, aren't you?"

"He said it was some kind of personal matter."

Mary Lou and Barbara started to laugh uncontrollably.

"It sure was," Barbara sputtered.

"What was it?" Roger begged.

"We can't tell," Mary Lou said. "We promised not to."

"God, it must have been awful. Did he try anything lewd?"

"Well, I don't think he meant it to be. But we really can't tell you."

"Would he be discharged?"

"Can you be discharged for stupidity?" They all laughed at this.

"We'll get it out of you yet," Tony said.

"You girls working late?" Roger asked.

"No. We're staying for the movie."

"Great! We are too." Barbara and Mary Lou exchanged looks.

"There's an after-hours party tonight in one of the rec rooms near the theatre that you two can come to," Tony said.

"Oh great!" Barbara answered.

"I have to get home at a decent hour," Mary Lou said. "Any-

way, I thought those parties were declared illegal by the colonel. Didn't some patients get drunk and weren't able to make it back to their wards?"

"Yeah, they were too drunk to push their wheelchairs. Some passed out."

"Good for them!" Mary Lou said. "There's not much they can do to them at this point, but I don't want to lose my job. I've saved almost enough to go to college."

"Aren't you going to eat that pie, Mary Lou?"

"No, we've started dieting. You can have it, Roger."

He gobbled it down and the rest of the leftovers with it.

"Let's start over to the theatre," Tony said.

Ambulatory patients in pajamas, regular soldiers and a few civilians were taking their seats in the theatre. Wheelchair patients were lining up in the large open space allotted to them.

"Hi, Miss Cottrell!" It was one of the patients Mary Lou had visited in the wards. He was sitting with some friends in the wheelchair section.

"Hi, Corporal! It's good to see you're getting around now."

"Yeah, I've at least made it to the chair corps."

"See you later."

Mary Lou and Barbara sat with Tony and Roger. Tony leaned over. "The party starts right after the movie."

"Are you sure we won't get in trouble?" Mary Lou asked.

"No, everything's copasetic."

The movie was colorful, entertaining, and musical. Don Ameche sang to Alice Faye and Alice Faye sang to Don Ameche.

"We have to duck out fast and head down the back corridor," Tony ordered.

I'm not sure I really want to go, Mary Lou thought. At that point Barbara pulled her arm.

"Isn't this exciting?"

"I have a feeling we shouldn't be doing this."

"Oh, please come. I'm going anyway." Barbara was bubbling over with enthusiasm and hard to resist.

"Well, okay I don't want you to go alone."

Tony and Roger led them very quickly down the lengths of two corridors and then outside through a lot in back of the buildings.

"Tony, isn't this area off-limits to civilians at night?"

"Not if you know the right people."

"This is scary."

"Well, anyway, here we are."

He opened a back door, then led them through a storage area to a small room. They could see about a dozen people. A soldier was putting a record on the phonograph. Glenn Miller's "Moonlight Cocktail" started playing. An army nurse was arranging popcorn, potato chips, and cans of beer on a card table.

"Where are we?" Barbara whispered.

"We're behind a section of the hospital that hasn't been opened yet. We're perfectly safe. None of the brass knows about this. How about a beer, girls?" Tony asked.

"Sure." He got the beers and put a couple of dollars in a can on the table. They sat on the chairs in the corner of the room.

"I keep feeling like some M.P.'s are going to barge in and arrest all of us," Mary Lou said.

"It never happened before."

"That's what the old lady said when the cow died," Barbara said.

"Enough of this Virginia humor, let's dance." Tony led Barbara to the tiny dance floor.

Roger came over with his mouth full. "Hope you don't mind if we don't dance, Mary Lou. I have to let my dinner digest."

"Don't worry. But this doesn't look very glamorous to me, Roger."

"I'm sorry, Mary Lou."

"Well, don't worry about it. I recognize those two civilians, but who are the two girls over there by the phonograph?"

"Two off-duty nurses. Some WACS usually come too."

"Officers mingling with enlisted people?"

Just then a tall boy, a patient in pajamas, came over. "Wanta dance?"

"Sure," Mary Lou said. I don't want to hurt his feelings, she thought. They stepped onto the so-called dance floor.

"What's your name?"

"Mary Lou. What's yours?"

"I'm Sneezy, one of the seven dwarfs."

"You're awfully tall for a dwarf," she laughed.

"I escaped from a Disney movie and when I left the film I grew."

Mary Lou looked at his face. He looks dead serious, but it must be a joke. "Well, I'm really Snow White and that's the Wicked Queen over there." She nodded toward the off-duty nurse.

"Mary Lou, you mustn't make fun of me. I'm from a locked ward and my nurse brought me here for one hour." He said this in a quiet matter-of-fact way.

Oh, God! What have I gotten into? She thought. "Oh, I'm so sorry. What is your real name?" He didn't answer her, but started to move very fast. They danced, totally out of sync with the music for about ten minutes.

"I have to rest now," she said.

"You can't go until you ask me by name." He held her tighter.

"I don't know your name."

"Yes you do." They danced some more.

"Sneezy, may we stop now?"

"Certainly," he answered in a monotone. He escorted her to her chair, walked stiffly across the room, then sat next to the women in the corner.

Tony and Barbara came back and sat in the empty chairs.

"Tony, I had the weirdest experience."

"Did that 'Section Eight' bother you?"

"I danced with him and he thinks he's Sneezy of the Seven Dwarfs."

"I know. Every week he's a different one."

"Tony, how could you bring us here?"

"Aren't you having fun?"

"I'm sorry, but no. I think we'd better go now."

"Let's have one more beer, please," Barbara said.

"Okay, but I'm leaving soon."

"Let's try a boilermaker," Tony said.

"What's that?"

"Here, take a gulp of whiskey." He pulled out a flask. "Then take a swig of beer. Do that three times and then we'll go. We'll take you home in the jeep."

Barbara went first. "Wow! That's really strange. Go on, Mary Lou."

"I don't think we should. I've never mixed beer and whiskey."

"Come on, don't be a kill-joy."

"Well, okay, but then we're going." She took a gulp of the whiskey, then the beer. "Gad, more went down than I planned."

"Two more," Tony egged her on.

"I must be crazy. Okay, here's number two. First whiskey, then the beer." She swallowed.

"One more, Barbara," Tony and Roger chanted. By mistake she took the beer first.

"Is this your idea of fun, guys?" Barbara asked.

"Finish with whiskey," they all said.

"Okay." She took a large gulp of whiskey. "I feel really weird."

"You girls did that great."

Barbara giggled. "We're cheap drunks."

"Not only cheap, but fast," Mary Lou added. They both were getting high.

"We'd better go while we can still remember how to find our way out of here." Tony sounded really drunk.

"You do know, don't you, Tony?"

"Sure, I'm only kidding. But let's go now." They started out of the room. Mary Lou waved to the patient.

"What a night this has been, Barbara. I hope we don't lose our jobs." Barbara was a little unsteady on her feet.

Roger lingered for one last grab at the food. "Roger, come on!"

The other people hardly noticed them leaving. Tony led the way, then Mary Lou, Barbara, and Roger. They went through the storage rooms then through an outside door to a yard.

"This looks different, Tony."

"No, I never get lost."

"I think we should have gone out that other door," Roger said.

"It doesn't matter. Come on inside again."

"We're all turned around." Roger sounded nervous. Tony opened a door and they all followed him inside.

"This is the locked wards section for psychos," Mary Lou said. "See the grills on the windows? I've been here a few times. Sergeant Percy had to get me special permission."

"I'm scared." Barbara was almost crying.

"Let's go outside again and into another corridor. They'll have a guard down this way," Mary Lou said.

"Well, okay but I'm like a homing pigeon." Tony was really slurring his words now. They went out through a door then in another.

"Oh God, is this it?"

"I don't know but it'll have to do." They started walking fast—unsteady but fast.

"I'm scared, guys," Barbara said.

"We're not supposed to be here this time of night," Mary Lou said. "Oh God, look ahead!" Farther down the corridor they saw some figures.

"It looks like guards making rounds. We'll be court-martialed," Roger said. "What'll we do?" They started running.

I think I'm having a nightmare, Mary Lou thought. They came to a corridor that was shorter than the rest. The word *morgue* was printed on the doorway.

"What's this?" Mary Lou asked.

"We'll have to hide here," Tony said. "Roger and I can be seen here, but not you girls. Come on." The corridor jogged to the left. Drawers lined both sides.

"I know where we are," Barbara said. "My cousin drowned and they put him in a drawer, my Mamma said."

Mary Lou felt her blood run cold. "No, Tony, don't ask." He was already pulling out a drawer. "We'll suffocate."

"I won't close it all the way." Roger pulled out another drawer. It contained a body. He slammed it shut.

"Oh, Jesus, Mary, and Joseph, save us," Mary Lou whispered.

"Get in, Barbara," Tony ordered.

"No, I'm scared. I want Mary Lou with me."

"We'll never fit."

"Turn sideways." The girls hesitated. "Please!"

"Promise you'll let us out as soon as they've gone."

"They're coming closer," Roger said. "I'm getting in one too. I'm too drunk." He pulled open a drawer, squeezed in, and then Tony shut it.

"Leave him room to breathe!" Mary Lou ordered. "Come on, Barb, we don't want to lose our jobs. Feet first, then it won't be so bad." Barbara got in, then Mary Lou. "Remember Tony, we don't want to smother." Barbara started crying softly. "I'm here, I'm here," Mary Lou patted her. "It's just for a few minutes. Be quiet."

They waited and waited. They heard Roger, in a stage whisper, ask. "What's going on?"

"Shut up!"

Tony walked back toward the main corridor. Mary Lou heard

some conversation. Then one M.P. said in a loud voice, "Well, soldier, get back to your quarters. We could cite you for this."

"Sorry, I just got turned around." Some footsteps sounded for a few moments—then silence. The only noise was their breathing in the drawer.

That's the first dead body I've ever seen, Mary Lou realized. He's right next to us. Oh, Tony, please come back soon.

Soon turned into not-so-soon. Barbara started to shake. "He'll be back. He'll be back," Mary Lou tried to comfort her. Oh God, it's cold in here. Should be warm with both of us in it. Oh, no! They keep dead people cold, that's why. If he's not back in a few minutes we're going to get ourselves out. If we can! If we can? I'm not going to suffocate, job or no job!

"I'm going to try and open the drawer, Barbara." She put her fingers up through the opening but couldn't get enough leverage. "We mustn't shake the drawer. It might close all the way."

Roger was calling. "Help, Mary Lou. I'm stuck. I'm stuck. Where's Tony?"

"Maybe the M.P.'s took him," Barbara said.

"It didn't sound like it. Carefully let's put both of our hands up to the opening. Place your fingers on the wall, then push together." They did. Suddenly it sprang open. They stumbled out. "Thank God!" Barbara sat on the floor. Mary Lou went to Roger's drawer. She pulled it open and helped him out. Roger looked awful.

"It was a tight fit. I'm gonna be sick. Where's that S.O.B.?"

"Roger, there's no time. Let's just get out of here." They stumbled down the hall.

Roger was panting. "I almost died in there," he gasped.

If I get out of this I'll never break another rule, Mary Lou promised herself. As they turned the bend they saw Tony running toward them.

"There he is!" They met halfway. "Where were you? We could have died."

"The M.P.'s watched me all the way down the hall. Oh, I'm so sorry. I was coming back. Even if they caught me I would have told them you were in there. Hurry! The jeep isn't too far from here."

Barbara was in a state of shock.

"I can't run any faster," Roger said. Tony helped him.

"One more corridor. Almost there. You did great, girls."

They went faster and then out a side door to the parking lot.

"Over here, girls. Roger, I'll take them home. You don't look too good."

"No, I'm going too." Roger could barely talk. They all hugged each other. "This is our secret," Tony said. "No one can know."

"Who would believe it?"

They got in the jeep. Silence on the trip. Barbara home— then Mary Lou.

In the dark in her room she could see the dead boy in the drawer.

CHAPTER 12

6 JUNE 1944
56,000 Allied soldiers land in France.

SERGEANT PERCY was organizing the Military Personnel Department for the next batch of patients. "Did you girls hear about the excitement we had last night?"

"No, what?"

Oh my God, did they find out about the morgue? Mary Lou thought.

"One of the P.O.W.s escaped."

"Oh no!" I bet it was him, she thought.

"You don't have to worry, girls. They're pretty sure he's gone into Richmond or out to the woods by now. Of course, there's a chance he's still hiding in the hospital somewhere."

"Why would he want to escape now? The war's almost over. He can go home soon." Barbara asked.

"Maybe he doesn't want to go home, after all," Mary Lou said, half-joking.

"Hey, that's a good point. Things will be awful back in Germany. We've nearly destroyed it."

Oh God, I just know it's him. If he's still on the base, I bet I know where he's hiding, she thought.

"We've got a new shipment coming in an hour. Let's clear the decks. Get any supplies you need. We'll be here 'til twelve or one o'clock tonight."

What should I do? If I go there and find him I'll have to tell and they'll ask how I knew where he was. And suppose he tells them we've met before? Who said rules are made to be broken?

Ruth Bagdasarian, the file clerk, was making her rounds, getting orders for the PX, a job she volunteered for many times a day. "Coffee, sweet rolls, sundaes?" she called. She was a tiny girl who wore spike heels, dresses too long, and waist-length black hair. After a childhood under the thumb of a European father she reveled in her newfound freedom. She liked to be on the move and kept everyone supplied with their office necessities.

"I heard a new song for the WACS." She posed by Sergeant Percy's desk and started singing. " 'If you're nervous in the service and you don't know what to do, have a baby, have a baby.' How do you like it?" They all laughed. Sometimes she got on their nerves, but she was a clown and very appealing.

"Ruth, do you have many 301's for us? We'll need them for the new patients." Mary Lou knew she never kept enough on hand.

"Sorry, Mary Lou. I'll get some after I come back from the PX."

"Don't bother. I have to get something signed in Accounting, Sergeant Percy. I'll get the 301's while I'm out. Be back in a little while."

Where am I going? What am I doing? Mary Lou felt a compulsion to go to the hall where she had met Eric. I hope I'm wrong. I hope it wasn't him.

She walked down the corridors to the supply closet—looked both ways, then quickly went in. She saw no one. She felt relieved.

"I knew you'd come."

Startled, she heard his voice before she saw him. As he came toward her and her eyes adjusted to the dark she saw this was a different Eric than before. Hard, desperate, mean. His once-perfect uniform was rumpled. He grabbed her by the arm and pulled her toward him."

"Did they tell you I'd escaped?"

"They said 'someone.' I thought it was you."

"I've been waiting for you. I knew you'd come. Did you come to help me or kiss me goodbye?"

"Neither. I want you to give yourself up. You'll be killed."

He grabbed her by the back of the neck with his other arm and forced her face to his. This was no schoolboy kiss.

"I don't want this." She tried to get out of his arms. She couldn't move.

"Then why did you come?"

"They'll shoot you."

"So you do care. Give me some love before I go."

"Why did you do it?"

"An impulse. One impulsive moment. One stupid impulsive moment. I thought I could get into town, but this is as far as I got. You've got to help me. If you could get me a U.S. uniform or civilian clothes."

"No!"

"Why not?"

"Because it's wrong."

"Then some comfort." He backed her to the wall and pulled her skirt up.

"This isn't what I wanted."

"Don't lie. Why would you risk coming here?"

"I did like you, I admit."

"I thought so. Then help me."

"No."

"Stupid little girl."

"Let me go!"

"Not yet. Tell them and I'll say we've met many times. Keep quiet and I'll let you go soon." He reached inside her pants and pulled them down.

I never wanted this. This is my punishment, she thought. It was bad to come here.

His skin was hot. Thrusting pain—spine to wall—ugly stale breath—words she'd never heard. Please over soon. Do I tell this in confession? Please over soon. More pain—then he let her go. He pushed her away. She slid to the floor.

"Stupid virgin. Shame you couldn't enjoy." He went to the corner—stayed a moment—returned with a towel.

"Here, use this!" She did, then numbly rearranged her clothes.

"Go now. Quiet, remember we have a pact. My silence for yours." She slowly got up and went to the door.

"You look German, you know." He almost smiled.

"I hope they shoot you."

"They probably will."

She opened the door—looked—then went down the hall toward the nearest bathroom. Her legs felt like sand. She leaned on the basin—looked in the mirror. I'm not pretty anymore. Splashed water on her face, took a towel and soap into the cubicle and washed. Some blood.

She came out and sat in the corner on the floor. This place is full of violence and horror. How could I have skipped through the halls? I was a fool. I thought I was in a movie, I guess. Even that strange smell seems right now. I hope they kill him. Then she started to sob, but stopped herself. I have to be brave. No one must know. He was right. I am a stupid little girl.

* * *

After working all evening Mary Lou was dropped off at home around midnight. I feel numb. I can't remember what I did to-night. I guess I did the work all right. I wonder if people could tell by looking at me. No one said anything

She got into bed without turning on the light. I should take a bath, but they might wake up. I'll do it in the morning.

She kept waking up all night. What's going to happen? Should I tell? If I do he'll say I helped him. I don't want Daddy to know. I'm not Daddy's little girl any longer. Oh God, I liked things the way they were. Maybe I should say an Act of Contrition. Oh my God, I'm heartily sorry for having offended thee. And I detest all my sins…she stopped. But I don't really think I sinned.

Light came with the dawn. My pretty blue room with roses. It's a child's room—a virgin's room. I don't belong here. I'll tell Moth-er. She'll know what to do.

The alarm went off at 6:20. I'm not going today. When Mr. Roberts comes I'll tell him. She drifted back to sleep.

Horn honking. She jumped out of bed and ran to the front door.

"I'm not going today," she called out. "I'm sick."

"Sorry, hope you're feeling better," Mr. Roberts called back.

"Thanks, I'll see you tomorrow." She ran through the cold house and got back into bed.

I still don't feel like myself. Maybe I never will. Maybe sleep will help.

At eight her mother looked into the room. "Are you all right, Mary Lou?"

"Yes, Mother. I just needed a day off. Will you call the hospi-tal for me?"

"Sure, but do you have a fever?"

"I don't think so." All I have is a different me.

"Go back to sleep. You've been burning the candle at both ends."

At ten she woke up. I'll take a bath and wash him off of me. She stayed in the tub a long time. My body still looks the same. I wonder if my husband will know. Maybe if I sleep all day when I wake up I'll feel like me again. She got back into bed. I'll try and pretend nothing happened.

Elizabeth came in the room again. "I've got your favorite breakfast—orange juice, oatmeal, and toast."

"Oh, Mother, I never eat breakfast anymore."

"I know. You're never here."

"I'm going to fast all day." Maybe I'll be pure again like in Lent.

"Now, Mary Lou, you know that's no good for you. Come out in five minutes."

"Oh, okay," I do want to tell her. She put on her bathrobe and went downstairs and sat at the breakfast table.

Elizabeth sat down to have coffee. "Do you remember when you were five and we came down from Philadelphia. One day I was drinking tea and you came in and said, 'Make me cup, Mommie. I'll keep you company so you don't miss Aunt Peg and Aunt Mae.' After that we had tea every afternoon."

"Mother, there's a reason I didn't go to work today. Something happened to me yesterday."

"Something bad? Did you lose your job?"

"No, that's going really well. I can even go to the wards a lot now."

"What is it?" Elizabeth put her cup down.

There was a long pause. "I may have a baby."

"Oh my God!"

"Now don't get upset. I'm not sure. That's why I want to ask you some things."

"Whose baby could it be? One of the boys who drives you home? I thought they were just friends."

"They are." Another long pause. "It would be a German baby."

"Oh, Jesus, Mary, and Joseph." Elizabeth sounded panicky.

"I mean, I was raped by a P.O.W."

"Mary Lou, how could this happen?" she half-cried.

"He had escaped and was hiding in a supply closet. I thought he might be there. I went. I shouldn't have."

"Oh God, your father will die."

"I know. I don't want to tell him. I don't want to tell anyone. I shouldn't have gone looking for him. I'd talked to him before. It was a stupid thing to do."

"I'll call Dr. Boyle."

"Oh, no. He'll tell the army people."

Elizabeth got up and came over to Mary Lou. She was shaken. "Now, Mary Lou, don't you worry. Somehow we'll work this out. We'll say extra rosaries and start a novena."

"Not a nine-month one, Mother."

"Mary Lou, how can you joke?"

"I'm sorry, but I suddenly could picture you going to mass and communion every first Friday and me going too. Oh, God, what a disgrace it would be. If I tell what happened every time people look at me that's all they'll think of. I know I would. And if I'm not pregnant there's no reason to tell. He's already in big trouble as it is. God, I hope my life isn't ruined. I'll never get in a good college after this. Sister Antoinette will say she was right about me all the time. I'll never get a chance to do anything if I have a baby. Do you have a baby very often when this happens?"

"No, Mary Lou, only if God wants there to be one."

"Let's hope he doesn't. Because I sure don't."

"Now be serious. Do you feel all right?"

"I'm okay. I just feel weird. Like when you get a new record and it gets a scratch right away. I'll never be the same again."

"That's not true, Mary Lou. Your soul is just as beautiful as it

always was and that's all that counts. Now go back to bed. I'm go-
ing to call Aunt Nan. She'll know what to do." Nan was the
worldliest of the four McClain sisters.

Mary Lou slept. A few hours later Elizabeth looked in on her
and said softly. "When did you have your period, Mary Lou?"

"Last week."

She came in and sat on the bed. "Then you won't get preg-
nant."

"Are you sure?"

"Pretty sure. It's what the Church calls the rhythm system."

"Oh, thanks, Mother." They hugged. "You won't tell Daddy
or anyone, promise?"

"No. You're still my little girl and no matter what happens I'll
take care of you. I shouldn't have let you go to that place so
young, but I knew you wanted the money for college. You know it
might be good to try and get your mind off of this for a while.
Shall I have Nell and Claire over to play some bridge?"

"Sure, why not."

"I'll make a fire and some chocolate chip cookies."

And will you kiss it and make it all go away? Mary Lou want-
ed to ask.

"Mary Lou, I missed you." Barbara, her morning-glory self, came
rushing over to greet Mary Lou at the entrance to Military
Personnel.

"I was only gone one day," Mary Lou laughed.

"I know, but it's no fun when you're not here. What hap-
pened?"

"I think I was just tired so I rested. My Mother made fresh-
squeezed orange juice. I had breakfast in bed, then later I played
bridge with her friends." After I broke her heart, she thought.

Sergeant Percy arrived carrying a bundle of forms. "Mary Lou,
I'd like to see you please."

Oh God, do they know about Eric? She went and sat by his desk.

"I have some interesting news for you."

Oh no, she thought.

"The V.A. is taking over the hospital."

It's not about him. She breathed a sigh of relief.

"And you civilian workers will have the option of staying on or going to work at another army installation. Here are the forms to be filled out. Please pass them around."

"I'd like to go on working for the army."

"Well, there's a rumor that a new headquarters will originate in Richmond so maybe you can go there."

"What will happen here?"

"The Veterans Administration will staff it and they'll bring in patients from all the previous wars too."

"Oh, that sounds sad. We all get to leave and they don't."

"I know."

"Where will you go?"

"I may be sent to Valley Forge General Hospital in Pennsylvania, close to my family. Then when the war is over I'll be home free."

"That's wonderful." He looks younger, she thought. She started to get up, then hesitated. "By the way, Sergeant, did they ever capture that P.O.W.?"

"Didn't you hear? They shot him. He'd been hiding in the trunk of a car belonging to a civilian worker. I guess he was hoping to get off the base. The worker heard a noise and opened it and when the P.O.W. tried to run away an M.P. shot him in the back. He died soon after. Funny, if he'd lived he'd been a paraplegic and that's what we specialize in. Mary Lou! Are you all right? You're white as a ghost."

"Am I? I do feel a little funny. I don't know why." She sat down. He won't need those shiny black boots now! she thought.

"You look like you might faint. Put your head down." She did.

"What's wrong?" Barbara asked as she rushed back to Mary Lou.

"Oh, nothing," Mary Lou answered.

"Maybe you should have stayed out another day."

I hope they don't guess. She stood up to go. "I'm fine. We have these forms to fill out. I'll pass them around now."

"I think you should go to the rest room and lie down for a while," Sergeant Percy said.

"I don't know what came over me. I'm the rock of Gibraltar." They're looking at me like they know. "Maybe I will go and rest for a little while. I'll be back soon." She went down the hall and into the rest room.

I'm glad he's dead. I wished him dead. Is that a sin? I'm so relieved. No one will ever know. She sat on the cot. Thank you, God. I'll just pretend it never happened.

She lay down and closed her eyes.

"Stupid little girl!" It was Eric's voice.

Her blood ran cold. She sat up, slowly looked around. No one! But his smell was there.

CHAPTER 13

21 JULY 1944
55,000 Marines and G.I.s
land on Guam.

"BARBARA, I've been invited to visit Rose Hall."

"Who's she?"

"Not a she—it's a school. It's a really good one, too. I sent in an application and they want to interview me to see if they'll accept me for next year. I think I'll have enough money saved by then."

"Oh, I'll really miss you."

"I'll miss you too, but I've got to get some more education." The girls were on their way back to work from lunch in the mess hall.

"I'm supposed to spend the weekend in the dormitory and go to some teas and stuff. I'm going to Thalhimer's after work to get a new sweater and skirt and maybe a dressy dress. Of course, I don't want to spend too much. I'll need every penny I have for school."

"Oh look, there's Tony and Roger. Let's say hi." They were going by an intersection of hallways outside of the PX where patients sometimes had impromptu get-togethers. Pay phones lined one side where the army let every man call home once for free. Some patients were leaning on the walls—a couple of wheelchair patients in their pajamas were parked around the doors. Others were dancing to music from the jukebox with civilian workers.

"Hi, girls!" Tony said. "Hang around a while."

"We have to be back in twenty minutes," Mary Lou said.

"You have time for a couple of dances." He led Barbara to the dance area and they jitterbugged to "Juke Box Saturday Night."

"Wanta dance?" Roger asked Mary Lou.

"Sure."

Roger was soon out of breath. "I can't last very long, Mary Lou. Sorry."

"Roger, I'm really worried about your health. Are you okay?" They went to the side and he leaned on the wall.

"I think I'll get my medical discharge soon." He panted noticeably.

"Let's just watch Tony and Barbara." Mary Lou started clapping to the music.

Just then a patient came up to them. "Hello, Miss Cottrell." It was one of the patients Mary Lou had given the extra partial payment.

"Hi, Sergeant."

"Could you do me the honor?" He extended his good arm to her. The other one was gone.

"Oh, sure."

"My balance isn't too good, but I think I can manage a few minutes." He gripped her firmly around the waist. He took a few steps.

"Just put your right arm on my shoulder. Don't be nervous."

"I'm not," she lied. Gee, he's younger than I thought. Now that I see him up close he looks about twenty-two. I thought he was a much older man.

"Bet you never danced with a guy in pajamas before."

"Only my little brother."

He laughed. "You're a good sport, Miss Cottrell. Some of the guys think you're stuck-up, but I knew you weren't. We'll just go half time. I don't want to fall on my face."

I hope I'm acting normal. It's really not too bad, she thought.

"This is the first time I've danced in two years. I've been stuck in combat since Sicily."

"A lot of our patients are from that area."

"Wow, you sure smell good!" She drew back. "Don't worry, I won't get fresh."

"I'm not worried about that, but I do have to get back to work soon."

In a few minutes he led her back to the side. "This was great, Miss Cottrell. Will you do this again sometime?"

"Sure. We come by here every day after lunch in the mess hall."

He joined his buddies who patted him on the back. Mary Lou went over to Barbara and Tony who were slow dancing to "Embraceable You." "We have to get back, Barb."

"Just a few more minutes," Barbara said.

Someone tapped Mary Lou on the shoulder. She turned around and saw that it was a tall black boy.

"Would you dance with me, Miss Cottrell? I'm Private Marshall, remember?"

She hesitated for a moment. "Oh sure, but I have to get back to work in a few minutes." She recalled seeing him in Military Personnel.

"I hope I don't get lynched for this, but in Detroit we mix it up more than you do down here." They started dancing to "Senti-

mental Journey." "It just looked like such fun I couldn't resist. I hope you're not embarrassed."

"Of course not." I've never been this close to a colored man before. He's nice. I think people are looking at us but I couldn't hurt his feelings.

"You're really a good dancer, Miss, almost like one of us," he teased.

"Well, I've had a lot of practice. My daddy taught me to dance from the time I could walk." They danced a few more minutes.

Barbara and Tony came up to them. "Mary Lou," Barbara said firmly, "you have to stop now! We'll be late."

Tony was glaring at the patient.

"These are my friends, Private. Barbara Busser and Tony La Bianco. This is Private Marshall."

"How do you do?"

"How do you do." He bowed slightly. "That was a pleasure, Miss Cottrell." Then he turned and walked down the hall.

"How could you, Mary Lou?"

"What?" She pretended she didn't know what Barbara meant.

"Dance with that nigro."

"Barbara, if we're to stay friends you'll never mention this again."

"But..."

"I mean it."

"Tony said some of the southern boys were ready to start a fight and if he weren't a Congressional Medal of Honor winner they would have, but I guess you knew about that."

"He is? No, I didn't. And that's not why I danced with him. And if you have to ask why you'll never understand."

Barbara looked really hurt. They walked along in silence. "You know, Barbara, we moved down here from Philadelphia when I was five. My father hadn't worked in two years and he got

a job in a dental supply business for twenty-five dollars a week. We lived in the upstairs apartment of a big old white wooden house. Mrs. Davis, the owner, was a widowed music teacher who had been rich at one time. She knew the governor and lots of other important people. She and her sister, Miss Clary, and her daughter, Ella, still talked about the Civil War a lot. We didn't have any money to spare so my mother used to give Mrs. Davis a rug or a dress or something that had been sent from the North to pay for my music lessons.

"Anyway, one day when we'd been there a short time a colored man was going by collecting rags. My mother heard him calling from the street. 'Run downstairs, Mary Lou, and stop that man so I can give him some rags.'

"I ran down and out to the porch and yelled, 'Mister! Mister!' From inside the house Mrs. Davis heard me. She came running out to the porch and grabbed me by the arm and dragged me into the house.

"'We never call colored men Mister. Never, never, never! Don't you know that?'

"She let me go and I ran upstairs. 'Mommie! Mommie! Guess what Mrs. Davis said. We never call colored men Mister. Did you know that?'

"My mother took me by the arms, sat me down and looked me in the eyes. I'd never seen her mad before. 'We always call colored men Mister. We're different from people down here and we're never going to change.' So you can see, Barbara, I'm just different from y'all."

Soon they reached their office.

At four-thirty, when Mary Lou returned from the ladies' room, Sergeant Percy said, "Some patient dropped this letter off for you."

She opened it.

Dear Miss Cottrell,

Just a note to tell you how much I enjoyed our dance to-
day. I don't know how I got up the nerve to ask you. But
don't worry, I won't ask you again. I wouldn't want to be a
problem for you. I just wanted to say thanks to you for be-
ing such a lady.

 Sincerely, your friend,

 Thomas J. Marshall

P.S. I would also like to invite you to a ceremony tomor-
row. I'm to be honored with a medal. It will be held on
the front lawn at 4:00 P.M.

CHAPTER 14

8 AUGUST 1944
*Organized resistance by the Japanese on Guam
ceases. American losses were 1,400.*

EIGHT O'CLOCK in the morning—the workday was starting in Military Personnel.

"Why did you come to work today at all?" Barbara asked.

"Sergeant Percy wanted me to organize the payroll. But I do hope I don't get my new outfit smudged up. Do you like my skirt and sweater?" Mary Lou got up from her desk and turned around for Barbara's approval.

"I love the color of that sweater. What's it called?"

"Lavender. My mother says old maids love all shades of purple, but I sure don't feel like an old maid. I'll never be one."

"What's it made of?"

"Cashmere, from Pringle of England. I spent two weeks' pay on clothes for the trip. I looked all over town for these shoes. Criminey, I'm so excited. Am I talking funny?"

"Maybe a bit faster than usual. What time do you leave?"

"My train goes at 2:00."

"Where is the school?"

"Near a town called Farmville. Oh, I hope they like me."

"What else did you pack?"

"There's a dance and for that I have a black taffeta pinafore type outfit with a white blouse. I don't want to look too sophisticated. After all, I've been out of high school for two and a half years."

"Gosh, Mary Lou, you're only nineteen."

"I know but they're going to really look me over. That's what this weekend is all about. It's even bad to bring too many clothes. Jean Marie said last time one girl took a different outfit for every occasion and everybody thought it was too poor-white. The most popular girls at the school are ones from the Tidewater area whose families are First Families of Virginia and have hundreds of acres of land but aren't extremely rich."

"Gosh, that's a lot to think about."

"I know, that's why I'm so nervous. It's not good to be too rich or too poor—too pretty or too plain—too young or too old."

"Boy, I'm glad I'm not going to college."

"Oh gosh, I'd better finish my work." Mary Lou sat at her desk again.

"Good luck, Mary Lou."

"Thanks, I'll need it."

Four hours later, work finished, she got her camel-hair coat and new suitcase from the supply closet.

"I love your new luggage," Barbara whispered.

"I didn't want anything too new looking, but the only other bag we had was my Daddy's old dental supplies bag. I think my coat looks just right though—not too new and not too old."

Barbara got up and hugged her. "Oh, Mary Lou, I'm going to miss you when you go back to school."

"Well, I haven't been accepted yet. But I'm encouraged that

they've invited me for the weekend. They don't ask everybody. See you on Tuesday." Mary Lou waved goodbye from the corridor. "Bye, Sergeant Percy."

"Good luck, Mary Lou."

The train arrived at the brown wooden station in Farmville two hours later. Mary Lou got off and looked around. Wow! There's not much to see. This really is a small town, unless it's mostly out of sight.

She went over to the only taxi parked by the building. "I'd like to go to Rose Hall," she said to the driver.

"You could walk from here," he said without looking directly at her.

"How far is it?"

"'Bout a mile."

"Oh, no, I'd like to ride, please."

"Well, get in. Glad to take your money."

They rode through the main part of town, which was about six blocks long. One movie house. One drug store. One five-and-ten. One hardware store and two cafes, one for good people and one for the bad. Then she saw it. Rose Hall! Like a dream. A graceful old wooden structure, Civil War style—acres and acres of lovely green campus. She paid the driver fifty cents plus a five-cent tip. McClains are never cheap, she could hear her mother say.

She walked up the long path, and then entered through one side of the huge double doors.

Oh, this is lovely. She looked up at the three-story high ceiling. Balconies on each floor circled around and staircases were on both sides of the rotunda. This is just like something from *Gone With the Wind*. She stood still, not knowing where to go.

A young girl ran over to her. She had short blonde hair and a round face. "Hi, I'm Cindy. Are you one of the hopefuls?"

"I don't know."

"Well, did you come here to be looked over?"

"Yes, I guess so."

"Well, if looks mean anything you'll make it. Come on, I'll take you to the office." She picked up the suitcase and started toward a small office under the staircase. "I'm on duty to help with the weekend visitors. My punishment for skipping chapel. One word of advice! Don't seem desperate. Act nonchalant."

"I'll try."

When they got to the office the door was open. Cindy knocked on the door frame. "Pardon me, Miss Daffron, one of our visitors is here."

Miss Daffron looked up. She was all rust colored—hair, sweater, and skirt. Her skin was blue-white. She had a hard time smiling. "Please come in, Miss?"

"Mary Lou Cottrell."

"Welcome to Rose Hall. You can go back to the rotunda now, Cindy. Thank you. I'll call when we're finished and you can show Miss Cottrell to her room. Please sit down, Mary Lou."

Mary Lou put her suitcase by the chair and tried to look nonchalant, as Cindy had advised.

"I'll just get your file."

She's really skinny, Mary Lou thought. You can tell she hasn't been eating in a mess hall. I hope she doesn't think I'm fat.

Miss Daffron returned, reading. "I see you've been out of school for two and a half years. But you finished at seventeen so you aren't too old to be starting college. We wouldn't want a really older girl to start as a freshman—too sophisticated."

"No, ma'am."

"I see your grades are less than sterling, but you do have a Catholic University certificate, so that's a good sign. Also, I see you are a Catholic. Well, we do have three or four other Catholics here. We like to have a cosmopolitan mix."

"That's nice, ma'am." Why do I keep saying that?

"As for your working in an army hospital, we'll have to have a separate conversation about that. Now, I'm second-in-command here but I am the rules enforcer. Some of the girls call me Deputy Daffron, behind my back." She almost smiled at this. "But I take it in good humor. Here's the schedule for the weekend. Of course, it's summer and we're only a quarter full so you'll have a room to yourself."

I guess that's so I won't try to convert anybody to Catholicism! she thought.

She stood up and shook hands with Mary Lou. "Good luck, we'll have an in-depth interview later in the weekend."

"Yes, ma'am." There I go again. I don't sound very clever.

Miss Daffron rang a bell on her desk. Cindy appeared. "Please show Mary Lou to room three thirty-three in the main building."

They walked across the huge entry and up the stairs. "You're lucky you missed dinner tonight. We had half-cooked liver and spinach laced with saltpeter."

"What's that?"

"That's stuff to keep our sex drives down and it tastes funny. I think they always put more in on Fridays so we'll not get hot on the weekend."

"I never heard of that. It sounds horrible!"

"Well, with Hampden Sydney only three miles away containing a thousand sailors in officer's training they have to do something to keep us little magnolia blossoms under control. Well, here we are, room three thirty-three. Hope you don't get hungry before morning. There's no food available, unless you brought something from home." She looked hopeful.

"No, I never thought of that."

"Well, it's probably better you didn't. We have huge rats here."

"What!"

"Oh, don't worry. If you don't have food in your room they won't bother you."

"Oh gad!"

"But one girl woke up one night and felt something in her hair. She reached up and it was a huge rat."

"Oh my God!"

"Her parents came and got her two days later. I heard she had a total breakdown."

"Can't they do anything about them?"

"They try but the building's about a hundred years old and they can never be totally eradicated. Well, see you tomorrow. Sweet dreams!" Her cherubic face had an evil grin. "The bell rings at seven-thirty. Breakfast's at eight."

Mary Lou closed the door. She stood still for a few seconds afraid to move. Then slowly she went to the bed and carefully sat down.

How can I last a whole weekend? If I see a rat I'll die. But I can't sit here all night. She tiptoed to the closet—hung up her clothes—put on her new nightgown and bathrobe. This room sure isn't plush. I guess I was expecting more than two beds, two desks and a bureau. She peered out of the door. Girls dressed up for dates went giggling down the hall. "Where's the ladies' room?" Mary Lou asked.

"Oh, the loo's that way, to the left," a girl answered.

Oh, I'd better call it the "loo." This must be date night. The brochure said they could go out to the movies if they were back by eleven.

She showered, brushed her teeth, then went back to her room and got in bed. She lay terrified for hours listening for rats and saying "Hail Mary's" before going to sleep.

The morning bell rang at seven-thirty. Thank God it's morning and no rats so far. She dressed and went out to the hall. Girls were rushing along with pajama pants rolled up under their raincoats.

"Where's the dining room?"

"First floor to the right. Just follow the crowd," a tall brunette answered.

The dining room had round tables for ten covered in white tablecloths. There were sounds of china and silver clinking. Two tables in the corner were reserved for the girls being "looked over."

Mary Lou found an empty seat. "Hi! I'm Mary Lou Cottrell from Richmond."

"Hi! My name is Jane Marie. I'm from Lynchburg."

"Hi! I'm Phyllis Thatcher from Baltimore."

"I'm Georgianna Ann from Savannah."

"What do y'all think of this place?"

"Well, I was a little shocked at my room, but I could see possibilities and I hear that upper-class women have little sitting-rooms and are in that new building across the road," Phyllis said.

"Maybe they don't have rats there," Mary Lou said.

"What?" Jane Marie almost screamed.

"Did you see one?"

"No, but Cindy told me that they have them."

"Who's Cindy?"

"The girl who shows you to your room."

"Oh. A tom-boy type named Jackie helped me."

"If that's true my Momma will never let me come here."

"Who'd want to if they have rats."

"But it's one of the best southern girls' schools."

After they had eaten their breakfast of hot cereal with cream, biscuits with honey, and milk and coffee, Miss Daffron appeared. "Now girls, we're going to tour the grounds. Then later we'll have a seminar and discuss what Rose Hall can do for you and, just as important, what you can do for Rose Hall."

This looks like a room in an old English manor house, Mary Lou decided. The hopefuls were gathered in an upstairs sitting room

after having toured the grounds. Tiny English-style sandwiches with the crusts cut off were passed around while Miss Daffron poured tea from a silver teapot.

"Well, young ladies, what did you think of our 'acreage,' as we like to call it?"

"I thought it was beautiful," Mary Lou said. "What kind of giant bushes were those?"

"Those giant bushes as you call them are English boxwood. Some are thirty feet high and they were imported over one hundred years ago. They're our pride and joy."

"I see." Oh gosh, I don't think I'm acting nonchalant enough. She tried to put on a bored face.

"Jane Marie, what do you think of Rose Hall?"

"I just love it! Of course, I've heard of it all my life. My mother and aunts and all of my cousins went here," she gushed. Jane Marie was a robust southern flower whose cheeks grew bright pink as she talked.

"And what will you contribute to us?" Miss Daffron asked.

"Well, I'll carry on the important traditions like a southern lady should," she replied.

Mary Lou thought this all sounded rehearsed.

"And Phyllis Thatcher from Baltimore?"

Phyllis raised her hand.

"Oh, there you are."

Phyllis, a tall girl with very short hair was wearing a no-nonsense navy blue jumper.

"If you like Rose Hall and Rose Hall likes you what do you want from us?"

Phyllis seemed a little baffled by this question. "Well, I'd like to get a B.A."

The other girls started to giggle.

"And I'd like to play some basketball." They giggled some more. She looked around the room puzzled. "And maybe some

volleyball. Other than that I really don't know." She sat down.

"All right girls, not all of us have thought much about this before. And Mary Lou," she pointed to her. "Mary Lou is our woman of the world. She's been working for two years. Why do you want to come to Rose Hall?"

"Well, I want to be educated and read all the great books and be a better person."

"And what can you do for Rose Hall?"

Mary Lou paused for a moment. What a stupid question, she thought. "To tell you the truth, I really don't know. But I guess I'll find out once I'm here. I just know that the war's almost over now and the army hospital where I work will be changed to a Veteran's Administration hospital and some of the men will never leave and that's too depressing. So I want to get on with my life and make something of myself." There was a long silence. Oh God, I said all the wrong things. I feel like a fool.

Miss Daffron looked slightly disapproving. "Of course, we don't want to discuss anything too depressing, Mary Lou, but I will say we've done our part in the war effort here at Rose Hall." She turned to another girl. "What do you have to say for yourself?"

Georgianna Ann seemed incongruous. She was extremely plain but had the fluttery manner of a southern belle. "I'd like to marry a good southern boy and run a beautiful house and I think four years in Rose Hall will help me do this." She smiled and blinked her eyes a few times then sat down.

You would think they taught housekeeping here, Mary Lou thought. "All right, now that we've found out a little about each other let's adjourn and you can get ready for our Saturday night soiree."

The girls prepared to leave the room.

"The guidelines for the dance are very simple. Basically, no behavior that your Daddies and Mummies couldn't observe. We stay in the ballroom at all times. No sneaking outside for ciggies

and such. And no alcohol, of course. And one more thing, no smoochie dancing as the girls say."

"What girls are they?" Mary Lou couldn't help whispering to Phyllis, the athlete. They tried to hold back their laughter.

Miss Daffron gave her a disapproving look. After she left, the girls went down the hallway to their rooms.

"Isn't she too much?" Jane Marie said.

"Daddies and Mummies," Georgianna Ann mimicked. They all said goodbye, then continued to their rooms.

The Dance

Oh, this is lovely. Mary Lou entered the ballroom and stood by the door. It was a round room with French doors leading out to the terrace, which overlooked the gardens. There were cut-glass punch bowls and antique china plates with brown-edge wafer cookies on them. Those two grown-ups must be chaperones. Oh, I wish we had on formals. That would make it perfect. Clusters of girls were standing around waiting for the invited Hampden Sydney sailors who were being brought over by bus.

Then they arrived. Groups of three and four, ready for fun, some looking awkward and self-conscious.

I think I'll stand over by the table. I don't see any of the girls in my group. The small band started playing "I'll be Seeing You." Hope I don't look unpopular standing here by myself.

"Would you like to dance?" A tall sailor with black hair and aquamarine eyes had left his group and stood before her. He bowed slightly in fun.

"Why, yes."

They danced. No words. I've never danced with anyone this good, except maybe Daddy, she thought.

The band played "Tuxedo Junction." They jitterbugged. When the music stopped they headed toward the punch bowl.

"You're a great dancer," he said.

"Well, so are you."

"Where are you from?"

"Richmond. Where are you from?"

"Brooklyn. Do you go to school here?"

"No, but I hope to. A group of us is being looked over to see if we're up to the standards of the place."

"That sounds like a bore."

"I guess it is, but I don't mind too much. The only problem is I've been working in an army hospital and I don't know if I fit in. Where did you go to school?"

"George Washington University. I was on a basketball scholarship. After the war I'm going to law school. My dad's a police lieutenant, but I don't want to go into police work."

"Does this punch taste funny to you?"

"Well, it's awfully sweet."

"Maybe it's the saltpeter they put on the food here."

He looked shocked. "Where did you hear that?"

"The girl who escorted me to my room. She also told me there are giant rats that run around at night. I hardly slept."

"What a weekend! What's your name, funny one?"

"Mary Lou Cottrell, and yours?"

"James Cantwell. Let's dance some more." The band was playing "Embraceable You."

"I'll be commissioned soon, then off to the Pacific. Wish I were going to be here in September, that is if you make the team."

"I do too." Can you fall in love in three dances? she thought.

"Can you fall in love in three dances?" he said.

She stopped and stared at him. "You got that out of my head."

"You mean you were thinking that?"

"I shouldn't admit it but it's such a coincidence."

"Let's sit out on the terrace and discuss this."

"Oh no, we're not allowed, Miss Daffron said, and anyway, if we talk about it it might disappear."

"You're superstitious!"

"Well, I'm Irish."

"Want some more punch?"

"Yes, I'm dying of thirst." They got their cups and sat on the gilt-colored chairs on the edge of the room.

She drank her punch quickly. Then she felt beads of perspiration coming out on her lips. "I don't feel too great," she said. Oh God, she thought, don't let me get sick when we're falling in love.

"You look awfully pale, Mary Lou. I think you need some air." He took her by the arm out onto the terrace.

"I'm afraid I may be sick," she said. "Please don't look."

She ran down the steps and went behind a bush. Oh God, save me. How humiliating! Mary Lou leaned over and was sick. Oh, St. Jude, Patron Saint of Lost Causes, get me through this. She was sick again. I hope it doesn't kill the bushes. I feel so weak. She finished, then stood wavering for a few seconds. Hope he didn't hear me. Mary Lou used her handkerchief, then superficially combed her hair. She felt damp all over and the cold night air made her shiver. Then she went back to the terrace.

"Oh James, I'm so embarrassed."

He was smoking a cigarette. "Think nothing of it. I think you've had a rough weekend."

"I'm afraid I don't feel like dancing anymore."

He laughed. "Of course not." They started back inside.

He opened the door. Deputy Daffron was standing there.

"Well, Miss Cottrell!"

"I can explain, Miss Daffron."

"You know the rules. No girls allowed outside on the terrace during dances."

"This is James Cantwell, Miss Daffron."

"She was feeling ill."

"No excuses, sailor. You'll only make it worse."

"I'm going back to my room," Mary Lou said.

"Yes, that's a good idea," Miss Daffron replied. "We'll talk in the morning."

"Goodbye, James—sorry."

"I am too, Mary Lou."

Where am I? Mary Lou thought as she awakened. *Oh, Rose Hall. My mouth is so dry. What time is it? Eight-thirty.* She took the schedule, which she'd propped up on the lamp, and sat up. *Chapel at nine, then brunch at eleven. Guess it's okay to go to Protestant Chapel. Wonder if I have to tell in confession. Have to rush.* She got out of bed—quickly put on her bathrobe—raced down the hall—found an empty shower. She saw herself as she brushed her teeth. *My face is a little thinner, at least. What a terrible night. My stomach's never been the same since that darn Southern Comfort. But I had no alcohol last night. Hope Miss Daffron understands.* She raced back to the room, put on her new skirt and sweater, and ran down the hall. Fortunately the chapel wasn't too far from the main building.

She saw some of the girls in her group and joined them in their row.

"Where were you last night?" Phyllis asked.

"I was only there a short time and got sick."

"Oh, Jane Ann heard a rumor that someone was in big trouble."

"That must be me. I had to go out on the terrace when I felt nauseated."

"Oh, Mary Lou, you poor girl."

The minister appeared. *I hope he doesn't preach too long. My stomach still isn't back to normal. He seems more like a regular person than our priests. Maybe because he can get married and doesn't wear vestments.*

Miss Daffron greeted them by the door as they left. Mary Lou tried not to catch her eye.

"We're having brunch in our lavender garden." They walked through a large flower garden to an opening where small tables with pink cloths had been set up.

Oh, this is just like I always dreamed it could be. She couldn't eat any of the breakfast of ham and eggs, baking powder biscuits, sweet rolls, and coffee. It's just as well. It looks pretty fattening.

When they had finished eating, Miss Daffron stood up. "And now I'd like to announce that all of you have been accepted to Rose Hall with one exception. But I'll discuss that in private with the person concerned."

Without knowing why, Mary Lou stood up. "Do you mean me, ma'am?"

"Well yes, as a matter of fact I do. But I'll talk to you privately."

"Why wasn't I accepted?" Oh, why am I doing this?

"We'll discuss this in my office."

"I'd like to know now."

"If you must know, because you broke the rules at the dance last night and lied about us having rodents here."

Why are my cheeks so hot? "But I was sick to my stomach and went out on the terrace to get air. And Cindy told me that there were rats here."

"That's no excuse. You shouldn't have repeated such a thing. And anyway, you just don't belong here. You're a troublemaker. I can see that."

"You're right. I don't belong here. I don't know where I belong, but it's not here. I wish I were like the other girls but I'm not. I've seen men with tubes coming out of their stomachs—rows and rows of stumps where arms and legs used to be."

A few girls gasped at this.

"I'm sorry it didn't work out. I guess my time passed by and I was somewhere else. I can't catch up and be a girl again. I'll never be a sweet southern lady now. Maybe I never could be."

She started to leave but stopped. "I'll go pack now. Don't wor-
ry about me. I almost feel relieved." She ran from the garden.

When she got to her room she saw a note stuck under her
door. "Some sailor asked me to leave this for you, your guide, Cin-
dy." She put it in her pocket.

After packing she went downstairs, stopped, and looked
around the rotunda. It is the perfect-looking school. She started
to feel like she might cry, so she hurried out the front door. I think
I'll just walk the mile to the depot. I don't feel like waiting for a
cab and I don't want to see anyone.

When she got to the depot it was three o'clock. The train to
Richmond was due at eight. She sat down and looked at her new
shoes. They're really scuffed, but maybe they can be fixed. Who
am I kidding? They're a mess—just like me. Well, easy come easy
go.

She read the note on the train. "Don't let this place get you
down. You deserve better. Please write. Love, James."

By the time she got home it was eleven and everyone was in
bed. "It's just me. I'm home a day early," she called to her family.
And a couple of years too late, she said to herself.

CHAPTER 15

15 DECEMBER 1944
*200,000 Germans launched a surprise
attack along the Ardennes front. 19,246
American lives lost.*

MARY LOU was waiting to be interviewed in Captain Brade's office. This is really nice. Not exactly pretty or anything, but so organized. All the books have covers on them. I bet it's neat inside the drawers too, with everything all lined up. Not like home. I wonder if the army does that to people. Even the picture of McGuire General is in a neat silver frame. From now on I'm going to be neat too.

Captain Brade finished on the phone. "Miss Cottrell, you have an exceptionally fine record, so I'm honoring your request to stay with the army when the Veterans Administration takes over the hospital in six months."

"Thank you, ma'am."

"You'll finish here in two weeks. Then you'll work at our new headquarters in downtown Richmond. We're starting fresh and I'm assembling a first-rate group to work there. How does that sound?"

"That sounds great!"

"You'll be working under Sergeant Stokey, who will be arriving from Guam any day. He spent the whole war in the South Pacific and has quite a distinguished record."

"Do you mind my asking, is Barbara Busser coming too?"

"I wasn't sure about her. Is she a good worker?"

"Oh yes, ma'am. She never gets tired."

"Well, all right, I'll see that she gets transferred too."

"Oh, thank you so much."

"You may go back to work now. And you may tell Barbara also."

"Oh, thanks again." Mary Lou got up and went out into the hallway.

She started the walk back to her office. "Hail Mary, full of grace.

I'll be happy-sad to leave this place.

Back to work.

Two weeks will fly.

I feel like skipping

But I'd better not try. (Hey, I'm rhyming.)"

She walked faster. "No more stumps—no more smell. No more boys who've been to hell.

Come on guys—come with me.

We'll be ten—we'll be free.

We'll be at recess.

We'll play our game,

We'll all be the original same."

God, I wonder if they give Section Eights to civilians. By then she'd reached her office.

Chapter 16

December 1944
The 101st Airborne Division still holds out
in Bastogne, the logistic center of the
Ardennes, which is completely surrounded
by the German armies.

"MARY LOU, I have to tell you a secret. I don't want to spoil things, but I think you should know. There's more to tonight than just dinner with Roger and Tony."

Mary Lou and Barbara had finished working and were walking down the corridor to the central section of the Hospital.

"What do you mean?"

"I can't tell you everything, but we'll be here most of the evening."

"I don't understand. I thought they were just treating us to a farewell dinner."

"Well, there's a little more to it than that."

"Something fun?"

"Well, I hope so."

"Gosh, it's Christmas Eve. I don't want to get home too late. Why are you turning left?"

"We're not meeting at the PX. We're meeting at the Non-Com club. Please act surprised."

"That won't be hard. I can't imagine what's going on."

"I promise it's nice."

"It is dinner, right?"

"Yes."

"Because I'm getting pretty hungry. I haven't eaten much for three days. I wanted to lose ten pounds for Christmas. I figured that would be the greatest present in the world."

The girls stood for a moment in the doorway of the Non-Commissioned Officer's Club—a large room with a makeshift bar at one end and a jukebox at the other.

Someone had tried to make it look festive by putting a sprig of mistletoe over the entrance and a sparsely decorated Christmas tree on a card table in the corner. Some soldiers and patients were sitting at the small tables scattered around the room. Roger and Tony waved to them from a larger table where they had started the party with girls from Military Personnel and one sad-looking WAC.

"I've been here before, but I'd forgotten how bleak it was," Mary Lou whispered to Barbara.

Six wheelchair patients called to them from the end of the table where they were talking among themselves.

As Mary Lou and Barbara entered, the group started singing, "For She's a Jolly Good Fellow." Tony and Roger got up and escorted them to the table.

"Sit down, girls, we're having a feast," Roger said. "Steaks, fries, and all the beer anyone wants. Of course, I'm not eating much. I figure the war will be over before I reach my discharge weight, so I'm dieting."

"How come you're giving a party for me?" Mary Lou asked.

"Because you're known as 'Princess of Partial Payments.'"

Sergeant Spangler, a patient she'd helped many times, called

from across the table. "We know you always come through for us and we want to show our appreciation."

"I didn't know I had such a reputation. I guess it's okay," she laughed and thought, I feel a little silly about this.

"Mary Lou, look who just came in." Barbara pointed to the door. Sergeant Salvio sauntered over to their table.

"Can't stay, girls, but I just wanted to wish you good luck down at the new headquarters. No hard feelings between us, huh?" He patted them on their backs. "Sorry you didn't work out in the show that time. I just needed a little more sophistication."

"No hard feelings," Mary Lou answered as she turned around to look at him. "Where will you go when the V.A. takes over?"

"Oh, I don't know. I might turn Regular Army or I might go to Hollywood and try my luck there."

Mary Lou and Barbara exchanged looks. "Doing what?" Mary Lou asked.

"Well, I am a professional musician after all."

"Oh, I forgot."

He leaned down and whispered to them. "By the way, I really appreciate you girls not telling anyone about my little stunt at the park. I could have been discharged for that. The army don't appreciate us creative types that much. They wouldn't have realized it was just a practical joke."

"Is that what it was?" Barbara asked.

"Yeah. But you gals knew, right?"

"I guess so, but we weren't positive."

"Well, thanks for giving me the benefit of the doubt. Gotta go now." He straightened up again. "If you ever see my records come through headquarters add some medals and put some good recommendations in it."

"What?" Barbara asked.

"That's a joke, girlies!" He straightened out his custom tailored jacket and strutted out.

"Wow, what a character." The girls giggled uncontrollably.

"What's so funny?" Roger called from his side of the table.

"Guess!" Mary Lou said.

"Oh, the sarge." Roger came over and leaned between them. "What did he do now?"

"Nothing, he's just funny. I don't know why," Mary Lou said. "He might go to Hollywood after the war."

"Why?"

"That's what we asked."

"Probably to molest pretty young girls."

"By the way, has Tony given you the note, Mary Lou?"

"What note?"

"Oh, he'll tell you about it! I'll send him over."

"What's this about, Barbara?"

"I really don't know, for sure."

"Your face is getting pink, Barbara."

"Well, let him show you."

Tony was standing by the jukebox. "What's this note Roger was talking about?"

"I'll tell you later. Let's dance!" They jitterbugged to "Chattanooga Choo Choo."

"I want to see the note."

"Later." He swung her away from him.

"Well, tell me what it's about," she said as they came together.

"Just something some patient wrote."

"What?" She stopped. "Somebody needs a partial payment?"

"No."

"Records changed or something? You know I won't do that."

"To tell you the truth he's here at the party."

"And he wrote a note to me?"

"Well, about you."

"I don't get it. Why didn't he give it to me himself?"

"You'll see."

"Tony, if it's about me I want it right now."

"No. I promised before you read it I'd do some explaining first."

"Well, at least point him out to me."

"Don't look now but he's the guy in the wheelchair at the end of the table. But don't look until you get back to your seat."

"Gad, this is so complicated." She went back to the table. After drinking some coke she glanced down at the patient.

He'd been a tall, thin boy—still thin. The useless part of him hidden by the table—orange red hair—a look of surprise on his face.

I wonder if that look came on him when he was hit? she thought. She glanced away before he could catch her staring at him.

"Barbara, Roger, do you two know what's up?"

"Yeah, but we can't tell you," Roger said.

"I have a feeling I'm going to get in trouble."

"Oh no, Tony's got it all arranged."

"Oh, that makes me worry even more. Roger, please tell Tony to come over here right now." Roger brought him back. They formed their chairs in a circle.

"Well, here's the story. In ward B3 all the patients were asked to write a letter with their Christmas wish in it and put it in a box. No miracles like injuries disappearing or anything like that. And everyone promised that whoever's note was pulled out would get their wish granted if humanly possible."

"What does this have to do with me?" Mary Lou asked. They all just looked at her.

"Oh no. What do you think I am?"

"Mary Lou, it's nothing bad," Barbara said.

"No. Read the note." Tony handed it to her.

She read. "My Christmas wish is that I go to a party one night someplace, even here at McGuire, and that Mary Lou Cottrell,

who works in Military Personnel and who is the most beautiful girl in the world, takes a liking to me. And when the party's over she wheels me back to the ward and back to my bed—and after I get in bed she closes the curtain and lies down beside me. We don't do anything unchristian, of course, even if I could I wouldn't. I wouldn't hurt a hair on her head. Then she waits until I go to sleep to leave. That's it. That's my wish. Yours truly, Private Christopher Bost."

There was a long pause then Mary Lou said, "And everyone knew about this but me?"

"Just the three of us, the guys in the ward and two orderlies."

"In other words, everyone. Is that the reason for this party?"

"Half and half."

"Well, thanks for being honest at least. Gad, if I got caught doing this I'd never get to work at the headquarters."

Tony told her the plan. "I've got it all figured out. My friend, who is the orderly there, is going to get the nurse on duty called away for a few minutes. You wheel Chris into the ward—pull the curtain, etcetera, stay about fifteen minutes. Then he'll call her away again and you'll slip out."

"Where will you three be?"

"Right around the corner in the orderlies' room."

"You know I could lose my job, but y'all could get a dishonorable discharge for this. Why are you doing it?"

"We thought it'd be a great trick and even if we're caught maybe we'll get a Section Eight and be out of the army," Tony said.

"Well, at least introduce me to him. Then I'll give my answer."

Tony led her down to the end of the table. "Chris, I'd like to introduce you to Mary Lou Cottrell."

"How do you do, ma'am." He extended his hand. "Sorry I can't stand up. My momma did teach me better."

"I'm sure she did."

Tony pulled out a chair next to the wheelchair. "Why don't you sit down, Mary Lou, so you two can get acquainted."

"Thanks, Tony."

She smiled. "Where are you from, Private?"

"Johnson City, Tennessee."

"How long have you been in the army?"

"I joined up at eighteen, the day I graduated from high school. Six months later I was on Anzio Beach. I'm nineteen now."

"So am I."

"I know. I've asked about you. I've been going by your office every time I can get a push down that way." There was an awkward silence, then, "Did Tony tell you about our contest?"

"Yes, he just did."

"Well, I feel real stupid about it now. I don't want you to take it serious, but I do appreciate you coming to sit with me. You remind me of Ramona, my high school sweetheart. We were going to be married when I got out of the army, but when she came to see me she got sick to her stomach and had to go right back to her hotel. She called me that night and said she was sorry, but she always got sick to her stomach around cripples and didn't know how we could ever be man and wife. So I let her off the hook. I told her to keep the engagement ring I'd sent her. And she did."

Mary Lou was speechless. He just sat looking at her with a very serious expression on his face.

Oh God, what can I say, she thought. He looks like a Raggedy Andy doll.

After a few minutes he said, "Don't feel sad, ma'am. I'd like to buy you a coke. Will you go to the bar and get us one?" He handed her a dollar.

When she went to the bar Tony came up to her. "Well?"

"You know I'm going to do it."

"Great! We'll go in about half an hour."

When she came back to the table she said, "I will push you back to your ward, Chris."

"I told you you don't have to. What I wrote about in that note I put in the box…that was just a crazy dream."

"I want to."

"I don't repulse you too much?"

"No, you don't. Not at all. Let's go down and sit with my friends." She pushed him to where the gang was sitting.

"Chris, this is my best friend, Barbara Busser. I guess you know Roger already."

"Yes, I met him with Tony."

"How about a little rum in our coke." Tony pulled a paper bag from under the table.

"Sure, why not."

"I guess one won't hurt."

"I was brought up on my daddy's moonshine so a little rum won't bother me," Chris said.

They drank their drinks and sang "Don't Sit Under the Apple Tree with Anyone Else but Me."

Tony looked at his watch. "It's ten o'clock, almost curfew time for you, Chris. We'd better start for your ward."

They left the club and started down the corridor. Mary Lou was pushing Chris. Barbara started singing "Silent Night." They all joined in softly. Then they sang "Jingle Bells."

"We're almost there. It's around the corner. We'll wait here for the orderly," Tony said.

"I don't want to get y'all in trouble," Chris said. "I've already had a great time. Let's just say good night here, Mary Lou."

"No, we're going through with the plan."

"Are you sure you want to?"

"Yes."

"Well heck, it will give all the guys on the ward a shot in the arm."

Just then the orderly came around the corner. "Hi, everybody! I'm Mike Mikowski and I'm your quarterback, so to speak." He looked like one too.

"These are my friends from Military Personnel," Tony said.

"Now, we've timed this down to the last split second. At ten-thirty my orderly friend on Ward C has arranged for one of his patients to create a disturbance. They'll call the nurse on Chris' ward for more morphine and she'll have to go there with it, because orderlies aren't allowed to carry it through the halls. You'll arrive with Chris, go to his bed, pull the curtain, and stay until eleven o'clock. Then right on the dot you'll leave, not one minute later. That's how long the patient will keep up his act." He let out a soft whistle. "When this is over it'll either be the stunt of the year or I'll be banned from any medical school for life. Everybody ready? Let's check our watches. Ten twenty-five."

At ten-thirty Mary Lou pushed the wheel chair around the corner and gave one last look to Barbara, Roger, and Tony. "Be sure and wait for me."

"We will." Tony gave her the "V for Victory" sign. "Are you scared, ma'am?" Chris asked.

"A little, are you?"

"Yeah, but I'm not sticking my neck out like you are." They arrived at the ward a few minutes later. They could see that the nurse's desk with a tiny Christmas tree on it was empty.

"Where's your bed, Chris?"

"Way in the back."

It was quite dark. That funny sweet smell again. She held her breath. They passed eight beds. They heard soft calls to them. "Good luck!" "I don't believe it." "Almost there!"

"Here's my bed." She pushed the wheelchair beside it. Chris lifted himself up. She pulled the curtain around it and stood for a moment looking at him.

"You've done enough, ma'am. This is great."

She looked at her watch. "Ten forty-five. I have until eleven." Without saying another word she lay down beside him, her head on his arm.

"Your hair smells sweet," he whispered.

"Thank you, Chris."

"I'll remember this night all my life."

She turned and looked at him. He leaned over and kissed her. That's the sweetest kiss I've ever had, she thought. He has angel breath. Mother said babies have that because they've been here from heaven such a short time. Now I know what she means.

"Try and sleep now, Chris."

"Okay, thanks again and don't worry. You're as safe as in the arms of Jesus." He closed his eyes. She heard a small sigh, then soft breathing.

I'll close my eyes for just a minute, she thought. When she opened them she knew too much time had passed. She looked at her watch—one o'clock. Oh my God, I've slept two hours. I've ruined every thing. My poor friends. My heart's pounding. Chris was sleeping soundly. She lay paralyzed wondering what to do. I can't get out of the ward. After a while she slipped off the bed and peeked through the curtain. She could see the back of the nurse on duty sitting at her desk. I'll be here all night. I'll lose my job. I'll lose my reputation. I'm trapped here. What can I do? She almost cried—then she heard a whisper.

"The window, the window!"

The patient in the next bed was pointing to the window on the back wall.

Oh God, I'm so scared, she thought, but I've got to try for it. It'll only get worse the later it gets. St. Jude, patron saint of lost causes, please help me. That's the phone ringing! She looked back. The nurse was talking. She tiptoed to the window and tried to open it but it wouldn't budge. One more push with all her might and it opened. Wow! That air is cold. She looked back

again. The nurse's still talking. I can climb out now. Thank God we're close to the ground. She was able to practically step out. She closed the window behind her. It was a clear, moonlit frosty night. It's almost like daytime out here. Now if I can just find the gang. I'll walk alongside the building and look in the windows. Hope I can figure out where I left them. I wonder if they've waited for me. Maybe they've left. I wouldn't blame them. How could I have gone to sleep?

Someone tapped her on the shoulder. Her blood ran cold. She turned and saw a gun in a holster—white spats on boots. It was an M.P. Lieutenant—tall and authoritative.

"What are you doing out here, miss?"

"I work here." A moment of silence. "I went to a Christmas party and got lost."

"Let me see your I.D. card."

"Here it is. I was supposed to meet my friends near Ward B3. Do you know where that is?"

"Do you realize it's one o'clock in the morning, miss? I'm going to have to arrest you. It's way past curfew."

"Oh, no!"

"Come on, we're going inside." He led her through a door.

"Please don't arrest me. I'm sure my friends are waiting for me—unless they got tired and went home." Gee, he's really cute, she thought.

They turned the bend of the hall and almost bumped into Barbara, Tony, and Roger who were walking toward them. They all stopped.

"What's this about, soldiers?"

"I told the lieutenant how I got lost looking for the parking lot," Mary Lou said very quickly.

"Does this girl work here too?" he said, pointing to Barbara.

"Yes sir. Here's my I.D." Barbara rummaged through her purse. "See!" She sounded pretty frightened.

"When did they start hiring teenagers to work here? I'll have to place you all under arrest until we get this straightened out. Come on, we're going to the Command Post."

They all started walking quickly down the corridor. The lieutenant was in the rear.

"You soldiers in the band?" the lieutenant asked.

"Yes, sir," Tony answered.

"How long have you known these girls?"

"About a year, sir."

"They look like butter wouldn't melt in their mouths, but that doesn't mean anything. I can't figure what you're all doing in this part of the hospital this late. It's against all the rules."

"Well, we started at a party at the Non-Com Club."

"That's about half a mile from here. Here we are." They'd arrived at the M.P. office.

The sergeant on duty saluted when they came in. "I've arrested this motley crew here, Sergeant. Check and see if any reports of wrongdoing have come in." The four were standing by the door looking scared.

"No, Lieutenant, some reports of drinking in the wards but it's pretty calm, this being Christmas Eve and all."

Tears started pouring down Barbara's cheeks. Mary Lou put her arm around her.

"Sir, please only arrest me. They didn't do anything but wait around for me. It's all my fault."

"I should lock you all up. You must realize that being here at this time of the night is a very serious offense. I should investigate further. Stop crying, miss. In the meantime, since it's Christmas, I guess I'm going to let you go."

"Oh, thank you, sir," Mary Lou said.

"We really appreciate this," Tony said.

Barbara wiped her tears. "Thanks a million."

"Now remember, you're not off the hook. If I find out you did

indeed do anything wrong I'll come and get you. Consider your-selves on probation. Soldiers, take these girls home immediately."

"Yes, sir."

"Yes, sir."

They left fast—hurried down the corridor and out to the parking lot and into the jeep. On the way Mary Lou explained what had happened.

"Oh, Mary Lou, you're so brave. I never could have done it," Barbara said.

"Never again!" Mary Lou said.

"That's it for me!" Roger said.

"It's a miracle we got out of that one," Tony said. "Of course we knew she was safe. After all, he is a paraplegic."

"I would have been safe anyway."

During the rest of the ride they sang "Silent Night" and Mary Lou thought about the kiss.

Chapter 17

20 January 1945
The Germans were preparing to retreat to
their original positions in Alsace. General
Patton's Third Army was advancing on
every front.

I LIKE THIS a lot, Mary Lou decided. She had arrived at the new headquarters in downtown Richmond. It had large fan-shaped windows trimmed in dark green, high ceilings and a view of the Capitol building.

This is really spacious. Sergeant Stokey and I have a separate office from the others. This is going to be fun.

"How do you like it?" Captain Brade was showing her around.

"I love it."

"Just make yourself at home until the sergeant gets here. I'll be down the hall in my office."

Mary Lou put her bag in the desk drawer then straightened the in-out basket on her desk. I'm going to keep everything extremely neat, just like Captain Brade. Then she sat down and tested her new typewriter.

In an hour Sergeant Stokey arrived—traces of his movie-star good looks still showing. Coal black hair combed straight back—thinning a bit—pants worn low to make room for his paunch.

"Well, what have we here? A bobby soxer! My God, what will the army do next? Are you sure your momma knows where you are, little one?"

Oh no, not more of this, she thought, as she stood up. "Yes, sir, and I've been working for the army for three years now."

"Well you must have been straight off the cheerleading squad when you arrived." He went back to his desk, sat down, carefully centered his nameplate on his desk, then concentrated on her.

Oh gad, I'm blushing! "Maybe I was, but a lot has happened since then."

"Captain Brade said you were from McGuire."

"Yes, sir."

"That's getting down to nuts and bolts. Did they let you in the wards?"

"Yes, sir."

"Just proves how crazy this army really is. Well, sit down, honey. We don't want to start work too suddenly. The shock might kill me." He swiveled his chair and looked out the window. "I don't know what the hell I'm doing here. I guess they had to put me someplace until I'm eligible for my pension." He turned back to face her. "But between us we'll figure this out. We're the whole Military Personnel section right now. We have to do morning reports—enlisted men's payroll—officer's payroll—special orders. Can you do this stuff?"

"Well, I've only done enlisted men's pay, but I've seen all of the other things."

"They usually have an officer in charge to sign and make everything legal, so Captain Brade will do that. She's quite a gal. Taught philosophy at Vassar or some such place. Now listen, kiddo, don't let my style throw you off. I'm a miracle worker. I kept

supplies moving where they were needed. I found stuff the army had forgotten they had and put it where it belonged. I've got contacts all over the damned world. I can get anything and everything. They even gave me some medals. One place they just put me ashore with my supplies—I started wheeling and dealing. I know what generals want and colonels and majors—and natives. It takes 'em all to make it work."

"You make it all sound like fun."

"And fun is what we're going to have here, little girl. I can get anyone to do anything and everything. Just watch my smoke!" One more grin just for her then he turned toward the window again.

What a character! she thought. Why do I feel like I'm about to do something I shouldn't.

The next day Mary Lou arrived at work at eight. A note on her desk read: "Have to get a physical. Do the officers payroll after you've done the morning report." Signed, Master Sergeant Stokey.

Sergeant Percy always said to look things up in the Army Regulations. They have all the examples in there. She got the A.R.'s and took them to her desk. Yep, here's the way they're supposed to look.

I'll have to get the information for them somewhere. She went to the sergeant's desk. The staff sergeant had left his reports on it. So many men attached, semi-attached, sick—on special assignment. Well, I'll do the best I can. It has to be in by ten o'clock. She filled in the form as best she could, then took it to Captain Brade for her signature.

"How are you and Sergeant Stokey getting along?"

"Oh, fine, ma'am."

"This all looks in order," she said as she signed.

If it does it's a miracle! Mary Lou thought.

She attacked the officers payroll the same way, got it signed and took it to accounting.

"Where were you, Sergeant?"

It was four o'clock and Stokey had just returned to their office. He had a wild grin on his face. "I just had a little R. & R., honeychile."

His teeth look like Chicklets, she thought.

"Did you do the morning report and officers pay?"

"Yes, but I don't know if it's right. I just kind of faked it."

"I think you have the makings of a general, Rosebud."

"I got the officers' files out and put the information on the forms. But there must be more to it than that."

"That's how it's been done since Washington crossed the Delaware. You know what SNAFU means, don't you?"

"Sure, situation normal, all fouled up, sir."

"Don't call me sir. I feel ancient enough. Have a seat.

"Okay."

"Well, if things aren't SNAFUed the army couldn't function. Everybody's faking it. One time the Seabees put a landing strip and road on the wrong island. Totally misunderstood the orders. Everything SNAFUed. But it turned out copasetic. The ships and planes delivered the men and supplies to the wrong island also by mistake and it worked out smooth as silk. So you can see you're just what the army's looking for." He lit his pipe and grinned.

"But I'd hate to think I'd just be making one mistake after another. I like to do things right if I can."

"That kind of thinking will ruin everything. We have the makings of a great team here, kid. Don't muck it up."

"Well, I'll try not to."

"And if anything goes wrong I'll get blamed anyway. That's why it's great to be low girl on the totem pole. By the way, when does your little cohort arrive?"

"Who?"

"Your bobby-soxer friend from McGuire."

"Oh, Barbara! She'll be here tomorrow."

"Good! You'll need her if I'm to get all my gold-bricking done."

I sure do like him and he's the boss, so why am I worried? But Mary Lou figured somebody should be.

CHAPTER 18

18 FEBRUARY 1945
30,000 men of the 4th and 5th Marine
Divisions land on Iwo Jima.

"BARBARA, Sergeant Stokey is the wildest character you'll ever meet." It was Barbara's first day at the new headquarters and Mary Lou was showing her around.

"Here's your desk right outside our office in your own little niche."

"Oh, I just love working in town," Barbara said. "What does Sergeant Stokey do?

"He comes in late, tells me what he'd like done, and then never checks on anything. Here's my office. That's his desk by the big window and here's mine. Notice how neat it is." She picked up a package on it. "What's this? 'To my favorite bobby-soxer and her friend from McGuire.'"

"What could it be? Open it, Mary Lou."

"Gosh, this is exciting." Mary Lou ripped open the paper and

saw a dozen nylons. "Oh, my goodness, I've never had more than one pair at a time. Here, six for you and six for me."

"Mary Lou, I don't know anybody who has this many."

"I told you he is amazing. He gets all kinds of calls from generals on down, and Captain Brade never says anything about his hours or anything else."

"I can't wait to meet him."

"Why don't you make yourself at home. Organize your desk and everything. We have a huge, complicated report that's due Friday. We have to dig up all the facts and figures concerning personnel—whether they're attached, semi-attached, temporary assignments and so on, and I'm not really sure how to do it." They each went to their desks.

"Can it be done by Friday?" Barbara asked.

"I guess so, but I'm afraid we'll have to work a few nights."

"Well, we're used to that."

"Yes, but I was hoping we could keep normal hours working here. Actually, when it comes to the work itself I think we'd be better off without Sergeant Stokey. At least I'd know what has to be done ahead of time."

Sergeant Stokey arrived at three o'clock. "You must be the famous Barbara from McGuire General." He stood by her desk.

"Well..."

"Mary Lou told me all about you. I guess you know you two are going to be part of a great Military Personnel section. In fact, you're going to be the Military Personnel section since I don't know one whit about it."

"Yes, Mary Lou told me. I'd like to thank you for those beautiful nylons, Sergeant."

"Think nothing of it." Then he walked back toward his desk, stopping at Mary Lou's. "And how's my genius assistant?"

"Well, Sergeant, I'm trying to figure out how to do this report that's due on Friday."

"Oh, is that this week? I thought we had a lot more time than that."

"No, we only have three days."

"Don't look so worried, little chickadee. We can always get an extension if needed, can't we?"

"Well, we could, but I'd rather not."

"Mary Lou, you're starting to sound like one of my wives. I seem to have that effect on women. They all start to get serious and panicky."

I think I know why, Mary Lou said to herself.

He went back to his desk, put his feet up and opened the newspaper.

Mary Lou called over her shoulder, "I do love those nylons you left. Thanks a million."

"You're welcome, honey. And don't worry about that report. Just do the best you can. I'm working on another deal. Might surprise you one day with some real French perfume."

At five o'clock a tall sandy-haired major walked up to Barbara's desk. "Who's in charge of Military Personnel, miss?"

"Sergeant Stokey, sir. He's in there." She answered, pointing to Stokey's office.

He strode past Mary Lou and addressed the sergeant who was still reading the paper. "Sergeant, if you can drag yourself away from your reading I'd like to report in. Here are my records." He half threw them on the desk.

"No trouble, Major." Sergeant Stokey moved as though under water, put his cigar down, folded his paper, and pointed to the chair by his desk. "Have a seat. How long you here for, Major?"

"Two weeks at the most. I'll be on detached service. Here to do some work for Colonel Collins. I'm Major Moriarity."

"We'll take good care of you, Major. Miss Cottrell here is a cracker-jack worker."

"How do you do, miss."

His hand is cold and clammy! "How do you do?" I don't like him one bit, she decided, even though he was incredibly handsome.

"This looks like a pretty bare-bones operation here, Sergeant."

"We've only been here a few weeks. Just setting things up really. I'm here from Guam and Miss Cottrell is from McGuire General Hospital."

"Oh, I see."

"Well, Major, just let us know what we can do for you. We'll process you through now."

"Thank you, Sergeant." He got up and left.

"I don't like that son of a bitch one bit, Mary Lou. Excuse my French."

"That's funny. I didn't like him either."

"You've got good instincts, honey. He smells like trouble to me. Be on your guard."

"What do you mean, Sergeant?"

"Just watch your step around him." He gave her one of his Chicklet smiles. "I'm gonna do some research tomorrow and see if I can find out what he's up to. I think he might be with the Inspector General's office."

"What's that?"

"You might have met them but didn't know it. They're sneaky bastards. Excuse my Latin, honey, but I've had a few run-ins with them. They don't like anybody who doesn't play strictly by the books. And with my retirement coming up I don't want anything going wrong."

At five o'clock Sergeant Stokey stood up, stretched and announced, "Quittin' time!"

"Oh Sergeant, I think Barbara and I had better stay and work on that report. We're not about to be finished."

"Hope you kids didn't have dates tonight."

"No, sir."

"Well, don't work too hard. I'd stay but I'd be no use to you. And I do have a date so I'll see you tomorrow. Here are the keys." He threw them to her.

After dinner Mary Lou was calling out information from files on Stokey's desk to Barbara. They heard footsteps. Someone knocked.

"Who's there?" Mary Lou called out.

"Major Moriarity."

"What could he want?" Mary Lou whispered to Barbara. "Come in, Major."

"Good evening, girls," he said, oozing charm. "I was driving by and saw the lights so I thought I'd see what was going on."

"We're working on a report," Barbara said.

"Oh, do you work a lot of nights?" he asked.

"No, we don't," Mary Lou answered.

"Where's the sergeant?"

"I really don't know," Mary Lou answered.

"We'll probably get more done without him," Barbara joked.

"What do you mean by that?" he asked.

"She was just joking," Mary Lou said firmly. "Sorry we can't visit with you but we have to do our work."

He leaned on her desk. "Listen, Miss Cottrell, you can save me a trip tomorrow." His voice had a husky, confidential tone.

"How?"

"Just type a partial payment slip for me tonight and I won't have to bother you in the morning."

"I can't do that. I haven't checked your records. You'll have to come tomorrow."

"He must have heard that you're princess of partial payments," Barbara giggled.

"What does she mean by that?"

"Oh, it's just a joke from our hospital days. But I never give a partial until I've completely checked the records. So you'll have to come in tomorrow. Anyway, the paymaster's not open now, so you'd have to come back anyway."

"So you're not going to cooperate?"

"I'm afraid not. Sorry."

He leaned closer until his face was even with hers. "You might need a favor from me sometime."

"Why would I?"

"You just might. Why, even tonight I could give you two a lift home."

"No thanks!"

"Why not, Mary Lou?" Barbara asked.

"I have a staff car."

"No thanks! We have a ride." She gave Barbara a stern look. "Sergeant Stokey?"

"No, my Father," she lied. "In fact, he'll be coming pretty soon so I wish you would leave, if you don't mind. We have to finish our work."

"Well, you don't have to be so unfriendly! See you girls soon." He gave a mock salute and left.

"Mary Lou, why did you turn him down?"

"Sergeant Stokey thinks he might be an inspector trying to trap us into doing something illegal."

"Oh, no."

They worked until ten o'clock, then rode the bus home.

When Mary Lou got to work the next morning Sergeant Stokey was already at his desk.

"Good morning, Sergeant!"

"Good morning, little one! Don't look so shocked. I always come through when there's an emergency."

"You mean the report?"

"No, I know you'll do that just fine. I called some friends last night and found out Moriarity's with the Inspector General."

"Oh, thank God I didn't give him a partial payment last night."

"He was here last night?"

"Yes, he said he was driving by and saw the lights on and asked if I could give him a partial to save a trip tomorrow."

"And you didn't?"

"No. I told him I wanted to go over his records."

"He was trying to trap you."

"Why would he do that?"

"I told you he's a bastard. It goes with the job. But I'm not sure if he's out to get me or just looking around in general."

"He also offered us a ride home, which I refused."

"Good going, honey. Don't worry about it though. You can work up his records. We'll be ready for him when he comes in again." He handed her the records folder.

She started to read. "It says here he's in transportation. He escorts prisoners or patients around the country."

"That's just a cover so he can come and go and not be tied down to one place too long."

"He was in North Africa for six months. That's a short time to be overseas unless you're wounded and sent home."

"He probably got something on his superior officer and blackmailed him to get home," Leo laughed.

"He was made a major as soon as he got back and was stationed in Washington with short trips all over." She flipped some pages. "As far as I can see he was paid right on time and has nothing due him."

"Then he'll get nothing from us. We'll treat him strictly by Army Regulations. Remember honey, don't worry. When he comes in I'll take care of him."

She told Barbara the latest information.

"Gee, Mary Lou, I'm scared."

"Well, he can't do anything to us if we don't break any rules."

"I'm going now, kids." It was late that afternoon and Sergeant Stokey was on his way home. "Much more to do on the report?"

"No, Sergeant. If we work tonight I think we can finish it."

He threw the keys to Mary Lou. "Remember, be on guard."

"We will. Night."

"Don't look now, Barb, but that's Major Moriarity parked across the street." The girls had finished the report and were waiting at the bus stop.

Just then the lights on the khaki-colored sedan went on. It made a u-turn and pulled up in front of them.

The major pulled down the window. "I see you girls don't have a ride tonight. Hop in and I'll take you home."

"No thanks," Mary Lou said.

"Let's do," Barbara whispered. "I'm freezing."

"Our bus comes in a few minutes," Mary Lou said.

"What are you afraid of? I'm just trying to be friendly. We could get some coffee."

"I'm sorry, but we have to go right home."

"He's right, Mary Lou. What are you afraid of? I'm going." Barbara stepped to the car.

"Barbara!"

"Sorry, Mary Lou, but I've never been this cold in my whole life." She opened the door.

"Well, all right. I don't want you to go alone." Barbara got in, then Mary Lou. He smells like he's been drinking, Mary Lou thought.

"You'll see I'm not an ogre," he said. "Just a guy trying to be friendly. Where to?"

"Straight up Grace Street, then I'll tell you where to turn. We live out in the suburbs."

"You girls shouldn't be out at night alone," he said.

"Oh, we're used to that," Barbara said. "We used to be brought home in a jeep at two or three in the morning from the hospital." Mary Lou nudged her.

"Why was that?"

He tries to sound so innocent, Mary Lou thought.

"Well, we used to work in payroll and the patients had to be paid within three days of arriving," Barbara answered.

"Oh, why was that?"

"Because a lot of them were shipped out to other hospitals and the colonel in charge wanted them all paid while they were at McGuire," Mary Lou said.

"Oh, so there was no hanky-panky about using the jeep?"

"No! There was no hanky-panky," Mary Lou said.

"Well, I'm glad to hear that."

"We've never been involved in anything wrong since we've worked for the army." She gave him a stern look. Barbara looked frightened. Gad, I hope she doesn't mention the morgue or Christmas Eve. And thank God she doesn't know about Eric.

They were still on Grace St. when he suddenly pulled the car over to the curb in front of a stately old mansion. "Hey girls, look where we are! The Officer's Club! Let's go in and have just one drink and a sandwich or something."

"We really should get home," Mary Lou said.

"Oh, please, please, pretty please, Mary Lou. That sounds like fun," Barbara begged. "We haven't done anything fun in ages."

"I really want to go right home," Mary Lou said.

Major Moriarity leaned over Barbara. "Why do you hate me, Mary Lou?"

"I don't hate you."

"I know you've read my records. You didn't see anything bad, did you?"

"No."

"Well, come on. Let's see some of that southern hospitality."

"Come on, Mary Lou, don't be a killjoy."

"Well, all right. But we're not dressed properly. I'm not even wearing high heels."

"Me neither!"

Oh, I'd forgotten how beautiful it is, Mary Lou thought, as she looked around the club. The entry had a vaulted ceiling and glass doors etched in a wisteria tree design. Its former elegance hung over it like a mist.

"I love that staircase, don't you, Barbara?" It was wide and carpeted in antique lavender runners.

Major Moriarity signed and a white-coated attendant took their coats. "You ever been here, girls?"

"Yes, we used to come to dances here."

I wonder where Bill is now, Mary Lou thought. I feel sad thinking of him. I hope he never crashes his plane. A lot of farewells in my life so far.

"Mary Lou was dating this pilot and he came here and told this officer she was dancing with that they were married."

"Really? And did you almost marry him?" He escorted them to a table in the wood-paneled bar.

"I thought about it. But there are things I want to do before I settle down."

The waiter came over. "What'll it be, girls?" the Major asked.

"Why don't we leave it up to you, Major?" That way we don't have to take a chance and sound corny, Mary Lou decided, lighting a cigarette and trying to look sophisticated.

"Three old-fashioneds, please."

"I saw one in a movie once," Barbara said. Mary Lou nudged her under the table.

"It was a glamorous movie about these girls living in New York," she said glaring at Mary Lou as if to say "what's wrong with that?"

"What do you want to do when the war's over, Mary Lou?"

He seems really interested, but I think it's all an act. "Well, I did think I wanted to go to college, but I went for a weekend to be looked over…"

"And…"

"And to tell you the truth, it didn't work out too well. In fact, it was a disaster. Anyway, I went to a high school run by Benedictine nuns and we had four years of Latin and French, and I don't think I'd learn much more in that college. I don't know if I could be tied down to school now. I'm used to being pretty free, and I like it."

"But you girls work awfully hard."

"I know, but I think I like it out in the real world."

"You call the army the real world?" he asked.

"Well, at least we're part of things. Those girls seemed like something out of Gone With The Wind. And that's what's so funny. That used to be my dream—to be just like Scarlett O'Hara."

"And what about you, Barbara? What's your dream?"

"Nothing too fancy. I just want to have a good time until I meet the right man, then I'll settle down and be a really good wife and mother."

"Do you girls want to dance?"

"No thanks," Mary Lou said. "We really have to get home."

"Oh, just one, Mary Lou," Barbara said.

Major Moriarity stood up. "Come on, Barbara, we'll show Miss Scarlett here how it's done." He escorted Barbara out to the dance floor and led her in intricate steps.

Gad, I feel stupid sitting here alone. I'll go to the little girls' room, she decided. On the way three Marine officers sitting at the bar looked very friendly. I don't want to get involved. I just want to get out of here.

By the time she got back to her table the band was playing "Serenade in Blue." Gad, they're really dancing close. Barbara

had her head on his shoulder and he was softly kissing the top of her hair. This is ridiculous! She can't have fallen for him so suddenly. She knows he's not to be trusted and he's old enough to be her father. I'm not going to sit here by myself very long, she decided. She tried to wave discreetly to get their attention. The major looked over, then guided Barbara to the table.

"I've really got to get home, Major. Besides, I don't like sitting here alone."

Barbara lifted her head from his shoulder. "Now, don't be jealous, Mary Lou. The major and I are having a wonderful time."

"Great! Well, I'm not!" She has a strange look about her, Mary Lou decided. She's only had two drinks but she looks really drunk. I've never seen her like this.

"Why don't I get one of those Marines to dance with you?" Major Moriarity asked.

"I didn't come here to pick up some stranger. I want to go now."

They stood there for a moment. Barbara put both of her arms around his neck. "I think I'm in love, Mary Lou."

"Okay, honey, not here." He broke away from her and put some money on the table. "We'll go."

He had a difficult time driving because Barbara kept hugging and kissing him.

Gad, this is embarrassing, Mary Lou thought. What's come over her? They got to Mary Lou's house first. As she got out she said, "Major, I think Barbara's had too much to drink. I think she should come in with me."

"No, no, no," Barbara said. "We're going to go park and neck."

"Major, Barbara is only twenty. She's definitely not herself. She should spend the night here."

"That's not necessary," he said. "What do you think I am?"

"Well, promise to take good care of her and take her right home."

"Don't worry, Mary Lou. She's safe with me." Mary Lou hesitated, and then got out of the car with a sense of foreboding.

The next day Barbara didn't show up for work. Sergeant Stokey came in at two. "I'm worried about Barbara, Sergeant. Major Moriarity took us home last night and they dropped me off first."

"I told you not to have anything to do with him."

"I didn't want to but she would have gone without me."

"Did he take you right home?"

"No. We went to the Officer's Club and had two drinks, but Barbara acted like she'd had ten. I've never seen her so amorous."

"You mean she wasn't acting like herself?"

"Not at all."

"That S.O.B."

"What do you mean?"

"He might have put something in her drink."

"What do you mean?"

"We'll have to see what she says when she comes in."

"You mean there's something that can make a person act like that? Oh, the poor girl. She's just a big kid. I tried to get her to come into my house, but she wouldn't."

"If he did anything bad to her I'll have him court-martialed."

The next day Barbara came to work on time. "Oh, Barbara, I'm so glad you're here. I was worried about you."

Barbara was organizing the paper on her desk. "Why were you worried about me?"

"When you didn't come to work yesterday I thought maybe something had happened to you."

"I guess I made a fool of myself, Mary Lou." Her voice broke. "I don't even like him, but I couldn't stop kissing him. We went to the park after we dropped you off."

"Did he go too far with you, Barbara? If he did he could be court-martialed, Sergeant Stokey said."

"Oh, does he know too?" Tears started streaming down her face.

"I just told him you weren't acting like yourself."

"It's all a haze, Mary Lou."

"We'll get him punished."

"But I can't let my daddy hear about this. He'd never believe it wasn't my fault. Oh God, I'm so ashamed. Has the major been in?"

"No, he's off on a trip to pick up some prisoners in Georgia."

"Oh, Mary Lou, don't talk about this anymore, please. Don't tell Stokey anything."

"I don't know. He said there's something that can be put in a drink to make you act amorous."

"I know I wasn't myself, but please don't tell. I'll die if my parents hear about this. Let's just work now like nothing's happened, please, Mary Lou." She started to sort through papers on her desk.

Sergeant Stokey arrived at two o'clock, stopping for a moment at Barbara's desk. "Are you all right, little one?" he asked. "The world treating you okay?"

"Oh yes, Sergeant. I just had a slight cold yesterday. I'm fine now."

He stopped by Mary Lou's desk. "Is she really okay, honey?"

"She doesn't want to discuss it," Mary Lou said in a low voice.

"Well, let me know if that bastard did anything he shouldn't have." He picked up the report on his desk and said. "This looks terrific. You're really a whiz. Are you sure you're not bucking for my job?"

"Sergeant, how could you think that?"

"Just kidding, honey. I'm not long for this place anyway and I think you could carry on fine without me. I told Captain Brade that too, but she said the colonel thinks you're too young for the job, even though you do most of the work."

"But it wouldn't be any fun here without you."

"Sit down, honey." He pointed to the chair by his desk. "What are your long-range plans?"

"I'm not really sure. I just know I want to leave Richmond. I'll always be an outsider here. I never was like the other kids. When we first came down from the north I used to wear long cotton stockings. The other girls wore cute little socks. And my heavy underwear was always sticking out of my sleeves. They used to kid me about the way I talked, so I developed a southern accent thicker than anyone's. But it didn't matter. Just like my visit to Rose Hall. I'll never belong here. Anyway, I want to see what the rest of the world's like."

"What have you thought of doing besides going to college?"

"I used to go to the library at the hospital and read a magazine called *Theatre Arts*. There are wonderful schools in New York where you can study acting and history of the theatre and costumes. I think I'd like that. And all my life I always got the lead in school plays and stuff like that."

"Just make sure you follow your dreams, honey. Don't drift."

"I know I won't do that. Thanks, Sergeant."

CHAPTER 19

14 AUGUST 1945
Victory in Japan.
The Second World War is over.

COULD THAT be the phone? Mary Lou looked at her alarm clock on the table by her bed. It was two in the morning.

Who could it be?

The only other time their phone had rung in the middle of the night was when her Aunt Nan had died. She was the most artistic and talented of the McClain sisters and had died of tuberculosis. Mary Lou's mother had told her it was because her uncle was a cheapskate and wouldn't send her to a good sanitarium. Her mother always said there was nothing cheaper than a cheap Irishman.

"Mary Lou, it's for you." Her father tapped her on the shoulder. "It sounds like an emergency!"

"Thanks, Daddy." How did he wake up so fast? If she wanted a glass of water in the middle of the night he always appeared, magically it seemed, in a few seconds. "Sorry they woke you, Daddy."

"No trouble, honey."

Mary Lou went to the phone on the table in the hall. "Hello."

"Mary Lou, it's Stokey. I need your help."

"Why, what's happened?"

"I'm afraid you'll have to come to the office. I'll explain."

"But what's it about?"

"I'll tell you when you get here. I'd drive out and get you but it will be faster if you get a cab. Don't worry, I'll pay for it."

"But, Sergeant, please give me some idea."

"I need you to write some new special orders."

"In the middle of the night?"

"Yes. Now please come right away. I'll explain everything."

"Well, okay, I'll get dressed and come right down."

"Thanks, I'll never forget you for this. And be sure to wear something warm."

"Who was that, Mary Lou?" her father called.

"It was Sergeant Stokey, Daddy. He needs me to do some special work for him."

"At two in the morning?"

"I'm sorry, Daddy, but I have to go. He sounded desperate. Please go back to sleep. I'm going to call a cab."

"Well, call us and let us know when you've arrived safely."

"I will."

My God, what could be wrong? she wondered. What'll I wear. It's cold out in the middle of the night. I'll wear a sweater and skirt and my heavy coat. I'm shivering. She dressed quickly, combed her hair and looked out the window by the front door. At two-thirty the cab pulled up. She closed the door quietly.

"Where to, Miss?"

"Three Thirty West Sixth St."

"Downtown?"

"Yes!"

"Funny time to be going there."

You're telling me, she thought. "Well, I work for the army and sometimes we get special assignments at strange hours."

"Oh, part of the war effort!"

"Yes."

"My wife and me really cooperate with Roosevelt. We never get extra rations of meat or nothing!"

"That's wonderful."

I wonder if I did something wrong. He didn't even give me a clue. Gee, it's cold in here. Hail Mary, full of Grace. Please don't let it be anything too bad. Loose lips sink ships. Why did I think of that? I haven't told any war secrets. I don't even know any. St. Christopher, patron saint of travelers, get me there safely. This guy's a terrible driver.

Sergeant Stokey was standing out on the sidewalk when they pulled up. He paid the driver.

"What's wrong, Sergeant?"

"Come upstairs to the office and I'll tell you." They hurried up to the second floor.

"Come to my desk. Sit down, Mary Lou."

This is the first time I've ever seen him dead serious. No grin, no Chicklet smile.

"Well kiddo, remember the special orders I had you make up to send the twenty prisoners to Iowa?"

"Yes, they left last Friday."

"Well, I goofed. It should have been Ohio. They were supposed to be delivered to Fort Jefferson in Ohio. I got a call from the lieutenant in charge. There's no Fort Jefferson in Iowa and they have no orders for vouchers to pay for any more train tickets, meals or anything else. They're stranded there."

"Where are they staying?"

"The Lieutenant's got them stashed in some cheap hotel for now."

"Jesus, Mary, and Joseph!"

"You said it, honey. We'll need all the help we can get to pull this one off."

"We'll need?"

"Well me mostly, but I'm counting on you to help."

"What can I do?"

"Here's my plan: we make up new special orders to cover their trip from Iowa to Ohio. You know how to write these things."

"But I'm always half guessing. I never really learned how to do it properly."

"Well, you've been sending men clear across the country and so far so good."

"But even if we make new orders it'll take days on the train for you to get there with them."

"Well, that's just it, honey. I'm not going. You are."

"What?"

"And you're not going on a train, you're going on a plane."

"What?"

"I can't get leave right now, but you have lots of time off coming to you."

"But I've never been on a plane and that takes a lot of money."

"No, you're going free. Courtesy of the U.S. Air Corps."

"What?"

"I've talked to an old buddy of mine. He's a major now. I kept him supplied with Scotch from the Philippines to Japan—not to mention some other favors I did for him. He's gonna put you on a plane out at Bryan Field."

"But I'm a civilian."

"I know. I thought of disguising you as a WAC but it's better to stick as close to the truth as possible. We're just going to say you have these important papers to deliver to Iowa for our headquarters here—which is really true."

"You mean I won't be breaking any laws?"

"Well, not really."

"Oh, Sergeant, I'll be terrified."

"No, you won't be. I never saw a kid with your kind of poise. Now let's get started."

He brought out the Army Regulations regarding special orders for transporting soldiers from one place to another. Mary Lou started typing.

"Thank God they have all of these examples in here. It's really not too hard. Where did you say the soldiers are staying now?"

"The Grand Hotel in Jefferson, Iowa. Fortunately their due date at Fort Jefferson in Ohio was left flexible."

"How do they pay for the hotel if they've run out of vouchers?"

"Here's some money to give to the lieutenant."

In an hour they had finished composing the special orders and had put them in an official envelope.

"Come on, honey, I'll drive you out to Bryan Field. Here's the money. You carry your I.D. with you at all times?"

"Yes and I have my old hospital I.D. too."

"Good." They went downstairs and got into his car.

"I never knew you had a staff car, Sergeant. How come?"

"It goes with the territory, darlin'."

As they drove he explained. "Now here's my plan. My friend, Major McClary, is on special assignment here and he has cleared it with Air Transport to let you ride to Iowa with them. They're on their way to the coast, but they'll drop you off on the way. Then, twenty-four hours later you'll have a ride back on another plane. They call it the 'milk run'. Lots of big shots travel this way. Say as little as possible to everyone. The official scam will be that you're delivering papers for Colonel Collins, our C.O., here at headquarters, which is basically true. They don't have to know we sent the soldiers there by mistake in the first place. (We, she

thought?) If there are any bigwigs on the plane you might pretend to fall asleep so you don't have to talk."

"Oh, Sergeant Stokey, I'm scared. I can't get my teeth to stop chattering."

"Remember, I'm counting on you, Mary Lou. I'm getting out soon and I can't have a giant lash-up. I'd get demoted and my pension would go way down. It's especially dangerous right now with Moriarity snooping around."

"Well, I'll do my best."

"Here's my number and here are Major McClary's numbers at the field and at home. Now remember, you're really not breaking any laws or anything "

"You're sure?"

"Positive."

"What about my mother and father? They won't know where I am."

"I'll call them and say you're on a special assignment. Then you call them from Iowa, too."

Mary Lou could see they were at a small auxiliary field with one hangar, a tower and a one-story administration building. Outside two mechanics using portable work lights were checking a medium-size cargo plane.

Sergeant Stokey parked and they went to Major McClary's office. Gee, he's young to be an officer, Mary Lou thought. He looks like some high school student that Stokey's disguised as a major.

"Hi, old buddy! The major stood up and shook hands with Stokey. "What have you gotten yourself into now?" Without waiting for an answer he continued, "Maybe I don't want to know. Who's your young friend?"

"This is my assistant, Mary Lou Cottrell."

"How do you do, Miss Cottrell. Now, you're just delivering special orders, that's all?"

"Oh yes, that's all," she said.

"Because I can't be involved in anything really scruffy. You understand, Stokey. I'd never be able to sell any war bonds then," he laughed.

"No, I wouldn't do that to you, Bob. We just have to get these to some soldiers stranded in Iowa. Mary Lou, show the major the papers."

He read them. "They look okay to me." He paused. "Except for one thing."

"What's that?" Mary Lou asked.

"They're not signed by an officer."

Mary Lou sat down. "Oh, I forgot. Captain Brade always signs for us. Oh, Sergeant!"

Stokey looked at the major. "Well, Bob, what do you say?"

"Gee, Stokey, I don't think I have the authority."

"Actually you can, Bob. In circumstances of war if head of personnel can't be reached an officer above the rank of lieutenant can sign to expedite travel of troops."

"Well, I don't plan on a career in the army anyway so I guess I'll do it. I owe you." He chuckled. "But, you old devil, I bet you were counting on that, weren't you?"

The major signed. Stokey squinted his eyes and gave his Chicklet smile.

"Okay, young lady. I'll take you out to the plane. Fortunately there are no big brass going this time—just a couple of enlisted men going home on emergency leave." They walked outside.

I wouldn't be surprised to see a baseball mitt stuck in his back pocket, she thought.

Stokey patted her on the back. "Goodbye, honey. Don't worry, you're in good hands with Bob here. He's a Medal of Honor winner."

"Goodbye, Sergeant."

"See you soon, Mary Lou. Remember don't say much to anyone and you'll be all right."

They left Stokey standing by the building and walked out to the field, where a plane was being prepared for takeoff. "Here's a piece of paper with the date and time you'll be picked up in Iowa to come back. Get to the field a little early if you can." Then he handed her an envelope and said, "Here's a little insurance, Mary Lou. Keep it in your purse and in a real emergency show it to whoever is giving you trouble and you'll be all right. But don't use it unless absolutely necessary. Good luck!"

"Thanks so much, Major." His face smiles but his eyes don't, she thought.

The pilot and co-pilot approached. "Here's your passenger for Iowa, Lieutenant Burns. Official business." He introduced them. They looked slightly startled at the sight of her.

"We're off in ten minutes. Better get in, miss." Major Mc-Clary helped her on. "Goodbye and don't worry. Sergeant Stokey's projects always turn out great."

"Thanks again, Major."

I never pictured the inside of a plane like this, she thought. Three jump seats lined either side facing the center, where mailbags were piled up. In the dim light she could see two privates sitting on one side. She chose a seat opposite them. Thank God I won't have to talk to anyone.

"Better strap yourself in, ma'am," one private called to her.

"Thanks." They act like we do this everyday. Or maybe they're just putting on an act like me.

The pilot called back, "Everyone buckled up? We're taking off!"

Oh my God, I can't believe it! We're going up. I can't believe I'm hanging up here in the air. Oh, if Mother and Daddy could see me now. Funny, I'm not a bit scared. Just cold. It's really drafty in here. She put her scarf on. Gee, I feel drowsy. In a few minutes she was sleeping.

What's that loud talking?

She could hear the pilot on the radio. "We can pick up the

general, but we only have three seats for passengers left. I'm carry-
ing two enlisted men and one civilian. Yes, I said one civilian. As
assistant to the C.O. of Third Headquarters."

That's me he's talking about. Oh God, what's happening?

The pilot called to his passengers. "Sorry, troops, but we have
to make an unscheduled stop in Wheeling, West Virginia. Some
brass needs a lift."

Oh, I knew things were going too well. She reached into her
pocket for her rosary, which she carried for emergencies. I should
have sprinkled Lourdes water on for good luck. "Hail Mary…" she
prayed until they landed.

Gosh, that was bumpy.

"Sorry, passengers, we had so much turbulence going in," the
pilot called over the intercom. "We won't be here long. Just stay
in your seats while I check out the situation."

Mary Lou could hear him talking to the tower. "We've got
three seats available. If the general wants to bump somebody
that's his prerogative."

The pilot got out. It was daybreak and Mary Lou could see
him talking to a general and three aides—one short, one medium
and one tall.

"Well, sir, the enlisted men are on emergency leave, going to
funerals, I believe. The civilian is representing the C.O. of Third
Headquarters. Yes, I'll call her out here. Miss Cottrell! Please
come out for a minute."

The general, with his Texas twang and cactus soul, looked
shocked when he saw her. "What kind of a joke is this, Lieuten-
ant?"

"She's for real, sir. I'm sure. Major McClary in Richmond set
this up."

"I'd like to see your I.D., miss."

"Yes, sir." She showed him her headquarters and hospital
I.D.'s. I hope they didn't see my hand shaking.

"Well, they look in order, but I need your seat on this plane

for one of my aides. I'm afraid we'll have to bump you off this flight, miss. You are a civilian, after all."

"But, sir, I'm on an emergency mission for Colonel Higgins."

"Can't be helped. You can call him from the terminal and make other arrangements."

I guess this is the time to pull out the note! "I also have instructions to show this note if there is any problem, sir." She handed him the note from Major McClary.

He started to read. "Jim, look at this will you?" His aide looked over his shoulder.

"Is that the presidential seal?"

"Well, this is a first. I guess you have us all outranked, Miss." When he was born God had whispered in his ear how to play the game. "Lewis, you'll have to remain here at the base." Lewis, the short one, looked relieved. "You can work on those papers on my desk."

"Yes, sir."

He handed the note back to Mary Lou. "After you, miss."

Mary Lou got back on. "Do y'all mind if I sit over here?" she said to the privates. She moved to their side of the plane and sat next to them.

The one next to her whispered, "That's some kind of miracle you pulled."

"I know," she whispered back. In the light she could see them clearly for the first time. Poor-devil draftees—former lives trailing behind them. I know them well, she thought. They'll be patients someday.

The general and his aides sat on the opposite side. I can't wait to get alone and read this note. What could it have said?

Five hours later they landed in Iowa. The landing was smooth this time. They all got out to stretch their legs. The general came over and shook Mary Lou's hand. "Next time you see Major McClary tell him I think he's the greatest ace of this war, and good luck to you on your mission."

"Yes, sir, I will. Thank you." Oh, McClary's a hero. That's why he's on tour selling war bonds. Now I understand. "Thank you for the ride." She shook the pilot's hand.

"Have her come in," she heard a voice say.

Lieutenant Burkelman was barely visible behind a mountain of papers on his desk. I could clean that up for him in a few hours, Mary Lou thought.

"I'm in charge of operations here."

I wonder who's in charge of his laundry, she wondered. His uniform was crumpled—his collar sticking up funny.

"Now, what's this about?" he asked.

"I was only checking on my flight back to Richmond. It's all on that paper."

"Well, I'll have to make some phone calls." He tried to sound like he knew what he was doing.

"I'm sorry, but I'm in a hurry. I can't wait while you call. Here's Major McClary's number if you want to verify."

"Is that Major Robert McClary?"

"Yes, sir."

He seemed relieved. "Well, if he's your guardian angel I'll be glad to cooperate. I'll even have Sergeant Paris give you a ride to the city. To tell you the truth, you're a pretty implausible sight, Miss Cottrell."

And so are you, she thought.

"You look like a teenage Mata Hari," he continued.

"I can't say I blame you for thinking that. Thanks so much for your help."

It was a forty-five minute drive to the city. The sergeant talked about being stuck in Iowa. He was from Brooklyn. She tried to stay awake. They pulled up to the Grand Hotel, which wasn't.

The lobby was done all in mustard beige. The room clerk was done all in gray—suit, skin, and hair.

"I'd like you to call Lieutenant Bailey's room, please."

"Okay." He gave her a knowing look. "That's room four thir-ty-six."

"Tell him Miss Cottrell's here."

He called. "Lieutenant, there's a Miss Cottrell here. Send her up? Okay, it's your funeral. She looks like jailbait to me. You can go up."

Lieutenant Bailey was one of the army's ninety-day won-ders—blonde, altar boy clean-cut. He was waiting with his door open. "Oh, thank heavens you're here! You're a sight for sore eyes. I've run out of cash and the guys are really getting restless. They're a pretty rough group. I'll be glad to get out of here." He stopped talking for a moment and looked her over. "You sure are young."

"Well, so are you. Here are your special orders and here's one thousand in cash to pay for the hotel and any meals you have here before you go to the train. I'll just keep some for a cab back to the field."

"Great! It's all been put on room service, such as it is."

"I think I'd better sit down, Lieutenant. I'm exhausted. I haven't slept much. I'm sorry, but I'm having a hard time keeping my eyes open." She sat in the armchair.

"You poor girl. You'd be welcome to take a nap here, but I wouldn't want any of these guys to see you. They'd never believe you're from headquarters. I haven't told them the real scoop about what happened. I'm afraid they'd mutiny or something."

"What did you tell them?"

"That we're here on secret orders and I'm waiting for further instructions."

"That's almost true."

"They'd have a fit if they knew they'd spent three days and nights on a train to nowhere and more to come. I'd better call and get you a room. And here's some money back to pay for it."

The bellhop delivered the key. "Down this way, miss."

As she was leaving the lieutenant said, "Thanks, miss. I'll come by and say hello when I get back to Richmond. What time does your plane go?"

"Twenty hundred hours."

"Well, I think you're safe. Lock your door and I wouldn't wander around the neighborhood."

"Don't worry, I won't. I just need to get some sleep now. Bye."

"Good-bye and thanks again."

She lay on the beige chenille bedspread on the maple wood bed. That must be that new color, avocado green, on the walls. Oh, I've never been so tired. She never did get under the covers. When she woke up it was four in the afternoon.

Where am I? Oh, now I remember. I'm in Iowa. Iowa? This is crazy. I hope the lieutenant got to the train all right. He must have or he'd have let me know. Now all I have to do is get home. Home from Iowa! I still can't believe it. I'd better call and make sure Stokey called Mother and Daddy.

"Hi, Daddy, did Sergeant Stokey call you? Yes, I'm in Iowa on a special assignment. I know it sounds crazy, but I'll tell you all about it when I get home. I'm fine. Don't worry. See you soon."

When she got back to the airfield there was bedlam. Soldiers and civilians were running through the halls shouting to each other.

"The war's over! The war's over!" A private ran up to her and gave her a big hug. "We'll all be going home!"

She went to the Operations office. A new sergeant was on duty. "Hi, Sergeant. I'm Miss Cottrell, on the flight at twenty hundred hours."

He checked his list. "Okay, miss, have a seat. Isn't it wonderful? We just got the news. Victory in Japan! V.J. day! We're going to have a party and you're just in time."

"I'd love to, but I can't miss my flight."

"Well, at least have a beer!" He offered her a bottle.

"Thanks."

"I'll take you to the plane at nineteen-fifty. Just relax in the meantime." The radio was blaring and people were running in and out of the office. A smiling pilot came in, looked around and said, "Just what I'm looking for." He took the beer bottle out of her hand and gave her a long kiss on the mouth.

"Sorry, ma'am, but I wanted to start peacetime by kissing a beautiful girl. My name's Joe and thanks...." He placed her back on the chair and put the bottle back in her hand, then dashed out to the hallway.

"Sorry about that, ma'am," the sergeant said.

"Don't worry, it's fun to be part of the celebration," Mary Lou said.

A half an hour before takeoff he took her out to the plane. The pilot and co-pilot were getting in.

"Hello, I'm Mary Lou Cottrell."

"You're going to Richmond with us? Did you hear the great news? I'm Lieutenant Nelson and this is Lieutenant Bonner."

"Yes, I heard. I had a beer, too, to celebrate." He had red hair and a friendly smile. "Looks like your own private flight, miss. You're our only passenger. Sorry we can't provide more refreshments."

"Oh, don't worry about that. I'm just glad to be on my way home." She took her seat and buckled in. The war's over! I can't believe it. What'll I do with the rest of my life?

"You okay?" The pilot called back.

"Oh, yes. This is great. Any chance of my being bumped?"

"No, ma'am. We're going straight through to Richmond." The plane took off and the three of them sang, "You Are My Sunshine," then "God Bless America." Later they were quiet.

After a while she thought about the note. She got it out.

To Whom It May Concern:
Major Robert McClary, Medal of Honor Winner, is to be
granted any reasonable request that he might make. Con-
sider him under my special protection.
[signed] Franklin D. Roosevelt

Wow! There really are guardian angels, just like the sisters said!

CHAPTER 20

28 AUGUST 1945
The first American units arrive in Japan.

"MARY LOU, where were you? I called your house and your Daddy said you'd gone on a trip for Sergeant Stokey. But he said not to mention it to anyone here." The girls had just arrived at work.

"Oh, Barbara, you wouldn't believe where I've been in the last thirty-six hours. I'll tell you at lunchtime. But it's a big secret. If any of it got out Stokey would really be in trouble." Just then Stokey arrived.

"How's the heroine? Come back and tell me everything."

"Can Barbara hear too?"

"Only if she swears to secrecy."

Mary Lou told her story.

"Oh, Mary Lou, I can't believe it."

"You really are a trooper darlin'," Stokey said. "I think we've pulled it off. Now, as soon as I get a call from the lieutenant

that he's in Ohio we'll know we're home free. Were you scared?"

"Yes, but it was so exciting I didn't care."

"You'll both find a little surprise in your desks."

"Oh, Sergeant, what have you done now?"

"Just a little something from France."

"Real French perfume," Barbara squealed.

"I can't believe it." Mary Lou opened a box and found a huge bottle of Caron perfume inside. "Even the box is beautiful."

"This had better be our little secret, though. See you in a while. I'm going out to get some coffee." He patted them on the heads as he left the office.

"Yes, Captain, I'll be right in." Mary Lou hung up the phone.

"Oh, Barb, I have to see Captain Brade. Hope everything's all right." She went down the hall to her office.

Captain Brade's secretary was WAC Private Jane Johns, a sallow, sad-looking girl. She motioned for Mary Lou to sit down.

"Hi, Jane. I guess you'll be going home soon."

"Yes, I hope so."

"Aren't you happy about that?"

"Yes, in a way, but you know my four brothers stopped speaking to me when I joined the WACS and I don't know how they'll treat me now."

"Why did they do that?"

"They said the army was no place for a lady. But I was only trying to help the war effort the way they were."

"Yes, and maybe you freed a man up to go into combat by doing a desk job." Maybe that's not so good, she thought.

"That's what the recruiter said."

"If I'd been old enough I would have gone in."

"You would have? Oh, that makes me feel better."

The buzzer rang. "The captain will see you now. Thanks for cheering me up."

"You're welcome."

"Sit down, Mary Lou. Be right with you. I just have to finish this call."

Heavens, why am I so nervous? Mary Lou asked herself. The Captain put the phone down.

"I imagine you can guess why I've called you in, Mary Lou."

"Well, not really." Oh God, she must have heard about Iowa.

"It's about Sergeant Stokey."

Hail Mary, full of Grace, Mary Lou prayed. "Sergeant Stokey?"

"Yes. We all know the situation here."

"We do?" Should I tell her everything?

"Yes. About what you've done for the sergeant."

"Well..."

"Mary Lou, why are you so nervous? I think it's wonderful."

"You do?"

"Yes, Sergeant Stokey told me."

"He did?" Why didn't he tell me he told her, she thought.

"Yes, you can really be proud of yourself."

"I can?"

"Yes, and I have some wonderful news for you."

"You do?"

"Yes. When Sergeant Stokey retires I'm making you the Chief of Military Personnel. I don't think a civilian has ever had that title. Of course, I'll go on signing everything, but I do that for the sergeant anyway."

"You didn't mind that I went on that trip for him?"

"What trip?"

"Isn't that what you've been talking about?"

"I'm not sure what you mean, Mary Lou. What I've been talking about is that you've been doing all the work in Military Personnel for the sergeant. He told me that he has absolutely no expertise in that field and that without you nothing would have been accomplished. Now, what trip do you mean?"

A long pause. "Oh, I just went out to the hospital and got some forms we needed." Oh God, I almost spoiled everything for him.

"Well, don't worry about that. We're both really impressed with the fact that you were so unselfish and never told anyone what you were doing."

"Well, Sergeant Stokey is a wonderful man."

"You're a good judge of character, Mary Lou. In fact, he did something quite heroic in the South Pacific, but the whole story only came out recently. You may go back to work now, Mary Lou, I just wanted you to hear about your exciting future. I'm just waiting for final approval from Colonel Collins."

"Thank you so much, Captain." They shook hands.

"Oh, Barbara, I told an outright lie to Captain Brade." Mary Lou sat by Barbara's desk.

"What do you mean?"

"I thought she knew about my going to Iowa, but she didn't. So I said I took a trip to McGuire. It was really a harmless kind of a white lie. But I almost SNAFUed everything. I'm sure relieved."

"What did she want?" Barbara asked.

Mary Lou told her. Squeals of delight. "Let's celebrate and go to White's for a sundae."

"Great, and we'll roam through Woolworth's too."

Late that afternoon when Stokey returned from lunch he stopped by Mary Lou's desk. "We're home free, little one. The Lieutenant is in Ohio."

"Thank goodness!"

"Yeah, that was a close one. I'll never forget you for that. If Moriarity ever knew about that the jig would be up. Did Captain Brade tell you about your promotion when I leave?"

"Yes, I can hardly believe it."

"You really deserve it. Let's just hope the colonel approves."

"Why wouldn't he?"

"Well, honey, this is the army. He didn't get to be a colonel by breaking many rules."

"You're right, I guess. But I'll get my mother to say some rosaries and if it's God's will it'll work out."

"Yeah, God's and the colonel's. You know, sometimes I worry about you, honey."

"Why?"

"You're so damn naive." He patted her affectionately on the head and then went back to finish his reading.

CHAPTER 21

12 SEPTEMBER 1945
Japan: A little after 8:00 a.m., on board the battleship
Missouri at anchor in Tokyo Bay, the Japanese formally
surrender to General MacArthur, representing the
Allies. So ends the greatest conflict in history. It has
lasted five years and cost the lives of 55 million people.
Three million more are missing.

"WELL, TODAY'S the day, little ones. The old man's going back to the Islands." Stokey stood in the doorway for a moment looking at the girls before going back to his desk.

"Oh, Sergeant, we'll miss you so much," Mary Lou said. She went to his desk. Barbara joined them.

"Let's face it, you won't have more work to do when I leave 'cause I don't do much when I'm here."

"We don't care. We have such a good time together," Barbara said.

"My discharge came through from Washington. Mary Lou, you can type the final papers. Then I'm off to paradise." He handed his file to her.

"What will you do there?" Mary Lou asked.

"Just be, honey, just be. I'm going to get a haircut now. Be back in a while."

"Barb, come back and listen to this." Mary Lou had started going through his records. She read: "Master Sergeant Stockwell Stokey, having taken part in the landing of reinforcements on Guadalcanal on 13 Oct 42, had arrived at a secure position with the majority of his company. Upon learning that five of his men were trapped under heavy enemy fire in the rear he returned and lead them to safety at great personal risk. During this rescue he carried a wounded soldier most of the way. For valor above and beyond the requirements of his duty Master Sergeant Stokey is awarded the Silver Star."

"He's a real hero. I never knew he was in combat like that. I thought he had a safe job just handing out supplies and things like that."

"I guess that's why he never let us read his service record before."

"Yes, and you notice he went out when he knew we would be reading it. I can just see him acting like it was nothing."

"Yes, he probably smoked his cigar through the whole thing."

They laughed.

Later, when he returned, Mary Lou handed his records to him. "We're real proud to have worked with you, Sergeant."

"Come on, honey, you can't believe everything you read, you know."

When he finished emptying his desk he gave them each a small box. "Don't open this until tomorrow after I'm gone. And remember, the real heroes are out at McGuire." He stood for a moment and looked at them. "You girls are the best."

"We'll miss you, Sergeant."

"Take care of yourselves and remember, watch out for guys like Moriarity. No goodbyes now." Then he was gone.

"Gee, I feel sad," Barbara said.

"Me too."

Mary Lou answered the phone. "Military Personnel. Oh,

hello, George! It's been a really long time. Why yes, I guess I could. There's a girl I work with, she's my best friend. I think she could make it. I'll ask." She put her hand over the phone. "Barb, do you want to double-date tonight? A boy I knew who joined the Marines wants to take us to the Country Club."

"Sure, sounds like fun."

"Okay, George, Barbara will be at my house. See you then."

"What'll I wear, Mary Lou? I've never been there. I can't wait to see it."

"It's for dinner and dancing so something kind of dressy. I've been there a couple of times and it's really beautiful."

"I love your dress, Barb. You look great in red. You can really wear it with your dark hair." The girls were waiting to be picked up in the living room of Mary Lou's house.

"Yeah, I'm glad we've been sitting in the park on our lunch hour. I've gotten a little tan. And do you notice anything else?"

"Stokey's perfume?"

"Well, that too, but I'm wearing the nylons he gave us. I've been saving them."

"Me too. It's so much more glamorous than that awful leg makeup."

"I never could draw the seam on straight."

"Do you like my hair pulled back this way?" Mary Lou asked.

"I love it. It's so glamorous and your eyes look green when you wear that green dress."

The doorbell rang. Marine Captain George Barker and his friend came in and looked very happy when they saw the girls.

"This is Lieutenant Dan Sullivan." Dan was a clean-faced boy who looked relieved to be alive.

Mary Lou introduced Barbara to them. Dan looked over his shoulder once in a while like something was catching up to him.

"I can't believe you've been away for three years, George."

"Yes, when I left you were working at the Telephone Company."

"Well, I've been working at an army hospital since then and so has Barbara."

"Do y'all mind if we leave right away? Our reservations are for eight-thirty and we have one stop on the way."

"Okay. Night, Mother and Daddy!" she called. "We're off."

When they got out to the car another officer who had been waiting in the back seat got out.

"This is Captain Bob Lee."

"How do you do." He was a drawly southern gentleman. "Bob E. Lee?" Mary Lou joked.

"Well, not really, though I am related," he said without smiling.

He doesn't have much of a sense of humor. Can't picture him moving fast through sand, she thought. How did he ever make it back?

"We're going to pick up Bob's date. She lives near the club." Mary Lou and George sat up front. Barbara, Dan and Bob in the back.

"Her name's Patricia Post Lafferty. Sometimes known as Patricia Perfect."

"Why is that?"

"No one's ever seen her when she didn't look perfect. You'll see. She used to come to dances at V.M.I. before the war and no one ever saw her with a hair out of place."

"Okay guys, enough of that," Bob Lee said. When they got to Patricia's house, he went in to get her.

They were right! Mary Lou thought, as the couple approached the car. I love her lavender silk dress, lavender tinted lipstick, and even lavender nail polish. And that's the most beautiful honey-gold tan I've ever seen on a blonde.

"Guess you gals will have to sit on our laps," Dan said.

"Fiddle-dee-dee, I don't want to arrive all crushed," Miss Perfect said.

And I never had the nerve to use that expression. I hate myself!

"Well, it can't be helped," George said. "Unless we switch dates and you come up here with me." Mary Lou gave him a stare.

"Just joshing, Mary Lou."

"Heavens, this is just like when I was at St. Catherine's and you boys were at St. Christopher's. Remember those fabulous times?"

She settled her dress and sat on Bob's lap. "Where did you girls go to school?"

She's even doing a Scarlett kitten-like grin. "I went to St. Gertrude's," Mary Lou said.

"You mean the nun's school?"

"I never heard it called that," Mary Lou said. "But they did teach us. They were Benedictine Sisters."

"Oh, how Roman Catholic that sounds!"

Why do I feel insulted? Mary Lou asked herself.

"I went to Lakeside High School," Barbara chimed in.

"Oh, you mean public?" Patricia Post Perfect asked.

"Well, sure. But you had to live near it to go there."

"Oh, is that how it works? I never knew."

Oh, this is just like Tara, Mary Lou thought, as the car pulled into the circular driveway. The Richmond Country Club was white, colonnaded, green-shuttered, and spacious. Tables had been scattered inside the oval dining room and outside on the veranda overlooking acres of golf greens. A quiet waiter in white jacket and gloves showed them to their table.

"Let's go to the little girls' room," Miss Perfect said. "I feel absolutely disheveled."

"We'll order drinks," George said. "Trust our choice?"

"Sure," Mary Lou said.

While they were in the powder room Patricia Perfect saw friends and went over to them. They all squealed and hugged each other.

"She's a drip," Barbara whispered.

"I know. I can't stand her, but she is gorgeous. You have to give her credit. Oh gad, she's even got perfect little feet in perfect little lavender shoes."

Patricia came back and they all checked their make-up in the long mirror. They stood three in a row. Good, better, best, Mary Lou couldn't help thinking. Barbara, dark, with good-natured country sturdiness—Mary Lou, taller, finer boned, Irish, square face—Patricia, tallest, thinnest, chiseled features. Never let it rest till your good is better and your better's best. But I bet Barbara's really the best person overall, unselfish and sweet. I'm glad she's my best friend.

"How did you get so tan so early in the year?" Mary Lou asked.

"We've already opened our house at Virginia Beach for the summer. I just came up for the reunion with Bob and George. Where are you girls spending the summer?"

Mary Lou and Barbara looked at each other. "Oh, mostly in Richmond," Mary Lou said. "We work in an army headquarters."

"A what?"

"An army headquarters. We're in Military Personnel."

"I can't imagine what you could be doing there," Patricia said.

"It's too complicated to explain," Mary Lou said. Gad, I feel poor white, she thought. "Let's go back."

"Mary Lou!" It was Rose Marie Carney from St. Gertrude's.

"Oh, Rose Marie! I haven't seen you in ages."

"I know. We've really lost touch with each other." They hugged.

"What are you doing here?"

"I'm with George Barker who's home from the Marines."

"I'm going back to the table, darlin's," Patricia said. "Bob doesn't like me to be gone too long. Bye, y'all."

"Look, Mary Lou!" Rose Marie put her hand out with a diamond ring on it. "We're celebrating. I've just gotten engaged to

Kevin Kelly. He's getting out of the army next month. I'm sending you an invitation to the wedding."

"Oh, that's wonderful."

"I've been so busy—picking out patterns for silver and crystal and everything. Come over to our table and say hi."

"I will."

"Ann Marie's there too. She's engaged to Lionel Lindsey Brown and Margaret Mary's engaged to Bryan Butterworth." She paused a moment. "Oh, Mary Lou, I wish you'd come to school with us. We really missed you. You were always the most fun of anyone."

"Thanks, Rose Marie."

"Now be sure and come by and say hi."

"I will."

"And promise you'll come to the wedding."

"Don't worry, I will. Unless I have to go to Iowa or some place like that." Oh God, why did I say that?

Rose Marie looked puzzled as she left.

"Who was that?" Barbara asked.

"A girl I went to high school with."

"Did all of your friends belong here?"

"No, just a few. It was a Catholic school and didn't cost much so we had a mixture of people. But St. Catherine's, where Patricia went, was Episcopal and very expensive, so almost all of them belong."

"They sure have strange names, Mary Lou, if you don't mind my saying so."

Mary Lou laughed. "No, I agree. It's just a custom among some of these families. Well, we'd better go back."

George got up and helped them with their chairs. "We've ordered Southern Comfort and Coca-Colas for everyone," George said.

I think that's a bad omen! Mary Lou thought.

"Let's dance, Mary Lou." The band played "Long Ago and Far Away." He held her tightly. The war had given him confidence.

"God, it's great to be home, Mary Lou."

"Remember when you were waiting for your commission, George, and your pulse kept racing every time you had your physical?"

"Yeah, I couldn't wait to get in. And I made it just in time for every hellish landing in the Pacific. There weren't many of us who made it out in one piece."

His big face has collapsed. He looks old, she thought. But he still pants in my ear just like he used to.

"Let's go back and get our drinks," he said.

"Mary Lou and Barbara work for the army. Did you boys know that? At first I thought they might be WACS," Patricia said as they sat down.

"What do you do there?" Bob Lee asked

"Well, we're in Military Personnel, but for most of the war we worked in an army hospital," Mary Lou said.

"Oh, that sounds ghoulish," Patricia said.

"What do you mean by that?" Mary Lou asked.

"Well, I didn't think refined young ladies would be allowed to do that."

"Well, now you know they are," Mary Lou said.

"And the pay is great," Barbara said. "Mary Lou has saved enough to go to college if she wants to and I've saved a nice dowry for myself."

"I thought daddies were supposed to do that," Patricia said.

"Well, now you know some don't," Mary Lou said. The band started playing "I'll Be Seeing You." "Let's dance again. I love that song." She thought of the sweet ensign-to-be that she met at the dance at Rose Hall.

They danced. He still pumps his arm up and down like he used to, she thought, but I guess he hasn't had much chance to practice lately.

"Don't let her bother you," George said. "She just comes from another world."

"We're all in the same world, George, remember?"

"Well, you know what I mean. I've always admired you, Mary Lou, but you are different from the girls I grew up with."

"Thank God!"

"Oh, come on now, don't get mad." He kissed her on the cheek.

His kiss is still wet.

"You've been around by now. You're not still the little innocent you were, are you?"

"What do you mean by that?"

"Come on, who's kidding who? You must have had some wild times working with all those soldiers."

"To tell you the truth they were all perfect gentlemen." Except for the Nazi, she thought.

They joined the others at the table.

Dan was feeling no pain. "Let's clear out of here and go to the Washington highway. There's a place that stays open all night."

"Oh no, we have to work tomorrow," Barbara said.

"You can drop Bobby and me off at my house," Patricia said. "He's staying the weekend then going to the beach with me on Monday."

"Hanky-panky time?" George kidded.

"Well, what do you think?"

She's doing Scarlett again, Mary Lou thought.

"Let's go," George said. "Our little clerks have to work tomorrow." Mary Lou gave him a dirty look.

They dropped Miss Perfect and Bob Lee at her house.

"Night all. You boys'll have to visit me at Sweet Briar in the fall. Maybe we'll run into each other again, girls."

"Sure, if you ever need a partial payment look me up," Mary Lou said. Patricia looked confused. Nobody laughed. Oh, what a drip I sound like.

"Girls, the night's still young. Let's go dance some more," George said.

"Where?"

"That place on the Washington highway that Dan knows about."

"Gee, I don't know."

"I thought you'd be more fun than this, Mary Lou. Can't you do something for returning heroes?"

"I don't mind if you want to," Barbara called from the back seat.

"Great! First rate!" Dan said.

"Okay, maybe for an hour," Mary Lou said.

Jake's Lantern was rustic, barn-inspired, and dark. "There's a booth over there," George said.

"How can you see?"

A live three-piece band was playing hillbilly music. They sat down and ordered beer.

"Wish we had a bottle with us," Dan said.

"I think you've had enough," Barbara said. He had his arm around her shoulders and was kissing her on the cheek.

George tried to do the same with Mary Lou.

"Let's dance, George."

They tried. "Who can dance to this?" George said.

"Well, this place was your idea," Mary Lou answered.

"I know a better idea. They've got some cabins here."

"So…?"

"Let's check in." He started holding her very tight. "We could go to Heaven together."

"George, what's come over you? You used to be such a gentleman."

"Yeah, and you used to be a virgin. But I bet you're not anymore."

Oh God, my face is getting hot. She thought of Eric. Maybe he can tell. "We're going home—now." She led the way back to their booth. It was empty.

"I wonder where they are?"

"Maybe they checked in. He's quite a Romeo."

"Let's go to the car."

In the parking lot he grabbed her and pushed her against the building. God, that hurts. Wet kisses on her neck. Fumbling with her blouse. Not twice in a lifetime! I'll die first. She kicked him and he let go. She ran to the car. He followed.

Barbara was sitting in the back and Dan was stretched out with his head in her lap, sound asleep and snoring.

"Well, there's your Romeo, George. Drive us home—now! And no more funny stuff."

Dan's snoring was the only sound on the drive home. When they got to Mary Lou's George opened the door, but didn't get out. He was looking sullen. "You know, Patricia could have gotten her girlfriends from Sweet Briar to go tonight, but we thought you'd be more fun. But I should have known. You working-class girls are all alike—prudes. You promise, but you don't deliver."

"I never promised you anything and I'm going to be something someday, you'll see, and I won't get it through my father like you've gotten everything. Come on, Barb! And one more thing—you'd better learn how to kiss better or nobody'll ever deliver to you." She slammed the door.

The girls ran up the walk, tiptoed through the dark house, then got into bed.

"Oh Barb, I'm sorry it was such an awful night."

"Don't be silly," Barbara started laughing. "I never heard you talk like that. You really told him off." Mary Lou laughed too. "At least I can say I've been to the Country Club."

"Barb, we'd better get some sleep. We have to be up in four

hours." After a few minutes, "Can you believe that starting to-morrow I'm Chief of Military Personnel?"

"No." More giggles—then quiet—then, "Do you know what Dan said when he had his head on my lap?" Barbara asked.

"No. What?"

"Bring those lips down here."

"Oh, God, no!" They got hysterical.

"And George said Dan was a Romeo!"

"Do you think we would ever marry men like that and join the Club someday?"

"I used to want to, but I don't anymore. Oh, Barbara, I feel so free. I don't even care that he said working-class girls. He's such a horse's ass." They screamed with laughter at this.

"We've got to get some sleep. Night."

"Night, chief."

More giggles—then quiet.

CHAPTER 22

"SHALL WE MOVE, Barb? I'll go to Stokey's desk and you go to mine?" The girls were now officially the Military Personnel section — on their own since Stokey's departure.

"Sure, why not? You've been doing his work for three weeks now."

They started moving their belongings. "Captain Brade said I'd be getting a huge pay raise when the promotion comes through."

"When is that?"

"Soon, I hope. When the colonel gives final permission. Oh, Barb! Look who's coming down the hall."

"Oh, no, Major Moriarity! I thought he was gone for good."

"No, he's still on special assignment, so he can come and go like he wants."

"Oh, Mary Lou, stay with me if he comes here. I don't want to be alone with him."

"Don't worry, Barb. I won't leave you. Stokey said we should beware of him."

"He looks so much shorter than I remembered, Mary Lou."

"Maybe men are like houses. They look smaller when you go back. Quick, sit down! He's coming." They started typing.

Major Moriarity glided in—all smooth and sandy-haired. "How're the southern belles today?"

"We're fine," Mary Lou said.

He leaned on Barbara's desk and stared. "Not speaking? How come?"

She looked up from her work. "We're just very busy. We don't have time to talk." She was blushing

"Well, I have to report in. Where's the sergeant?"

"He retired," Mary Lou said.

"Who's taking his place?"

"I am."

"You are! That's impossible. You're not army."

"Captain Brade said as long as I know the job I can do it."

"Is this official?"

"Well, not one hundred percent but I've been doing the job for three weeks now."

"I can't believe this. Has Colonel Collins approved your promotion?"

"He's in the process."

"Well, this is very irregular, young lady."

"Why are you so bothered by this, Major? I can do it all—morning reports, enlisted pay, officer's pay, special orders. Why shouldn't I be head of the section?"

"Because it should be a soldier."

"And a man, you mean?"

"Well, yes," he stammered. "This is no job for a civilian bobby-soxer."

"I'm not a bobby-soxer. I'm doing the job and I'm doing it well. Give me your papers. I'll check you in."

He sat by her desk, opened his briefcase, and reluctantly got out his folder and handed it to her.

Mary Lou glimpsed a piece of black lace lingerie folded neatly beside his papers. I can't believe what I just saw, she thought, trying not to show her shock.

"This is extremely unorthodox. I'm going to get to the bottom of this," he said.

Oh God, I feel like I might laugh or something. "I don't see why this is any concern of yours. You're not on duty here permanently. Why should you care?" she said as normally as she could. She hardly heard his answer.

"Because it's my job to care. The army is my life. You'll be hearing from me." On his way out he stopped by Barbara's desk. "I'll talk to you later."

Should I tell Barb about the lingerie? Oh, Stokey, why aren't you here, Mary Lou thought. I guess I'd better keep this to myself. It's just all too strange and Barbara's been through enough. I'd better not tell what I saw.

Barbara joined Mary Lou at her desk. "Oh, Mary Lou, what are you going to do?"

"I'm not going to do anything. It's none of his business. Captain Brade says the final decision is up to Colonel Collins. After all, he's head of the whole headquarters."

"I can't stand Moriarity now, Mary Lou. There's something so weird about him."

Boy, is she right! "I know, he gives me the creeps. 'The army's my life'," Mary Lou mimicked. "I wish Stokey were here. He'd take care of him for us. But we'd better finish this work or we will be in trouble. Let's just forget about Moriarity for now."

"Look, Barb, I got this in the mail yesterday." The girls had finished their typing and were taking a break. "It's a brochure

from that school in California. I used to read about it in the library at the hospital. Besides acting classes they teach history of theater, costumes, art. It's almost like going to college. It's a two-year course and I have just enough saved to go there if I want to."

"But what about your wonderful new job? Would you really rather be an actress?"

"I think it would be fun pretending to be other people, don't you?"

"No, Mary Lou. That's where we really are different. I just like to be me."

"Gosh, it's almost five-thirty. We'd better hurry if we're going to catch our bus."

"It's kind of fun being on our own, isn't it?"

"Yeah, I can't believe how smoothly everything's going."

Barbara was waiting outside the office door when Mary Lou got to work the next day. "Mary Lou, where were you? You're late."

"Oh, I'm sorry. I've been to Mass. I'm two-thirds of the way toward a happy death now."

"What?"

"Well, if you go to mass and communion on the first Friday of each month for nine months you are guaranteed a happy death. And I've been to six so I'm two-thirds there."

"Wow!"

"Of course, it's not a hundred percent guarantee, but as close as you can get."

"What do you mean a 'happy death'?"

"Well, in good standing with the church and all. And I think it means there won't be too much agony connected with it."

"Holy cow, that's amazing. Oh, I wanted to tell you, Captain Brade came by on her way to her office and wants to see you."

"Oh, no! The one time I'm late. I'd better go right away."

Captain Brade looked concerned.

"Sit down, Mary Lou. I'm afraid something's happened that might jeopardize your promotion."

"What's that, ma'am?"

"Major Moriarity has gone to the colonel and is trying to block it. He's a real snake. Please tell me off the record if there's anything he might try to use against you."

She told her about the trip to Iowa. Captain Brade was flabbergasted. "I don't think he knows about that. I hope not anyway."

"I was only trying to help Stokey. His retirement was coming through and everything."

"Well, I'll help you all I can, Mary Lou. Your secret is safe with me, but if he knows about that I'm afraid it's pretty bleak."

"I'd like to tell you something bad that Moriarity did but it concerns someone else and I promised I wouldn't."

"I can almost guess what it is. Confidentially, Mary Lou, he's being investigated himself right now, but in the meantime he can do a lot of damage. Good luck tomorrow when you see Colonel Collins. We'll hope for the best."

Mary Lou almost bumped into Moriarity going down the hall.

"Hello, Scarlett, how's the world treating you?"

"Just fine, thanks." What's he doing here now? I didn't know he was in the building.

"What's the rush?"

"I'm not rushing—just going back to work."

"Actually, I was looking for you," he said blocking her way.

"Oh."

"Yes, we have to have a conference."

"Oh, what about?"

"About Sergeant Stokey."

Oh, no, she thought. "Why?"

"Well, I've unearthed some evidence about him, but you might be able to clear him of any wrongdoing. Anyway, you know

I've always had a thing for you, honey. Why can't we have a date and discuss this?"

"I would never date you after what happened to Barbara."

"What does that mean?"

"You know what I mean."

"I didn't hurt her. She just got what she was looking for."

"You took advantage of her."

"Let's drop this. I just thought you might want to help your beloved Sergeant…but if you don't…"

"Well, I guess I could meet you to talk about Stokey."

"Great! I'll pick you up after work."

"No, I'd rather meet you."

"Sneaky, huh? Afraid Barbara will get jealous? Well, I don't care. Let's meet at the Officer's Club at six-thirty."

"All right." God, he's so irritating. I'll offer it up for a good cause. Maybe it'll help toward my happy death.

I feel silly sitting here alone, Mary Lou thought. She was waiting for Moriarity in the lobby of the Officer's Club. The attendant had explained that single women were not admitted. Couples were coming and going. Mary Lou tried to act nonchalant by looking around at the wood paneling.

How could he keep me waiting after insisting on this so-called date? I'd leave, but I don't want to let Stokey down.

At six forty-five the attendant came out. "Are you Miss Cottrell? You're wanted on the phone. Come this way."

I can't believe this. I feel so poor white being stood up this way.

He handed the phone to her across the desk with a knowing look on his Kilroy face.

"Hello, Major?"

"I called to apologize for being late. How long have you been there?"

"About fifteen minutes."

"I'm having a problem leaving my apartment. I have to wait for a call from Washington. If you don't mind please take a cab to 8022 Monument St., apartment three. I'll pay for it. That way we can start our discussion and I'll drive you home as soon as the call comes through. It's from General Wynwright."

This sounds weird! "I don't know, Major. We can always talk tomorrow."

"There won't be time. I'm leaving on an important mission and I want to tell you the truth about what happened that time with Barbara."

"Well, all right." What a surprise! she thought. But at least I won't have to be seen with him in public.

"Good girl, see you soon."

His voice sure sounds strange, she thought, but I guess it'll be all right. I just won't drink anything.

She paid the cab driver. Nice building, she thought. Old mansion converted into apartments. Numbers one and two were on the ground floor. Guess number three is upstairs. She went upstairs and rang the bell and waited. No answer. She knocked. No answer. What kind of a joke is this? What's he trying to pull?

Then she heard a woman's voice. "Come in, dear." The door was unlocked.

Gee, it's dark in here! Just then the light went on on the end table lamp. And sitting on the sofa was a WAC Captain in army dress uniform drinking a highball and smoking a cigarette.

"Oh, I'm sorry. I must have the wrong apartment."

"I don't think so."

"Am I in the right place."

"You sure are, honey."

"I was looking for Major Moriarity."

"Well, look no further."

I must be crazy! Could it be?

The WAC got up and came over to Mary Lou. "Let me take your coat, honey."

It is! It is! It's Major Moriarity! And he looks very pretty! He was wearing make-up and his blonde hair was curled softly around his face.

"I'll fix you a drink," he said.

"Oh, no thanks! I don't have time. I can't stay long." He ignored her answer and went over to the bar. He's got pretty legs too!

"You can see now why I couldn't meet you at the club. I had an irresistible urge to be Joan, not John. Sit down."

They sat. He on the sofa and Mary Lou in the armchair. "I just thought if we couldn't be boyfriend girlfriend maybe we could be just girlfriends. After we dispense with Stokey, of course."

"What do you mean by that?"

"I mean about Iowa!"

Mary Lou was silent for a moment pulling herself together. "We didn't really break any laws or anything." I can't believe I'm really talking to him like everything was normal!

"But when I tell what I know to the colonel it'll be the end of Stokey's pension, you know that."

He's even painted his nails. "Why do you care so much, Major?"

"I'm only a captain when I'm Joan."

"Oh, sorry."

"Because rules cannot be broken." He said this in a mechanical way, carefully opening a pack of cigarettes. "Cigarette?"

"Oh, all right." I've got to get out of here. He's totally insane.

"Now, honey, I want you to tell me all the details and I'll try to go easy on you."

I'll just pretend to cooperate, she thought. "Maybe it would be better if I wrote it down and typed it up like a report."

"You just want to get out of here, don't you?"

"To tell you the truth, yes."

"You feel uncomfortable with me like this?"

"Well, yes, I do."

"Don't be so shocked. There's a whole group of us who do this."

"Oh, I didn't know."

"Well, it's not something we put in our service records, honey."

"But Major, I mean, Captain. I don't know why you invited me to see you like this."

"Maybe I just wanted to see the look on your face—and I must say it was a doozey. And maybe I like to live dangerously, as you and Sergeant Stokey definitely do." He laughed at this. "You know two girls can have just as much fun as boy and girl. Besides, there's a side of me that likes to see the army get rooked, even though my job is to see that everything's according to Hoyle."

"Can't you just forget about Stokey? He's retired now."

"You wouldn't even give me a partial payment. I don't like to be made a fool of and I think Iowa is just the tip of the iceberg."

"No, I swear that's the only thing we ever did wrong!"

He leaned forward and blew smoke in her face. "I don't believe you, honey."

Mary Lou stood up and put on her coat. "Well, it's true!"

Moriarity got up and went to the door barring her way.

"You don't think you're getting out this easy, do you?"

"I don't think you're in a position to give me orders after what happened with Barbara."

"She just fell for me—John, I mean. I can't help that."

"There was more to it than that. I think you put something in her drink."

"That's just an old wives' tale. You're just no fun at all, Mary Lou."

"I don't care if you tell on Stokey. I'll tell about Barbara. She's only twenty, you know."

He grabbed her wrist. Suddenly his voice dropped. He was Major Moriarity again.

"I'll teach you a lesson." He started twisting her arm.

"Let me go! I'm leaving—don't try to stop me." She kept pulling away. "If you do I'll tell about you, I mean Joan and you'll get a section eight."

She managed to get the door open and ran out into the hall. She heard Major Moriarity yelling after her "Bitch! Bitch!"

Oh God, let me get away. He can't follow me dressed like that, I hope. Blessed Mother save me!

She went down the steps—onto the pavement—ran down the street until she found a phone booth and called a cab.

In the cab on the ride home she thought, I've never been so scared. How do I get into these things? Maybe God's testing me. But I don't want to be a saint. I don't even want to be holy.

When she got home she called Barbara and told her everything. They decided she should keep quiet until after the meeting with Colonel Collins.

I can't believe it. His secretary looks just like Betty Grable. I never saw a WAC like that. Where did he find her? Mary Lou was waiting outside of Colonel Collins office the next day.

"Miss Cottrell, you can go in now."

Colonel Collins' office was almost perfect government issue, khaki colored furniture and rugs, but it had one major flaw. There was a picture of him on the wall painted by his wife and it was done on velvet and it was large. In fact, it covered the wall behind his desk. Mary Lou couldn't take her eyes off of it.

"Sit down, Miss Cottrell." He didn't get up.

"Thank you." He's not as old as I thought.

"You're younger looking than I remembered, Miss Cottrell."

"Oh, am I?"

"Someday you'll be glad when people say that."

"I don't mind now, actually, except when they go on and on about it." Gee, it's really hard to concentrate. I must look at him and not his picture.

"I've been looking through your records folder—pretty impressive."

"Thank you." On second look he is old—about forty. And he looks like he's trying to eat his way out of the Army too, just like Roger.

"Scored third on the Permanent Civil Service test in this area of the country."

"Yes, sir." Oh God, please help me concentrate. I feel like I might laugh. That picture's so weird.

"A nice comment in here from the C.O. at McGuire about your visiting the wards and explaining pay problems."

"Well, the patients couldn't make it to the office and it worried me."

"Very conscientious!"

"Thank you."

"You're a can-do kind of person. I can see that. But what makes a pretty little girl like you want to do this kind of work?"

"What do you mean, sir?"

"I mean be connected to the army?"

"I'm not sure I know what you mean."

"Well, I should think you'd want to go to parties and have fun with other kids your age."

"Well, a lot of the kids my age were in the war, sir, fighting. And besides, I have to work. My father couldn't afford to send me to college. Anyway, I actually like it and the Veterans Administration was taking over the hospital and I thought that it would be sad to stay there during peace time." Oh, darn! Why do I have to explain? she thought.

He came over and sat by her on the leather sofa.

"I really like you, Mary Lou."

I don't like you, Bob, she thought, but I'm glad you've moved away from the picture.

"And, if you were a man the job here at headquarters would be yours, but I can't have a young girl be my Chief of Military Personnel." He patted her hand.

"But I've been doing the work for six months."

"Yes, but we didn't know that, did we?"

"I can't help that. I don't know who would have done it if I hadn't."

"Now don't get me wrong. No one's going to change your responsibilities here. You're to continue just like you are. It's just that we can't possibly elevate you officially."

"You mean no promotion and no pay raise?"

"I'm afraid not, dear." He patted her again.

"But you're going to let me go on just like now?"

"Yes, dear." He stood up and looked at his watch. "Afraid I have no more time. But I've enjoyed our little chat."

"Well, I haven't."

"What do you mean?" He looked shocked.

"I don't think this is fair. I'm doing the work. I should have the promotion. Captain Brade approves and Sergeant Stokey said there's nothing in Army Regulations against it."

"Well, I can see that Major Moriarity was right about you."

"What does he have to do with it?"

"He told me you were a willful young lady."

"Oh, he did, did he?"

"Yes, and he thinks something suspicious was going on when Sergeant Stokey was here." He spoke into his intercom. "Peaches, send Major Moriarity in here, please."

"Why are you bringing him in?"

"He has pertinent information that I think you should hear."

Oh God, he'll tell about Iowa! she thought.

Moriarity came in and shook hands with the colonel. He's not even looking at me, she thought. He's acting like I'm not even here.

"John, we're at an impasse here. I'd like you to state your findings in front of Miss Cottrell."

And the picture, she thought.

"Well, as I told you, Bob, I don't have proof-positive because my investigation is not finished, but I have unearthed evidence of gifts of perfume and stockings to the girls in Military Personnel from Sergeant Stokey."

"What do you mean evidence? We told you about that. There's nothing wrong." She wondered when he was going to tell about Iowa.

"Maybe in exchange for favors?"

"Favors?" she asked.

He continued to avoid looking her in the face. "Of course, there's nothing personal in this, Colonel."

He's not going to mention Iowa, she decided. He's afraid.

"Colonel Collins, this is ridiculous. You weren't even going to bring him in if I'd gone along with your plan."

"This sounds like insubordination to me, Mary Lou."

"And this sounds like blackmail to me, Bob."

"Now, Mary Lou, let's not say things we'll be sorry for."

"Oh, you're right, Colonel. I apologize. I don't want to argue with you. But you want to know something. All of a sudden I realize I don't really care. This isn't what I want. I'm leaving. I'm going to give myself an honorable discharge. You did me a favor." She stood up. "No hard feelings." She turned to Moriarity. "And as for you, Major, I'd watch my step. And I think you know what I mean. Goodbye."

She went down the hall to the ladies' room and looked in the mirror. Well, Mary Lou, you've done it now! I hope you're happy.

She smiled. I am! God, what came over me? Everything just clicked into place. He made it so easy for me. If he'd given me the promotion I might never have left. I feel great and Stokey's safe too. I'd better go and tell Captain Brade.

Captain Brade was expecting her.

"I'm leaving, Captain."

"Yes, I know. Colonel Collins called me. I hate to see you go. You're irreplaceable."

"Give my job to Barbara. She's just as smart as I am. I'll teach her everything before I go."

"Mary Lou, I'm so sorry he didn't promote you."

"Don't feel bad. I have to leave anyway. I can't stay in Richmond. I don't belong here. In the middle of the meeting I knew I didn't care about the promotion."

"What will you do?"

"I'm going to California to study theater and acting with a Russian teacher." She stood up. "Thanks for everything, Captain Brade. You've always treated me fairly."

"Goodbye, Mary Lou. Good luck!"

"Thanks. And please don't let Moriarity bother Barbara when I'm gone."

"Don't worry, Mary Lou, I won't. And confidentially, he won't be around much longer. We're wise to him."

"Oh."

"I can't tell you any more. Sorry."

Barbara was waiting back at the office. "Oh, Mary Lou, Mary Lou, what happened? Tell me! Tell me!"

"I'm leaving."

"Oh, no! Why?"

"He didn't give me the promotion."

"Oh, no!"

"But it's all right."

"I'm so sorry."

"Don't worry. I really shouldn't stay. I suddenly knew."

"What about Stokey?"

"Colonel Collins called Moriarity in, but he never mentioned Iowa. He just said that Stokey had given us stockings and perfume. Barb, he never even looked at me. I couldn't believe it."

"Oh, Mary Lou, what'll I do without you?"

"I'll teach you my job. You'll be all right. Maybe in a while they'll get used to a girl as head of the department."

"I'll miss you."

They hugged. "I'll miss you."

"Where will you go?"

"To California. I'm really happy, Barbara. It's time to go."

That night when Mary Lou got home from work she asked her mother and father to come to the kitchen for a conference. Her brother, Glenn, Jr. joined them at the round table.

"I've got something to tell y'all."

"You got the raise?" her Father asked.

"No. But don't worry. I'm really happy."

"You've saved enough to go to college?" Elizabeth asked.

"No, I'm going to California to study acting with Mme. Maria Ouspenskaya."

"Who's that?" her Father asked.

"A Russian woman from the Moscow Art Theatre. I read about her at the hospital in a magazine."

"Oh, how wonderful!" Elizabeth said, her face especially beautiful since she'd stopped drinking.

"My little girl alone in a big city?" Glenn, Sr. asked.

"We've always wanted to go there, too," Elizabeth said.

"I know. Maybe y'all can come someday."

"I'm going to call my brother George and ask him if you can stay with him."

"Oh, no Daddy. I want to be independent. I don't want any favors."

"I haven't seen him for twenty-five years. But we still talk once in a while. It would only be for a few weeks until you get settled."

"Well, okay If you must."

Elizabeth went over and hugged her—then Glenn, Sr.—then her brother. They all laughed a lot and kept holding each other.

A month later Mary Lou was on a train going to California. The porter had turned down the lights, but Mary Lou was too excited to sleep. She leaned on the window and looked at the houses in the distance. Smudges of yellow from their lights spilled into the night around them and they looked safe and secure. But I'm glad I'm here, she thought, I'm on my way and I'm not afraid. I love my new luggage with my initials on it—my new black suit for traveling—my new shoulder bag. I don't think I spent too much. I still have enough to pay for everything when I get there. The severance pay will be coming too. Mother will send my trunk when I have a place to stay. I feel so free, so happy. I know wonderful things are going to happen.

She put her head back and closed her eyes and in that dark place the wards of McGuire appeared and she remembered the men and she wished they too could leave.